Masterpiece Paintings

Museum of ‌ *om the* *Boston*

Selected by

Theodore E. Stebbins, Jr.

John Moors Cabot Curator
of American Painting

and

Peter C. Sutton

Mrs. Russell W. Baker Curator
of European Painting

with commentaries
by the curatorial staff
of the Department of Paintings

Museum of Fine Arts, Boston

in association with

Harry N. Abrams, Inc., Publishers, New York

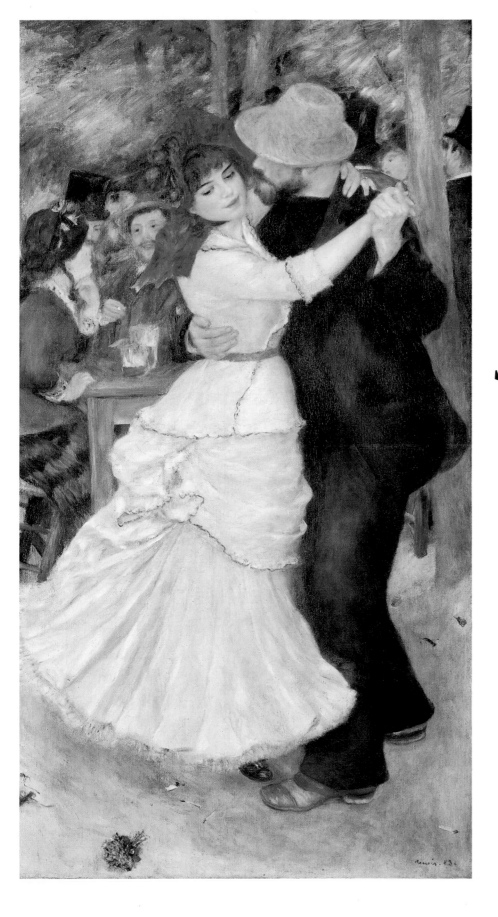

Masterpiece Paintings from the Museum of Fine Arts, Boston

Editor: Beverly Fazio
Designer: Michael Hentges

Library of Congress Cataloging-in-Publication Data

Museum of Fine Arts, Boston.
 Masterpiece paintings from the Museum of Fine Arts, Boston.

 1. Painting—Massachusetts—Boston—Catalogs. 2. Museum of Fine Arts, Boston—Catalogs. I. Stebbins, Theodore E. II. Sutton, Peter C. III. Museum of Fine Arts, Boston. Dept. of Paintings. IV. Title.
N520.A7178 1986 750′.74′014461 86-14200
ISBN 0—8109—1424—7
ISBN 0—8109—2342—4 (pbk.)

Published in 1986 by Harry N. Abrams, Incorporated, New York. All rights reserved. No part of the contents of this book may be reproduced without the written permission of the publishers

Times Mirror Books

Printed and bound in Japan

Front cover: John Singer Sargent. *The Daughters of Edward Darley Boit* (detail). 1882. Oil on canvas, 87 × 87 in. Gift of Mary Louise Boit, Florence D. Boit, Jane Hubbard Boit, and Julia Overing Boit, in Memory of their Father, Edward Darley Boit

Back cover: Luis Meléndez. *Still Life with Melon and Pears.* ca. 1770. Oil on canvas, 25⅛ × 33½ in. Margaret Curry Wyman Fund

Frontispiece: Pierre Auguste Renoir. *Dance at Bougival.* 1883. Oil on canvas, 71⅝ × 38⅝ in. Picture Fund

Contents

Foreword

With the publication of this book, we celebrate the rebuilding of the entire Evans Wing, which houses the Paintings Galleries at the Museum of Fine Arts, Boston. Our public has waited patiently for several years while these galleries have been dismantled, and while a whole new system of climate and air control has been installed. Now, we can say with pride that more paintings are on permanent exhibition at the Museum than ever before in our history. The paintings have been sensitively installed for the enjoyment of the public in beautiful, refinished galleries, which have been made possible by farsighted gifts of some magnificent donors, for whom the Trustees have named many individual galleries and other spaces. And perhaps most important, the new climate-control system, making possible as it does stable temperature and humidity in the galleries and in the storage areas, helps us fulfill our highest obligation, the physical preservation and safeguarding of these collections for the enjoyment and instruction of future generations.

This rebuilding project has been truly a community effort, made possible by numerous acts of generosity and of devotion to this institution and its collections on the part of donors, Trustees, and staff alike. This project thus mirrors the way in which the paintings collection itself was formed. As the curators note in their short history of the paintings collection that follows, Boston's tradition is not that of the single, princely collector, but rather reflects a phenomenon quite special to this city—the widespread taste in the community for collecting paintings of all kinds, and the equally significant habit of making public-spirited gifts and bequests of those paintings, and of purchase funds to buy others, to the Museum of Fine Arts.

Boston has loved fine paintings, both American and European, for many generations. Over the years the city has formed its own taste, and so our collection has its own special strengths, which reflect the special regional culture of Boston and of New England itself. We reopen our Evans Wing with the hope that present and future generations will carry on this great tradition.

Jan Fontein, *Director*

Introduction

On the occasion of the reopening of the Paintings Galleries of the Museum of Fine Arts, Boston, after several years of renovation and the installation of a climate-control system, we take pride in presenting here 125 of the finest paintings in the collection. Each one is illustrated in color and each is accompanied by a commentary written by our colleagues in the Department of Paintings or ourselves. These masterworks were painted between 1310 and 1973 in eight countries of Western Europe and in the United States, and they provide a sampling of our collection of nearly four thousand American and European paintings.

The Museum of Fine Arts, Boston, was incorporated on February 4, 1870, "for the purpose of erecting a museum for the preservation and exhibition of works of art, of making, maintaining and establishing collections of such works, and of affording instruction in the Fine Arts." It grew out of the Boston Athenaeum, a private library and art gallery that served in effect as the city's art museum from shortly after it was founded in 1805 until 1877.

On May 26, 1870, the city of Boston awarded to the Museum of Fine Arts a parcel of land on Copley Square in the newly filled "Back Bay," next to the lot upon which Richardson's Trinity Church was shortly to be built, and where the Copley Plaza Hotel now stands. Fourteen architects submitted design proposals for the new building, and the Trustees chose that of the Boston firm of Sturgis and Brigham, which provided for a Ruskinian Gothic structure built of red brick with terra-cotta trimmings, similar to the Victoria and Albert Museum in London. Martin Brimmer, first president of the Museum of Fine Arts, proclaimed that the prizes of a museum's collection are "its best pictures and marbles," noting especially the "local duty" of the Museum, saying that its "collections would be singularly deficient if it did not contain a full representation of Copley and Stuart, of Allston and Crawford, of Hunt and Rimmer." From the start the Trustees followed this goal, aiming for a collection rich in the Old Masters and in European painting and equally committed to the best of American painting, with a special interest in Boston's own artists.

In the 115 years since its initial accessions, Bostonians have with equal generosity both established endowed purchase funds for paintings and given and bequeathed many of their best pictures to the Museum. Thus, of the 125 works included in this book, about half were gifts or bequests of friends of the Museum, and half were bought with the Museum's purchase funds. In general, the great holdings for which the Museum is best known—the superb, large groups of paintings by Copley, Heade, and Sargent, among the Americans, and by Millet and Monet

among the French—have come from gifts and bequests of private collectors, while purchase funds have been used to buy very special pictures unlikely to come to the collection as gifts, such as Harnett's *Old Models*, Turner's *Slave Ship*, Rosso's *Dead Christ*, or the Pollock, *Troubled Queen*.

This book reflects the whole of the paintings collection and thus records Boston's history and the city's special way of seeing as it has evolved over several centuries. One of the great strengths of the collection lies in the art of Boston and New England. Beginning with the first American school of painters, led by the Freake Limner around 1670, outstanding artists in every generation have worked in Boston and have been well patronized in the city. Local families have maintained a long tradition of passing along to the Museum their treasured paintings. As a result the collection is now unrivaled in eighteenth-century Bostonian painting—including Smibert, Copley, and Stuart—as well as in the nineteenth-century painters, from Washington Allston through William Morris Hunt and William Rimmer to such turn-of-the-century masters as the Museum School teachers Edmund Tarbell and Frank Benson and favored out-of-towners including Winslow Homer and John Singer Sargent. The latter's masterpiece, *The Daughters of Edward Darley Boit*, 1882, given to the Museum by the four sitters in 1919, remains one of the most popular pictures in the collection. During the nineteenth century Boston was busy collecting in two other fields, the Old Masters from the Renaissance through the eighteenth century, and what was then modern French painting of the Barbizon and Impressionist Schools. Boston had only one truly great collector of Old Masters, Isabella Stewart Gardner, who was advised by Bernard Berenson, and whose collection, with its great Rembrandts, its Vermeer, and the Titian, *Rape of Europa*, far overshadowed that of the Museum of Fine Arts, Boston, when she opened her Venetian palace, Fenway Court, in 1903. In contrast, the Museum's Old Master pictures came into our collection singly and in pairs, often as the only or the major gift of a particular family. For example, Henry Lee Higginson, founder of the Boston Symphony, gave just one picture—but one of sublime importance—*St. Luke Painting the Virgin and Child* by Rogier van der Weyden. Our first great Spanish picture, Velázquez's *Don Baltasar Carlos with a Dwarf*, was bought in 1901, and the Crivelli *Lamentation over the Dead Christ* was purchased in 1902 with Berenson's advice.

It was in the late nineteenth century that Boston formed a special affection for modern French painting. Hunt had studied with Millet in Barbizon, and he became his champion, buying *The Sower* in 1851 and successfully urging other Bostonians to buy the work of this important French painter. Over forty families bought Millets and later donated them to the Museum; most notable among Millet collectors was Quincy Adams Shaw, whose collection included twenty-seven oil paintings by this artist and an equal number of pastels, all of which were given to the Museum by his heirs in 1917. The art critic William Howe Downes wrote about Boston's taste and its style of collecting thusly: "Boston amateurs have never made such extensive, costly, and showy collections as those of the Vanderbilts, Belmonts and Stewarts of New York, or of Mr. Walters of Baltimore, but the number of good pictures modestly housed in the homes of the 'upper ten thousand' of the city is astonishing; and it is a significant fact in

9

the history of art that there was a time when New York dealers who had a good Corot or Courbet were obliged to send it to Boston in order to sell it."

Boston's next generation of collectors naturally turned from these Barbizon masters to the French Impressionists. They bought exceptional paintings by Manet, Degas, Cézanne, and Van Gogh, but they favored above all the beautiful, light-filled landscapes of Claude Monet. One observer noted with gentle humor in 1888 that "among Boston collectors it is not altogether impossible to find extremists who already avow openly their admiration for those mad outlaws, the Impressionists." Today the Museum of Fine Arts, Boston, owns thirty-eight Monets, the largest collection outside of Paris. In the case of Monet's work, as with Barbizon and Impressionism in general, pleasing pictures of domestic scale came to the Museum from the homes of such collectors as Robert Treat Paine 2nd and John Taylor Spaulding, while purchase funds and the "eye" of curators and directors brought us such large-scale canvases as the superlative Gauguin *D'où venons-nous?* (bought in 1936), and the large Monet, *La Japonaise* (a 1951 purchase).

Throughout the eighteenth and nineteenth centuries, Boston was truly a modern city. Each generation of painters practiced an up-to-date style, often one recently imported from Europe. Copley portrayed his sitters, as they wished, in fashionable dress and surrounded by the very latest and most stylish furnishings. Eighteenth-century Boston was rebuilt in the latest Federal style by Charles Bulfinch, and it was rebuilt again in the most modern styles of Henry Hobson Richardson and McKim, Mead & White after the fire of 1872. Boston's taste for the contemporary served it well over the years, not least in the field of paintings that were collected here. This taste for the modern stemmed (as it frequently does) from confidence, which in Boston's case resulted from the fact that because the society was stable and money was being made, the city's future seemed bright.

But the city's mood changed around 1900. Van Wyck Brooks in his *New England: Indian Summer* studied this period in terms of literature and found Boston turning in on itself, increasingly pessimistic, and stagnating. A taste for the latest and best became instead a taste for the historic and sentimental; the modern and the experimental in paintings were no longer sought. Boston simply stopped buying contemporary art between 1900 and 1950 and consequently missed the opportunity to acquire works by Seurat and the Pointillists, Matisse and the Fauves, Picasso, the Cubists, and the Futurists, as well as the Surrealists and the advocates of Dada. Fortunately, this trend has been reversed, and the city's collectors are now actively and courageously buying in the contemporary field.

The building on Copley Square was soon outgrown, and it served as the Museum's home only until 1909. In that year a great new classical structure, designed by Boston architect Guy Lowell in the Beaux Arts style, and standing between Huntington Avenue and the Fenway, was opened. Its east wing housed Boston's great collections of Egyptian and classical art, while the west wing was given to the vast collections of Chinese, Japanese, and other Asian art. In 1911 a donor came forward to build a paintings wing on the Fenway side of the property: this was Maria Antoinette Evans, widow of the wealthy, self-made merchant Robert Dawson Evans, in

whose memory the gift was made. The majestic, colonnaded Evans Wing, designed by Lowell, opened in February 1915. Visitors admired its twelve spacious, beautifully articulated, second-floor galleries, all with skylights admitting natural light, and all lined with rich damasks in the nineteenth-century style. The marble Tapestry Gallery housed a fine collection of French and Flemish tapestries, while the whole of the first floor was devoted to curatorial offices, store-rooms, a lecture hall, and the Department of Prints and Drawings. Accompanying the opening was a special loan exhibition that included 110 European and American paintings drawn from the collections of thirty-five Boston families, and that put its emphasis on the directions the Museum would pursue in the following decade—Italian Baroque, English eighteenth-century, Barbizon, and French Impressionist painting. Major lenders included Mrs. Henry C. Angell, whose collection of French paintings came to the Museum in 1919, and Mrs. Evans herself. When Mrs. Evans died in 1917, the Museum received an endowed purchase fund as well as her collection of some fifty paintings, including the Jordaens and Vigée-Le Brun portraits illustrated here.

During the early years of the Museum there was no Department of Paintings as such, and responsibility for them fell to the "Division of Western Art," whose tripartite responsibilities included Paintings, Textiles, and "Other Collections." Beginning in 1902 John Briggs Potter, an able painter himself, was appointed keeper of paintings, and in 1910 a group of friends offered to fund for three years the post of curator of paintings, provided a distinguished scholar could be found. In 1911 the position was filled by Jean Guiffrey, adjunct curator of paintings at the Louvre, and the Paintings Department was founded. At the same time, a group of collectors pledged $100,000 a year for two years for the purchase of pictures. Guiffrey spent the funds wisely, buying major works by Andrea Solario and Lucas Cranach, by Guardi, Claude, and Turner, together with large groups of watercolors by La Farge and Sargent, an early Copley, and the telling portrait of *Marquis de Pastoret* by Paul Delaroche illustrated herein.

Guiffrey's leave of absence from the Louvre came to an end in March 1914, and he returned to France after a most productive tour of duty here. John Briggs Potter, as keeper, was again in charge of the department, this time until May 1, 1930, when Philip Hendy was appointed curator. An Englishman, Hendy had been assistant to the keeper of the Wallace Collection in London, and he had come to Boston three years before to write a scholarly catalogue of the paintings in the Isabella Stewart Gardner Museum. During his term in Boston he concentrated on conservation of the collection, the refurbishment and reinstallation of the galleries, and the organization of exhibitions (including an important show of American colonial portraits). He also published a catalogue of the collection in 1932, and in addition purchased several fine Italian pictures, including the exquisite Giovanni di Paolo, *The Virgin of Humility*. Moreover, a number of superb pictures were received as gifts during this time, including Manet's *Execution of the Emperor Maximilian* (given in 1930 by Mr. and Mrs. Frank G. Macomber) and the superior double-portrait by Degas, *Edmondo and Thérèse Morbilli* (given by Robert Treat Paine 2nd in 1931). In October 1933 Hendy resigned to become director of the Leeds Gallery in England.

A year later, in April 1934, George H. Edgell, a teacher of fine arts at Harvard and dean of Harvard's School of Architecture, was appointed curator. He was the institution's third curator of paintings, and he had served for only a few months when, in October 1934, he was also made director of the Museum. Continuing as curator, he was assisted by Charles C. Cunningham, who went on to a distinguished career as museum director in Hartford and Chicago; James S. Plaut, who later played an important role as director of Boston's Institute of Contemporary Art; and Mrs. Haven Parker, who wrote a pioneering book on Copley and whose close relationship with the department continues to this day.

Remarkable acquisitions were made in the years between 1935 and 1937. Robert Treat Paine 2nd, a notable and generous connoisseur of pictures, gave his famous Van Gogh, *The Postman Joseph Roulin*, and important purchases included the fine Renaissance panel by Fra Carnevale, the *Presentation of the Virgin in the Temple*, bought with income from the Charles Potter Kling Fund, Renoir's *Dance at Bougival*, and the unsurpassed Gauguin, *D'où venons-nous?* In addition, two important modern American pictures were bought, setting the stage for a collecting effort that continues today; these were Charles Sheeler's *View of New York* and Edward Hopper's *Room in Brooklyn*.

Edgell, who served as director until his untimely death in 1954, continued as curator only until 1937, when W. G. Constable, former director of the Courtauld Institute, London, was appointed as the fourth occupant of the post. Constable served for almost twenty years and is well remembered for his significant and wide-ranging acquisitions, including the Duccio *Crucifixion*, Canaletto's *Bacino di San Marco, Venice*, and the Poussin *Mars and Venus*, as well as several of the notable American pictures in the collection by Harnett, Eakins, and Ryder—all of which are included in this volume. Constable was a distinguished scholar who published widely on such painters as Richard Wilson and Canaletto; his ground-breaking book *Art Collecting in the United States* (1964) remains much in use today.

John Taylor Spaulding, who in 1921 had given a notable collection of Japanese prints, in 1948 bequeathed to the Museum a splendid, wide-ranging group of paintings strong both in the French School and in the modern American field. Included were magnificent examples by Renoir, Van Gogh, Toulouse-Lautrec, and Fantin-Latour, as well as by Prendergast, Henri, Bellows, and Hopper. If Spaulding was the typical Boston collector, with his genteel background and his Harvard education, then Maxim Karolik—who provided the other great donation of 1948—was cut from a different cloth. A Russian émigré with a flamboyant manner that struck some Bostonians as charming and others as crude, Karolik became a full-time collector of American art after marrying the much older, wealthy Bostonian Martha Amory Codman in 1928. He first collected American colonial furniture of the highest quality, and he gave this collection to the Museum in 1938. Karolik then turned to American nineteenth-century painting, seeing his opportunity in the unjustly neglected period between Stuart and Homer, or roughly the years 1815 to 1865. Karolik became the modern discoverer of Fitz Hugh Lane, Martin Johnson Heade, and a host of other major American masters. His gift in 1948 brought to the Museum 233 paintings that he had gathered over the past six or seven years; it

was followed by further gifts, and a generous bequest in 1964. All in all, the M. and M. Karolik Collection constituted the most significant single donation of paintings ever received by this Museum.

Edgell's successor as director was Perry T. Rathbone, who also served as paintings curator in the years 1955 to 1972 and who was in many ways responsible for bringing the Museum into the modern age. The pace of exhibitions quickened, and major shows in these years were devoted to the work of Copley, Sargent, Van Gogh, and Matisse, and to the "Age of Rembrandt." Magnificent acquisitions of Old Master and modern paintings were made in this era, and purchases included ten of the pictures found in this volume, notably the masterworks by Rosso Fiorentino and Giovanni Battista Tiepolo, as well as Lucas van Leyden's *Moses After Striking the Rock*, Ruisdael's *Rough Sea*, and Edvard Munch's *The Voice*. Significantly, it was during Rathbone's directorship that exhibitions of modern art and the purchase of important twentieth-century painters first occurred, and this led to the formation of a Department of Contemporary Art in 1971. Kenworth Moffett served as curator until 1984, and major acquisitions included a superlative group of paintings by Morris Louis. From 1972 to 1977 the Department of Paintings was managed by Laura Luckey and Lucretia Giese. The major acquisitions of this time occurred in 1975, when the Boston Athenaeum, facing the need to raise capital funds, decided to sell the best of its paintings collection, which had long been on deposit at the Museum. The Museum purchased several of these historic works, including *Picture Gallery with Views of Modern Rome* by Pannini, *Young Woman in a White Hat* by Greuze, *Pat Lyon at the Forge* by Neagle, and *King Lear* by West; later, after a protracted negotiation, it also bought half-interests in *George Washington* and *Martha Washington*, both by Gilbert Stuart.

In 1977 John Walsh, Jr., became the first Mrs. Russell W. Baker Curator of Paintings, and Theodore E. Stebbins, Jr., was appointed curator of American Paintings. A department that had frequently had no curator now had two. Working together with Director Jan Fontein they were responsible for an active series of paintings exhibitions, including "Pissarro," "Chardin," and "Jean François Millet," as well as "Washington Allston," "Thomas Eakins," and "The Lane Collection." They also organized exhibitions of American paintings for an international audience, including a show of sixty-three pictures from Smibert to Dzubas that toured the People's Republic of China in 1981 and the widely acclaimed survey of eighteenth- and nineteenth-century American painting, "A New World: Masterpieces of American Painting, 1760–1910," which traveled to Washington, D.C., and to Paris in 1983–84. Recent purchases of European pictures—for example, the beautiful works by Largilliere, Boilly, and Caillebotte included here—have of necessity been imaginative and eclectic, for the Museum's purchase funds, which have brought so many great masterpieces to Boston, can no longer compete in today's art market for major works by the greatest masters.

On the American side, the Museum's effort has been twofold: to add truly outstanding paintings where possible in the older areas and to build the modern collection. Superb gifts in pursuit of these goals have been received, most notably Copley's masterpiece of 1765, *Henry Pelham (Boy with a Squirrel)*, and Joseph Stella's *Old Brooklyn Bridge*. The Museum has also been

able to buy such nineteenth-century American works as the scintillating folk painting by Susan Waters, *The Lincoln Children*, and Thomas Birch's *Engagement Between the "Constitution" and the "Guerriere"*; and in the twentieth-century field much-needed, major paintings by Georgia O'Keeffe, Stuart Davis, Jackson Pollock, and Andy Warhol have been purchased.

John Walsh left Boston for the directorship of the Getty Museum in Malibu, California, in 1983, and Theodore Stebbins, now John Moors Cabot Curator of American Painting, took his place as head of the department. Early in 1985, Peter C. Sutton was appointed Mrs. Russell W. Baker Curator of European Painting. In 1985 Alexandra Murphy's valuable *Illustrated Summary Catalogue* of the entire European paintings collection was published. Late in the year the "Renoir" exhibition proved more popular than any other show in the Museum's history.

In 1986, the American and European collections were reinstalled in the newly refurbished and climate-controlled Paintings Galleries, a massive project made possible by the generosity of many friends of the Museum. With the collection again on view, and with the curatorial staff at full strength, the Museum today demonstrates its equal commitment to popular exposition and to scholarly enterprise. Now, relying on the devotion of old friends and on the support and the dedication of a new generation of patrons and collectors, Boston looks with great pride to its past achievements in the collecting of paintings, and it can look to the future with confidence.

Theodore E. Stebbins, Jr.
John Moors Cabot Curator of American Painting

Peter C. Sutton
Mrs. Russell W. Baker Curator of European Painting

Note: For an excellent history of the Museum of Fine Arts, see Walter Muir Whitehill, *Museum of Fine Arts, Boston: A Centennial History* (Cambridge, Mass., 1970). The collections are catalogued in the following: *M. & M. Karolik Collection of American Paintings, 1815 to 1865* (Cambridge, Mass., 1949); *American Paintings in the Museum of Fine Arts, Boston*, 2 vols. (Boston, 1969); and Alexandra R. Murphy, *European Paintings in the Museum of Fine Arts, Boston: An Illustrated Summary Catalogue* (Boston, 1985). Useful studies of Boston's taste and patronage are: Alexandra R. Murphy's "French Paintings in Boston, 1800–1900" in *Corot to Braque: French Paintings from the Museum of Fine Arts, Boston* (Boston, 1979); Carol Troyen and Pamela S. Tabbaa, *The Great Boston Collectors: Paintings from the Museum of Fine Arts* (Boston, 1984); and Trevor J. Fairbrother, *The Bostonians: Painters of an Elegant Age, 1870–1930* (Boston, 1986).

European Paintings

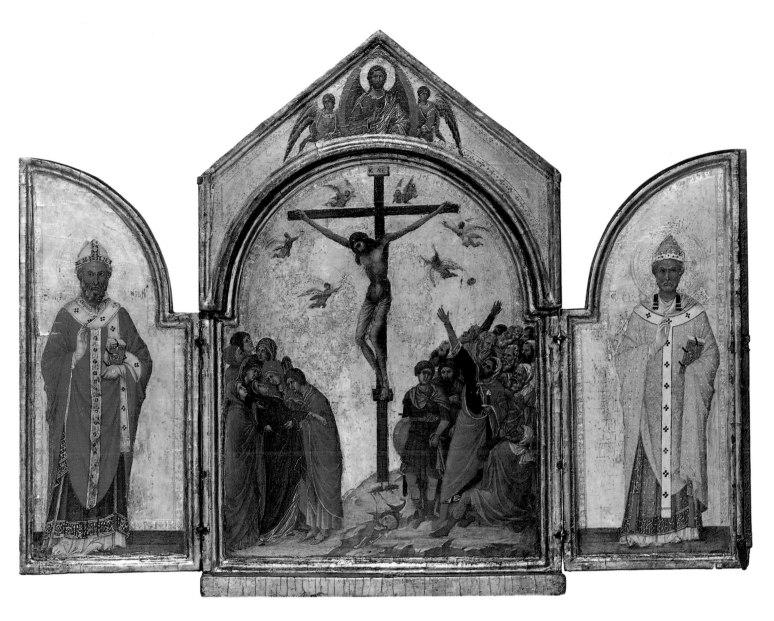

DUCCIO DI BUONINSEGNA
(Italian [Sienese], active 1278–died 1318)

The Crucifixion with Saints Nicholas and Gregory.
ca. 1310
Tempera on panel; center: 24 × 15½ in. left wing: 17¾ × 7½ in. right wing: 17¾ × 7½ in.
Grant Walker Fund and Charles Potter Kling Fund. 45.880

Duccio di Buoninsegna was the founder of the Sienese school of painting and the first great artist of what is today known as the Italian Renaissance. Duccio's style lacks the severe monumentality of his younger Florentine counterpart Giotto, tending instead to a more richly colored, elegantly calligraphic form, which entirely dominated the imagination of Sienese artists for nearly two centuries after his death.

The Boston *Crucifixion* tabernacle, a landmark of Duccio's late years, was painted close to 1310 and is one of the extremely rare autograph paintings by him to survive. It was conceived as an object of private devotion and intended to be fully portable. The wings are painted on the front face with images of Saint Nicholas and Saint Gregory, probably the name saints of the tabernacle's unknown patron, and on the back face with a fictive porphyry, a semiprecious stone, and inlaid marble design nearly identical to that on a similar triptych in the National Gallery in London. When closed the tabernacle was meant to resemble a precious reliquary case, with only the image of the Redeemer and the angels visible at the top.

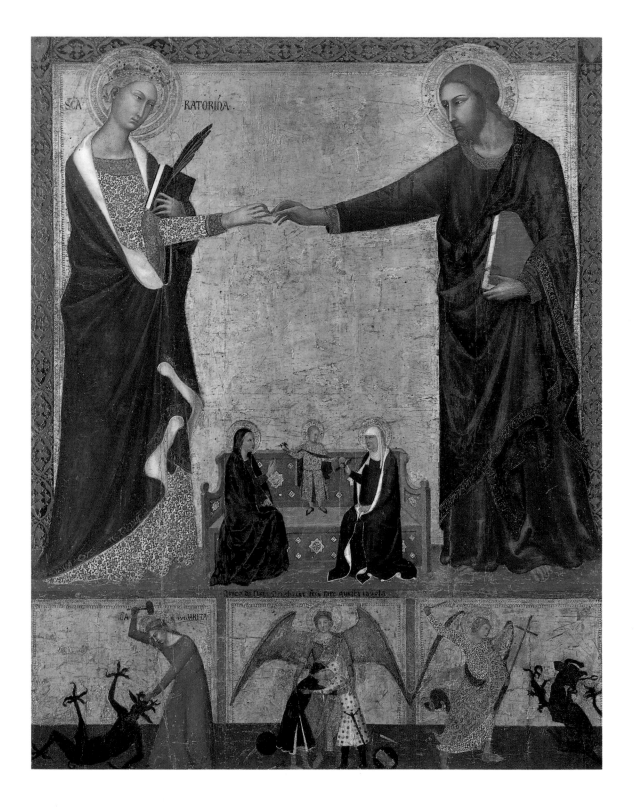

"BARNA DA SIENA"
(Italian [Sienese], active mid-14th century)

The Mystical Marriage of Saint Catherine. ca. 1340
Tempera on panel, 54⅝ × 43¾ in.
Sarah Wyman Whitman Fund. 15.1145

One of the most influential and at the same time mysterious personalities of the fourteenth century in Italy was the artist known as Barna da Siena. Recently attempts have been made to disprove the existence of a painter of that name, attributing all his works to other artists of the time in the circle of Simone Martini. But disregarding this controversy, there is a consensus that his most significant work, after the frescoes of the life of Christ in the Collegiata at San Gimignano, is the Boston *Mystical Marriage of Saint Catherine.*

Dominating the panel at left and right are large figures of Saint Catherine of Alexandria and Christ exchanging symbolic marriage vows, a scene usually represented in Italian art with the infant rather than the adult Christ. Between them, and much smaller in scale, are the Virgin and Child enthroned with Saint Anne. At the bottom of the panel are three scenes, showing Saints Margaret and Michael subduing demons and another Archangel reconciling two feuding enemies—presumably the occasion for which this panel was commissioned. Remarkable for its great size, technical virtuosity, state of preservation, and unusual iconography, *The Mystical Marriage of Saint Catherine* certainly ranks among the most important early Italian paintings in America.

18

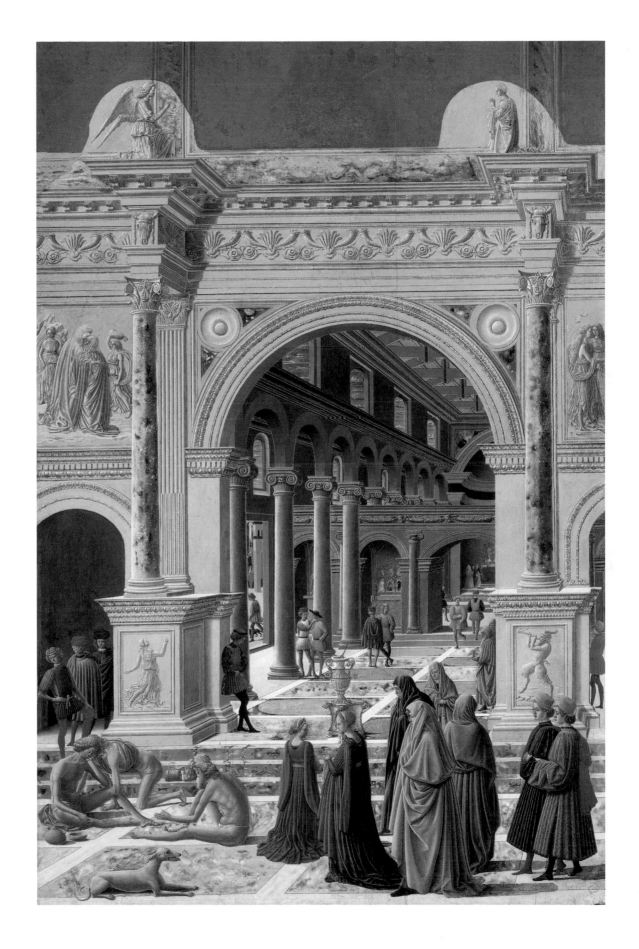

FRA CARNEVALE
(Bartolomeo Corradini, called Fra Carnevale,
Italian [School of the Marches], active 1445–died 1484)

Presentation of the Virgin in the Temple. ca. 1467
Oil and tempera on panel, 57⅝ × 38 in
Charles Potter Kling Fund. 37.108

The *Presentation of the Virgin in the Temple* is one of a pair of paintings formerly in the Barberini collection in Rome; its companion panel, representing the *Birth of the Virgin*, is now in The Metropolitan Museum of Art in New York. Despite their great size and elaborate detail, both panels seem to have formed part of a single altarpiece that was dismembered and removed from the church of Santa Maria della Bella in Urbino as early as 1631. The painter of this altarpiece traditionally was known only as the Master of the Barberini Panels after the two pictures now in Boston and New York. He has recently been identified as Bartolomeo di Giovanni Corradini, known as Fra Carnevale, a pupil of Fra Filippo Lippi, who was paid for work in Santa Maria della Bella in 1467. The extraordinary architecture and ornamental detail in this painting reflect contemporary work on the Ducal Palace in Urbino and on Leon Battista Alberti's Tempio Malatestiano in Rimini, two of the great masterpieces of Italian Renaissance architecture.

19

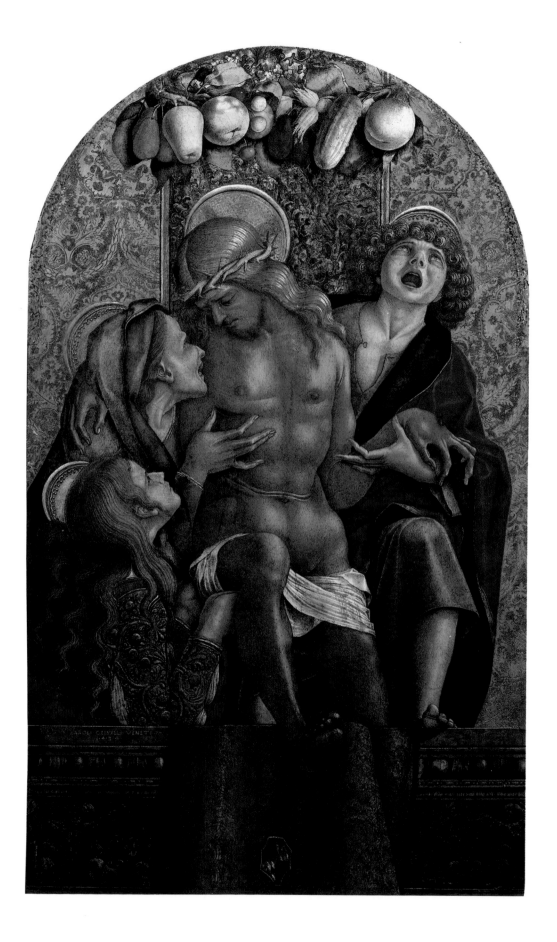

CARLO CRIVELLI
(Italian [Venetian], active 1457–died 1495)

Lamentation over the Dead Christ. 1485
Tempera on panel, 34⅞ × 20¾ in.
James Fund and Anonymous Gift. 02.4

Carlo Crivelli spent most of his career away from his native Venice working in the Marches along Italy's Adriatic coast. The Venetian style was already well known in these provincial centers through altarpieces painted by Giovanni Bellini and the Vivarini family, but Crivelli's very personal and expressive reinterpretation of their examples came to be the dominant influence on local painters well into the sixteenth century.

The Boston *Lamentation over the Dead Christ* is typical of Crivelli's mature work in its compelling pathos and in the exuberance of its decorative detail. The carved ornament on the marble parapet; the elaborate patterning, both engraved and modeled in relief, on the Magdalene's sleeve, on the gold background, and on the cloth of honor; and the illusionistic swag of fruit and vegetables arched across the top of the panel recur in numerous works by Crivelli of the 1480s. The shape of the picture and the steep perspective of its viewing point, well below the level of the main figures, suggests that it was removed from the upper part of an altarpiece, where it would have stood above a panel representing the Madonna and Child enthroned. No other panels from such an altarpiece have yet been identified.

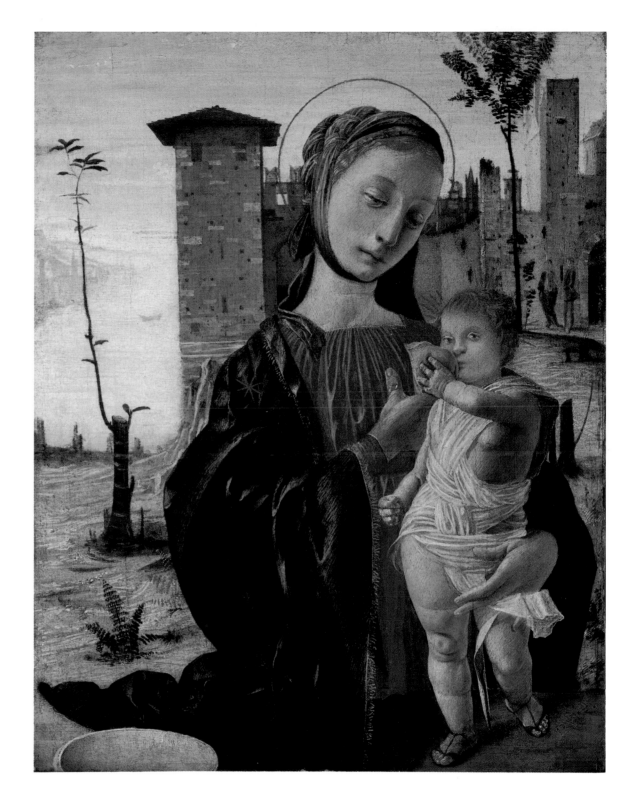

The most inventive and original of the native
Milanese painters at the end of the fifteenth
and the beginning of the sixteenth centuries,
Bramantino is best known for his elaborate use
of perspective in spatial constructions and for
the nervous, almost neurotic tension of his fig-
ures. Both traits were inspired by the example
of his teacher and namesake, the great archi-
tect Donato Bramante, who secured for Bra-
mantino a commission to decorate the papal
apartments in the Vatican before the project
was reassigned to Raphael.

The Boston *Virgin and Child,* perhaps his ear-
liest surviving work, reveals Bramantino's debt
not only to Bramante, in the precisely studied
fortifications rising out of the lake at the right,
but also to another revolutionary genius work-
ing in Milan in the 1490s, Leonardo da Vinci, in
the mysterious, dreamlike landscape painted
in the background at the left.

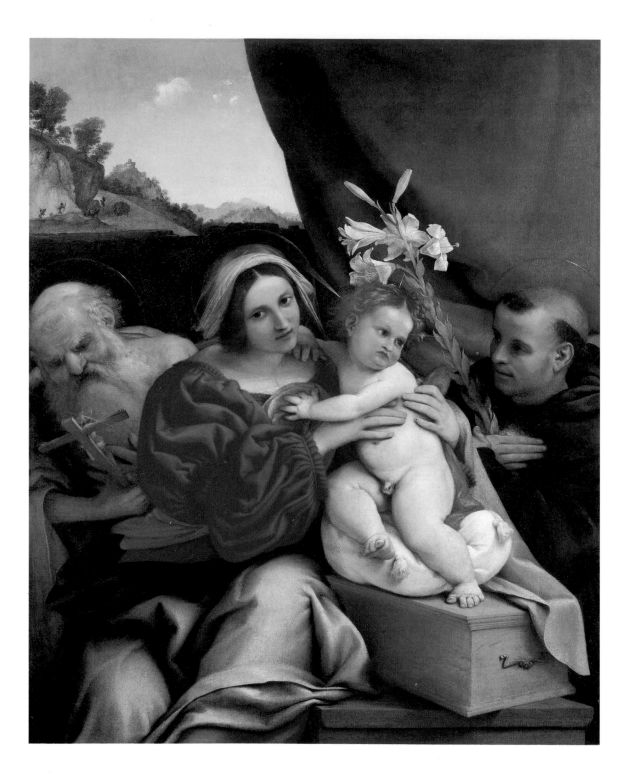

LORENZO LOTTO
(Italian [Venetian], about 1480–1556)

Virgin and Child with Saints Jerome and Anthony.
ca. 1521
Oil on canvas, 37⅛ × 30⅝ in.
Charles Potter Kling Fund. 60.154

Like Carlo Crivelli before him, Lorenzo Lotto spent most of his career away from his native Venice, producing highly dramatic, sometimes eccentric altarpieces and private devotional images for patrons in the Marches, in Treviso, and especially in Bergamo, the westernmost outpost of the Venetian empire. The last years of his life were passed in seclusion at the holy shrine of Loreto, to which he bequeathed all his property and for which he painted some of the most profoundly meditative religious images of all time.

The Boston *Virgin and Child with Saints Jerome and Anthony,* rediscovered only thirty years ago, is an important example of Lotto's work from Bergamo, where he lived from 1513 to 1523. Probably commissioned by a private patron who would have specified the choice of saints accompanying the Virgin and Child, it illustrates perfectly the virtuosity of the artist's technique, his sumptuous color sense, and the intensity and agitation of his religious expression, comparable only to Titian's among painters of his generation. A copy of this painting in the National Gallery in London is dated 1521, the probable date of the Boston picture as well.

ROSSO FIORENTINO
(Giovanni Battista di Jacopo, called Rosso Fiorentino;
Italian [Florentine], 1496–1540)

The Dead Christ with Angels. ca. 1524–27
Oil on panel, 52½ × 41 in.
Charles Potter Kling Fund. 58.527

Progressive taste throughout Europe in the sixteenth century was reflected in the highly refined, almost effete decorative style that has come to be known as Mannerism. Among the originators of the style in Florence and one of its most brilliant exponents was Rosso Fiorentino. More than any other painter, Rosso was responsible for making Mannerism a truly international movement when he settled, in 1530, at the court of the king of France at Fontainebleau. From 1524 to 1527 Rosso was active in Rome, where he painted *The Dead Christ with Angels* for his friend Leonardo Tornabuoni, Bishop of Borgo San Sepolcro. The picture's size and highly personal, meditative subject indicate that it must have been intended for a private chapel in the bishop's palace. It was seen and admired in the possession of Tornabuoni's heirs in 1550 and in 1568 and then disappeared entirely from view, reappearing only in 1958 in the collection of a member of the Spanish royal family. As one of the extremely rare surviving works by this exceptional artist, and among these one of the best preserved, it ranks as possibly the most important Mannerist picture in any American collection.

23

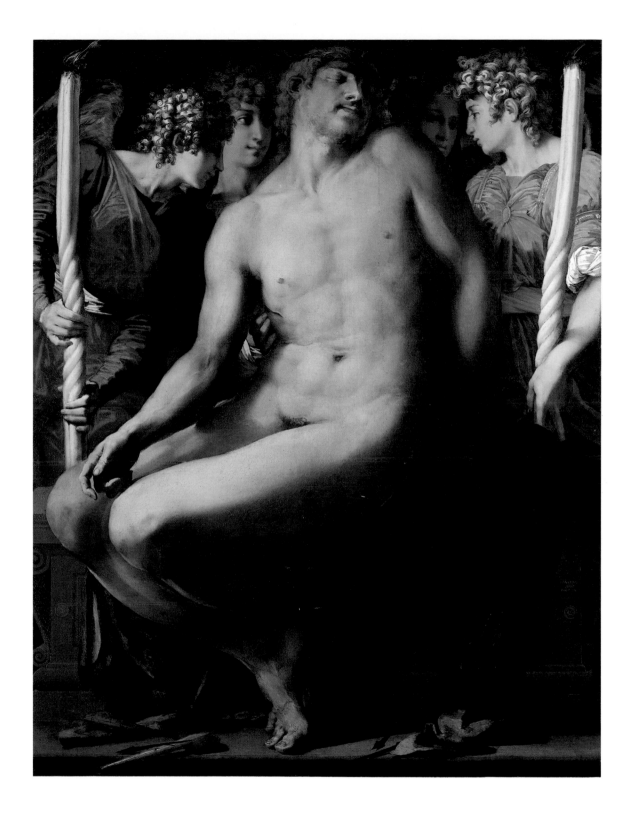

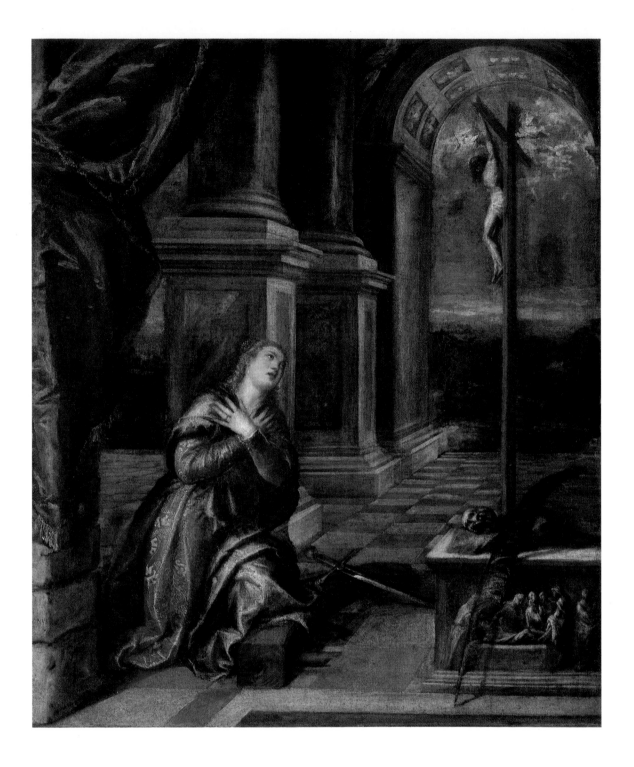

TITIAN
(Tiziano Vecellio, called Titian;
Italian [Venetian], 1488/89–1576)

Saint Catherine of Alexandria at Prayer. ca. 1567–68
Oil on canvas, 46⅞ × 39⅛ in.
1948 Fund and Otis Norcross Fund. 48.499

The greatest master of the Venetian school of the Renaissance was Titian. His work combines the power and psychological penetration of Michelangelo, the compositional sophistication of Raphael, and a coloristic exuberance entirely original to himself and unrivaled in all the subsequent history of European painting. In particular his late works—Titian continued painting to nearly the age of ninety—evoke a misty world of intense, quivering emotion through broad, jagged slashes of color reminiscent of the late works of Rembrandt and J.M.W. Turner, two artists who admired him greatly.

Saint Catherine of Alexandria at Prayer is one such late work. Painted probably in 1567 or 1568, Titian's eightieth year, it shows Saint Catherine kneeling in rapt adoration of a crucifix and surrounded by the symbols of her impending martyrdom: the spiked wheel broken by divine intervention, the sword that decapitated her, and her martyr's palm. The rich blues and reds and earthy grays and browns of the landscape and architecture are stunning examples of the infinite range of variation in the severely reduced palette that Titian exploited in his last pictures.

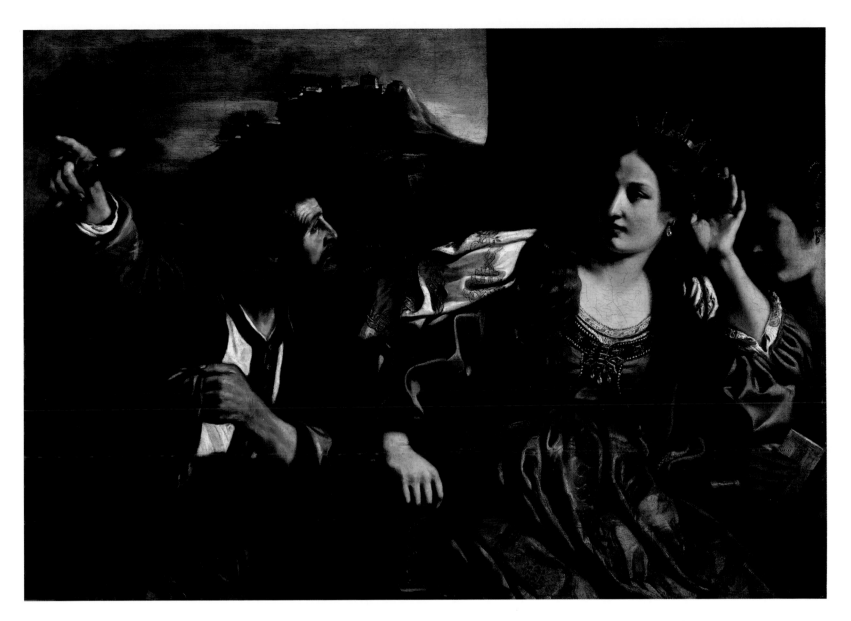

GUERCINO
(Giovanni Francesco Barbieri, called Il Guercino;
Italian [Bolognese], 1591–1666)

Semiramis Receiving Word of the Revolt of Babylon.
1624
Oil on canvas, 44¼ × 60⅞ in.
Francis Welch Fund. 48.1028

Born in Cento near Bologna, Giovanni Francesco Barbieri, called Il Guercino, built, while still very young, a reputation in Rome as one of the most dynamic and forceful painters of his generation. His long and prolific career was filled with commissions from patrons throughout Italy and France, though his best-known and most-admired works come largely from collections in Bologna and in the Marches along Italy's Adriatic coast.

Semiramis Receiving Word of the Revolt of Babylon, once the property of King Charles II of England, was painted in 1624, shortly after Guercino's return to Bologna from Rome. It portrays the legendary queen of Babylon inter-

rupted at her toilette by news of a revolt, which she quelled with a single command and then calmly returned to combing her hair. Although the exact moral of the story is unclear, Guercino's brilliant and colorful representation of the scene stands as one of the undisputed masterpieces of Italian Baroque painting.

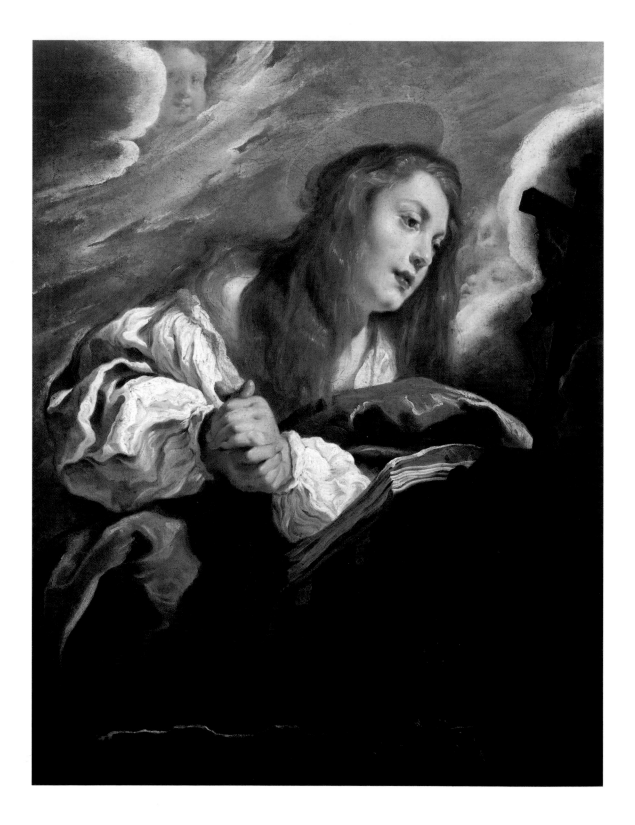

DOMENICO FETTI
(Italian [Roman], about 1589–1624)

Saint Mary Magdalene Penitent. ca. 1615
Oil on canvas, 39 × 30⅛ in.
Charles Potter Kling Fund. 1979.767

Domenico Fetti was one of the great precocious talents of the seventeenth century. He was trained as a very young man in Rome, but most of his brief career (Fetti died at age thirty-five) was passed at the Ducal court of Mantua and at Venice. Though he spent little more than a year in the latter city, the pictures he left behind there were enormously influential on Venetian painters for several generations after his own.

Fetti was accustomed to repeat his compositions, always with subtle variations, at intervals sometimes years apart. The Boston *Magdalene,* though an early work probably painted about 1615, appears to be a second version of a composition originally showing the saint full length in contrite repentance for her life of sin, symbolized by her loosely fitting blouse. The dramatic point of view from below may not have been intended to compensate for the height at which the picture was to be hung so much as to exaggerate the devotional intensity of the Magdalene's expression, complemented by the richly agitated handling of the paint itself.

26

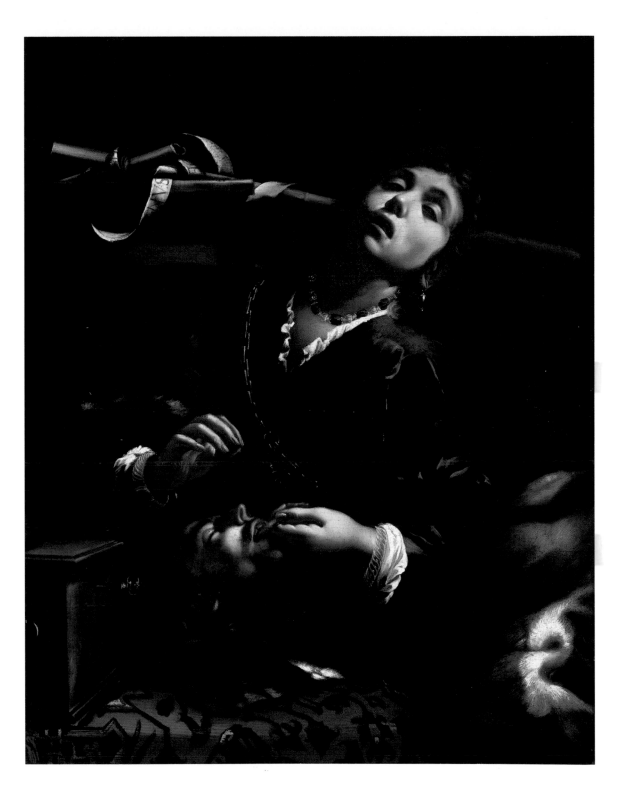

FRANCESCO DEL CAIRO
(Italian [Lombard], 1598–1674)

Herodias with the Head of Saint John the Baptist.
ca. 1625–30
Oil on canvas, 47 × 37⅛ in.
William Sturgis Bigelow Collection. 26.772

Active primarily in Turin and Milan in the second and third quarters of the seventeenth century, Francesco del Cairo blended in his art the dramatically illuminated realism of Caravaggio and a bravura technique native to Lombard painters with a sensuous poetic fantasy unique to his own eccentric temperament. *Herodias with the Head of Saint John the Baptist* is probably one of the artist's earliest works, heavily influenced by the example of Caravaggio, and the most sensitive of the many versions of this subject he painted over the course of his career. It shows Herodias, mother of Salome and wife of Herod, holding the head of the Baptist in her lap and piercing its tongue with a needle in revenge for having preached openly against her and the king. To the left is the locked chest in which she later placed the Baptist's head to keep it always near her. It is typical of Del Cairo's sense of the macabre that despite the gruesomeness of his subject he has painted Herodias with a look of swooning ecstasy.

27

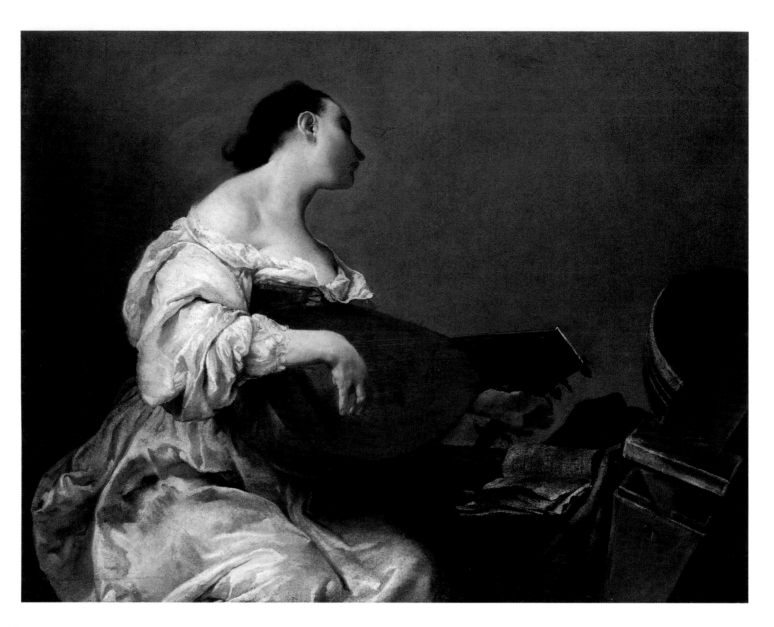

GIUSEPPE MARIA CRESPI
(Italian [Bolognese], 1665–1747)

Woman Playing a Lute. ca. 1700–1705
Oil on canvas, 47¾ × 60¼ in.
Charles Potter Kling Fund. 69.958

One of the most evocative and enigmatic painters of the late seventeenth and early eighteenth centuries was Giuseppe Maria Crespi of Bologna. A portraitist of rare distinction, he is better known today for his remarkable genre scenes, which were so influential on the development of that art form in Venice and, ultimately, throughout Europe later in the eighteenth century. Candidly composed subjects drawn from everyday experience and bathed in a warm, diffuse light, his pictures prefigure by nearly two hundred years Degas's pastel studies or the greatest efforts of late-nineteenth-century photography.

The *Woman Playing a Lute* is universally re-garded as one of Crespi's noblest images. Possibly meant to be an allegory of music, it is more likely a simple portrayal of a woman seated in lost profile tuning her instrument. Crespi's nearly monochromatic yet voluptuous palette of creams and browns lends to the figure something of the monumentality and timelessness of sculpture, vying for effect with the sensuous immediacy of his rendering of surface textures: flesh, cloth, wood, and leather.

28

GIOVANNI BATTISTA TIEPOLO
(Italian [Venetian], 1696–1770)

Time Unveiling Truth. ca. 1745–50
Oil on canvas, 91 × 65¼ in.
Charles Potter Kling Fund. 61.1200

Outstanding among the many great talents working in Venice in the eighteenth century was Giovanni Battista Tiepolo, one of the most significant artists of the late Baroque in Europe. His powerful decorative style, characterized by a light, high-key palette; rapid, forceful drawing; and a masterful command of perspective, was perfectly suited to the large architectural spaces he was commissioned to fill. He was an enormously prolific artist who is as prized today for his brilliant drawings and oil sketches as for his more finished large-scale works.

Time Unveiling Truth is one of the grandest of Tiepolo's works in America. Painted at the period of his fullest maturity, prior to his work at the archbishop's palace in Würzburg (1753) and at the royal court in Madrid (1761–70), it represents Time as a winged old man with a scythe revealing the nude figure of Truth, on whom the sun shines from above.

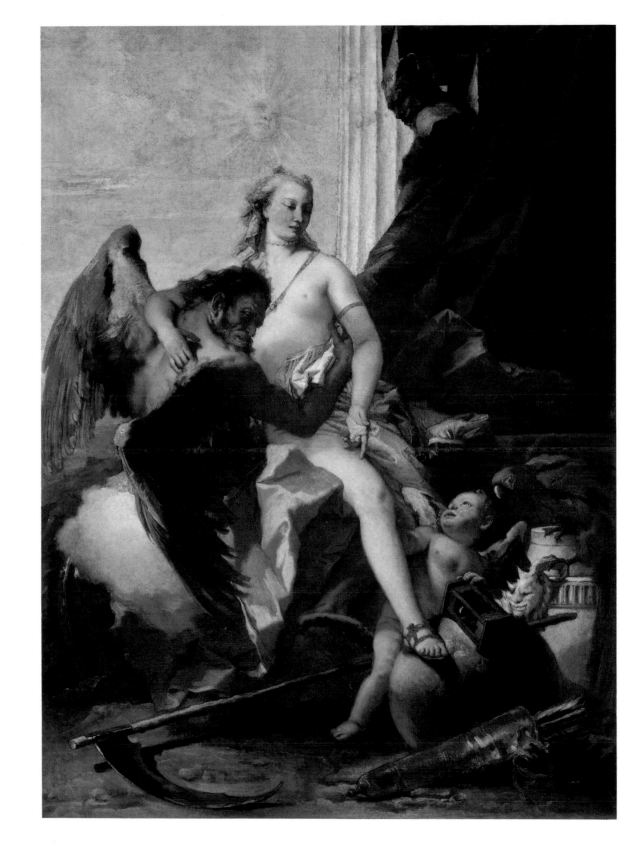

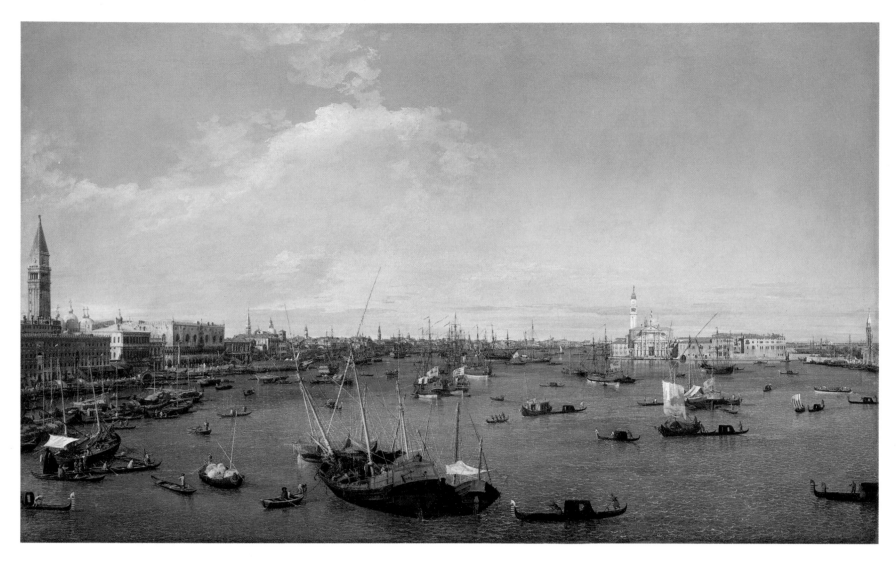

CANALETTO
(Giovanni Antonio Canal, called Canaletto;
Italian [Venetian], 1697–1768)

Bacino di San Marco, Venice. ca. 1735–40
Oil on canvas, 49 × 80½ in.
Abbott Lawrence Fund, Seth K. Sweetser Fund, and Charles
 Edward French Fund. 39.290

One of the glories of Venetian painting is the eighteenth-century school of topographical view-painters known as the *Vedutisti.* Their works were produced, in some abundance, primarily as expensive souvenirs for wealthy foreign visitors, but three artists—Francesco Guardi, Bernardo Bellotto, and especially Giovanni Antonio Canal, called Canaletto—raised the *veduta* to unparalleled levels of artistic sophistication. The earliest of these three artists was Canaletto, and the Boston *Bacino di San Marco,* dating from the years of his early maturity shortly before 1740, is widely recognized as one of his supreme achievements.

Unusual among Canaletto's paintings both for its great size and for the sweeping breadth of its panoramic view of the Basin of Saint Mark's, the *Bacino* is in pristine condition, preserving all the artist's painstakingly rendered details of light, shadow, color, and tone, a near-perfect re-creation of the mesmerizing effects of sunlight and reflections on the Venetian lagoon. The *Bacino* came to the Museum of Fine Arts from Castle Howard in Yorkshire, where it had hung since it was acquired in the eighteenth century by the then Earl of Carlisle, who possibly had purchased it from Canaletto himself.

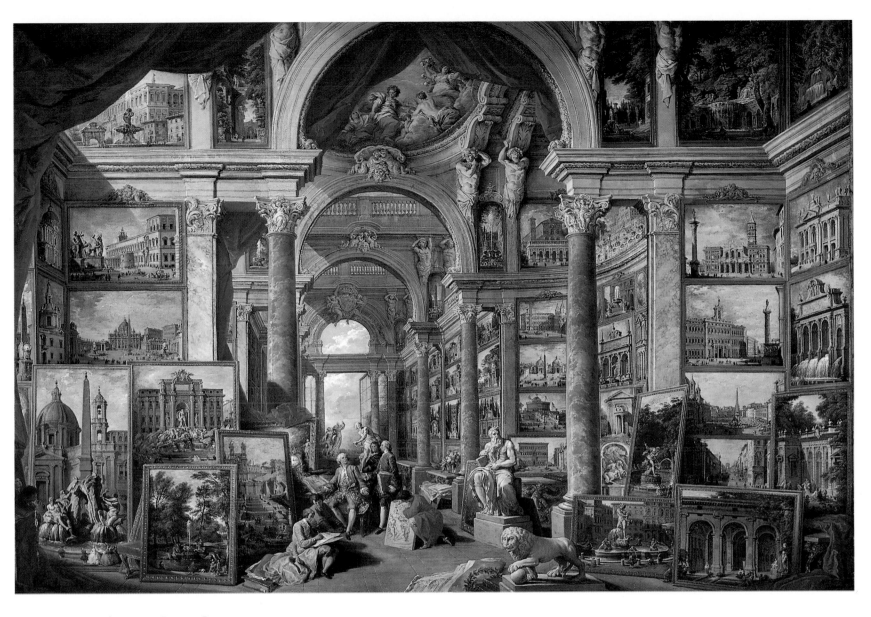

GIOVANNI PAOLO PANNINI
(Italian [Roman], 1691–1765)

Picture Gallery with Views of Modern Rome. 1757
Oil on canvas, 67 × 96¼ in.
Charles Potter Kling Fund. 1975.805

Pannini's *Picture Gallery with Views of Modern Rome* was one of four paintings commissioned in 1757 by the Duc de Choiseul, the French ambassador to the Holy See in Rome from 1753 to 1757 and a renowned collector and connoisseur. It was only natural that at the end of his Roman tenure he would turn to Pannini, Rome's most celebrated view painter, to create a group of pictures commemorating his stay. The duke is shown seated in the center of a theatrical architectural setting densely hung with views of contemporary Rome—a conceit based on the traditional depiction of collectors surrounded by their own holdings of paintings. Choiseul, however, is surrounded by views celebrating the seventeenth-century Roman architecture of Bernini, Borromini, and Pietro da Cortona, and eighteenth-century sites including the Spanish Steps and the Trevi Fountain. In another painting from the group, the duke is seen amidst paintings of the buildings of ancient Rome. Such paintings could be hackneyed and pedantic, but Pannini carried out the commission with such assurance and flair that it becomes a tour de force. All four of these paintings were in Boston in the nineteenth century, and this painting has hung in the Museum since its doors opened at the Copley Square site in 1876.

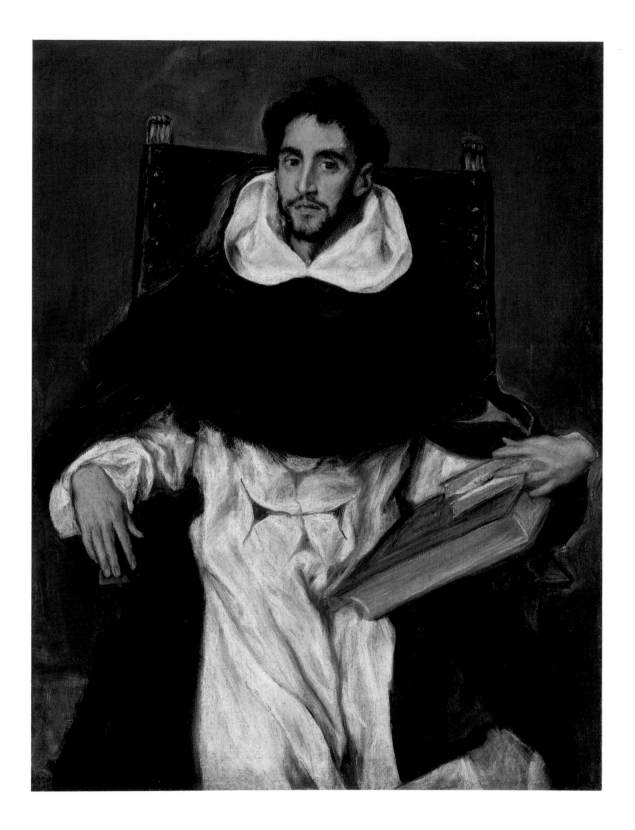

EL GRECO
(Domenicos Theotocopoulos, called El Greco;
Greek [worked in Spain], 1541–1614)

Fray Hortensio Félix Paravicino. 1609
Oil on canvas, 44⅛ × 33⅞ in.
Isaac Sweetser Fund. 04.234

Born Domenicos Theotocopoulos in Greece and trained in Venice under Jacopo Tintoretto, and in Rome, El Greco is thought of today as a Spanish artist, the most important and best known before Velázquez. His highly impassioned personal style earned him the patronage of the powerful Church hierarchy in Spain, in his adopted town of Toledo, though he never won much favor at the royal court. El Greco is best remembered for his highly dramatic religious compositions, but he was also a portraitist of rare distinction, as some thirty surviving examples by him reveal.

Fray Hortensio Félix Paravicino is widely regarded as El Greco's masterpiece in portraiture. The sitter, a close friend of the artist, was an important theologian, orator, and poet (much influenced by Luis de Gongora)—a central figure in Spanish intellectual circles at the beginning of the seventeenth century. He wrote four sonnets to the aged El Greco toward the end of the painter's life, one of them specifically praising this portrait. It came to the Museum of Fine Arts on the recommendation of another great portraitist and a devoted admirer of Spanish painting—John Singer Sargent.

32

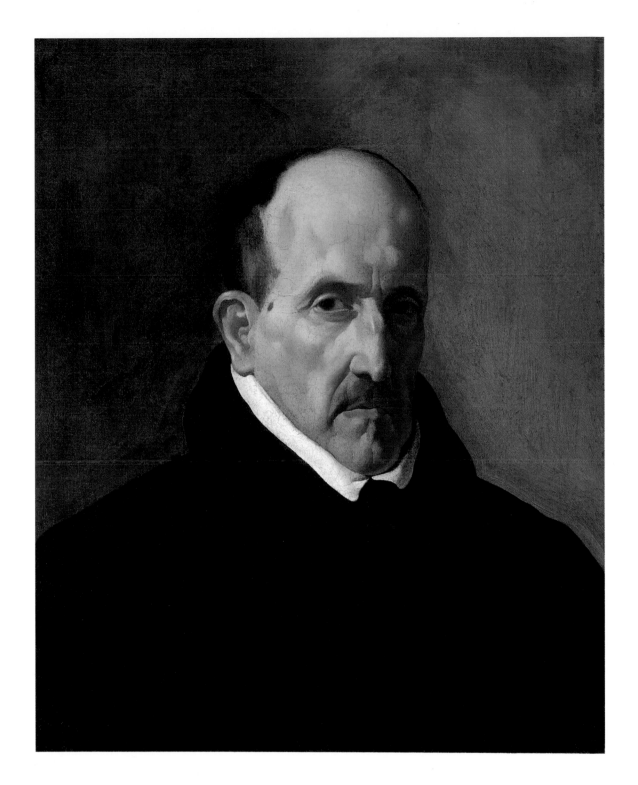

DIEGO RODRÍQUEZ DE SILVA Y VELÁZQUEZ
(Spanish, 1599–1660)

Luis de Gongora y Argote. 1622
Oil on canvas, 19¼ × 16 in.
Maria Antoinette Evans Fund. 32.79

The foremost painter of Spain's golden age, the seventeenth century, Diego Rodríquez de Silva y Velázquez became court painter to King Philip IV at the age of twenty-four. Though he is perhaps best known today for his portraits of the royal family, he was no less extraordinary a painter of still lifes, genre scenes, and historical, religious, and mythological narratives.

Velázquez painted this portrait of Luis de Gongora, one of Spain's leading poets, at the age of twenty-three on his first trip to Madrid. It was commissioned by his teacher Pacheco, who mentions it in his biography of Velázquez, and is said to have been the first work by the young artist to attract general attention and praise in the Spanish capital. The only documented work from Velázquez's first stay in Madrid, the portrait of Gongora had been lost for three centuries, though it was recorded in numerous engraved and painted copies, until it was rediscovered in 1921 and acquired shortly afterward by the Museum of Fine Arts.

33

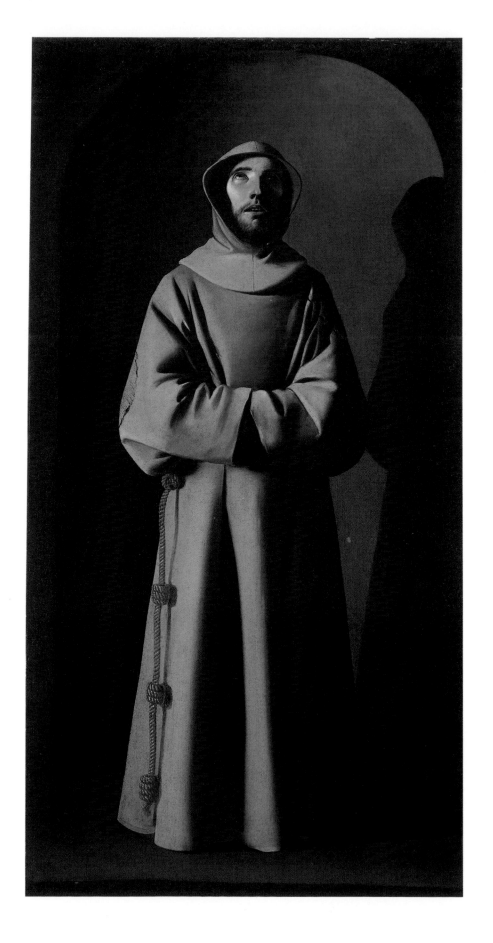

FRANCISCO DE ZURBARÁN
(Spanish, 1598–1664)

Saint Francis. ca. 1640–45
Oil on canvas, 81½ × 42 in.
Herbert James Pratt Fund. 38.1617

Preeminent as a painter of large-scale religious subjects, Francisco de Zurbarán's pictures were greatly in demand in churches and monasteries throughout Spain and the New World. His austere palette and severely restrained compositions were perfectly attuned to the profoundly meditative and devotional themes he was called upon to represent, and his canvases are today prized among the most evocative images of seventeenth-century spirituality.

The Boston *Saint Francis* may have been painted as one of a set of four portraits of founders of religious orders. It shows no specific episode from the saint's life, but rather a vision of the miraculous discovery of his incorrupt body in the crypt beneath San Francesco at Assisi by Pope Nicholas V in 1449, a pious legend that had gained currency in Spain in Zurbarán's day. The saint is presented to the viewer as he might have appeared to Nicholas V, picked out of the darkness of his burial niche by the flickering illumination of torchlight, a palpable re-creation of the eerie silence that must have accompanied so mystical a scene.

34

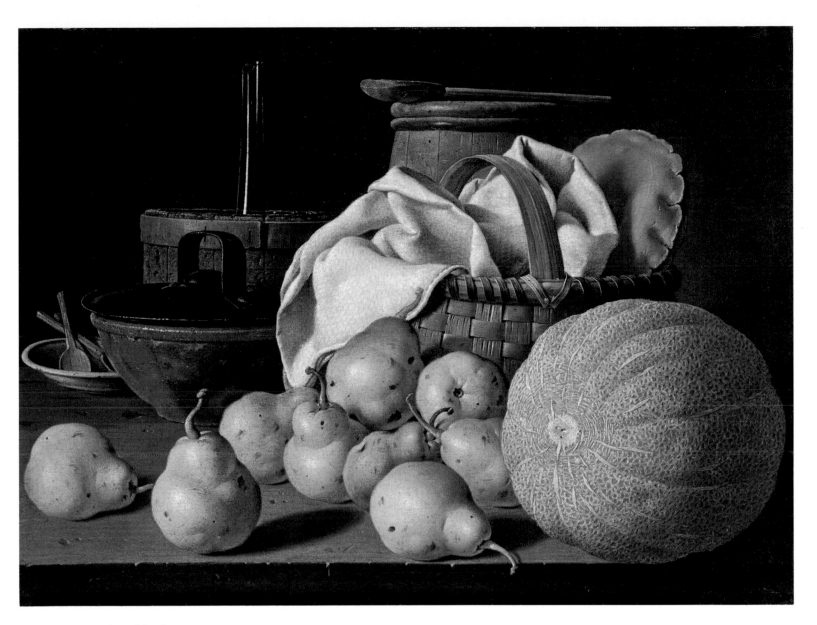

LUIS MELÉNDEZ
(Italian [worked in Spain], 1716–1780)

Still Life with Melon and Pears. ca. 1770
Oil on canvas, 25⅛ × 33½ in.
Margaret Curry Wyman Fund. 39.41

Although he is universally admired as the greatest Spanish still-life painter of the eighteenth century, Luis Meléndez was born in Italy, in Naples, and passed many of his student years in Rome. His father, a painter who specialized in portrait miniatures, gave him his first artistic training and the opportunity to develop an acute sense of realism in detail, which led Meléndez to perfect a style somewhat at odds with prevalent eighteenth-century taste, reminiscent more of the great still lifes by Caravaggio, Velázquez, and Zurbarán of a century earlier.

The Boston *Still Life with Melon and Pears*, a work probably from Meléndez's late years, is a tour de force in the representation of shapes, textures, light, and color. A cantaloupe melon, a loaf of bread, and a jumble of pears in the foreground are contrasted with the wood, glass, cork, clay, linen, and basketry of everyday kitchen utensils behind. The entire arrangement is set on a table with a meticulously rendered wood grain, one of the hallmarks of Meléndez's still lifes.

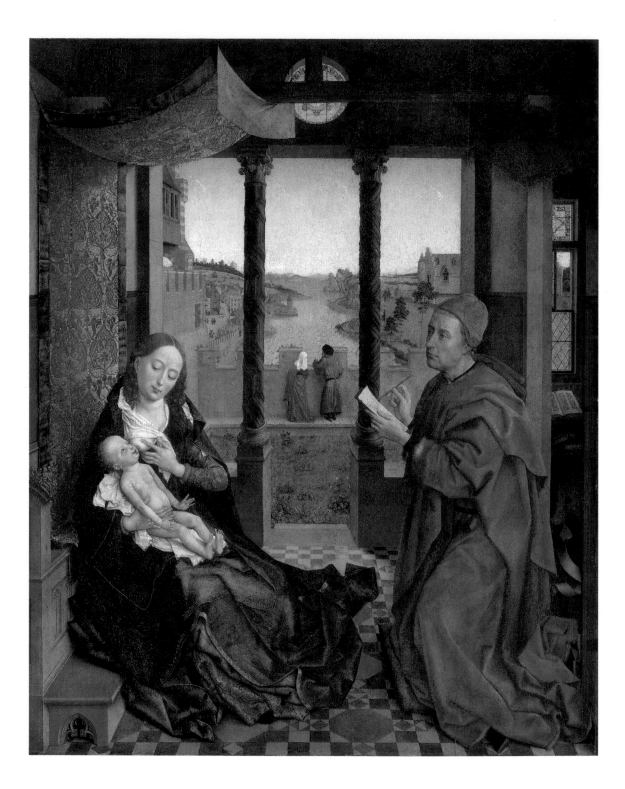

ROGIER VAN DER WEYDEN
(Flemish, about 1400–1464)

Saint Luke Painting the Virgin and Child. ca. 1435
Oil and tempera on panel, 54⅛ × 43⅝ in.
Gift of Mr. and Mrs. Henry Lee Higginson. 93.153

Heir to the pioneers of early Netherlandish painting, the Master of Flémalle and Jan van Eyck, Rogier van der Weyden was less artistically innovative but spiritually richer. Though scarcely a reactionary, he united the recent advances in naturalism and the expressive use of space with a Gothic sense of pattern and his own gentle emotionalism. This large and ambitious work takes its design from Van Eyck, but replaces Van Eyck's atmospheric effects and minute detail with a new aura of reverence and joy.

As with many early Netherlandish paintings, a rich symbolic program infuses the painting. The apocryphal subject of Saint Luke recording the Virgin's likeness takes place in an idealized medieval throne room. The Virgin, the *Maria lactans,* nurses the nude Infant on an elaborate canopied throne, an allusion to her future role as queen of heaven. The throne's tiny carvings allude to the role of Christ and Mary as the new Adam and Eve. The figure of the kneeling Saint Luke is identified not only by his activity (instead of painting the Virgin's portrait, he executes a fine silverpoint drawing) but also by the remarkably obedient little ox, his emblem, seen through the doorway on the right. The open book in his study alludes to the saint's Gospel. Across the *hortus concluses* (the enclosed garden symbolizing the Virgin's purity) the figures seen from the rear are probably Joachim and Anna, the Virgin's parents. The plants in the garden also include mariological symbols. Saint Luke's mild and dignified features have often been assumed to be Rogier's own; if it is a self-portrait, it would be the earliest example of an artist depicting himself in the role of the guild's patron saint.

Changes in the painting's underdrawing support its claim to be the first version of the composition: other versions or copies are in the museums in Munich and Leningrad.

JOOS VAN CLEVE
(Flemish, active 1511–died 1540/41)

The Crucifixion. ca. 1525
Oil on panel, 31⅝ × 24⅞ in.
Picture Fund. 12.170

One of the leading early Netherlandish artists active in Antwerp in the first decades of the sixteenth century, Joos van Cleve encompassed a variety of styles in his art. His eclectic but refined paintings incorporate both Gothic and Renaissance elements, reflecting the diversity of an art in transition. Here the stable triangular composition of foreground figures—the Virgin and Saint John flanking the crucified Christ—with carefully executed landscape beyond adopts a design much favored by the artist; in fact, it is a close variant of a composition that he first developed in the central panel of the *Crucifixion* triptych in the Museo di Capodimonte, Naples.

Typical of Joos van Cleve is the combination of decorative or rhetorically conceived elements—the frozen flutter of Christ's drapery and Saint John's exaggerated attitude of despair—and the fastidious concern with detail, such as the soft, ghastly green pallor of Christ's extremities and the minutia of the cityscape and foliage beyond. Writing many years later in 1603, Carel van Mander claimed that Joos collaborated with the pioneer of landscape painting, Joachim Patiner. Although this painting is surely not a joint effort, it may reflect Patiner's influence in the dramatic, panoramic vista in the distance.

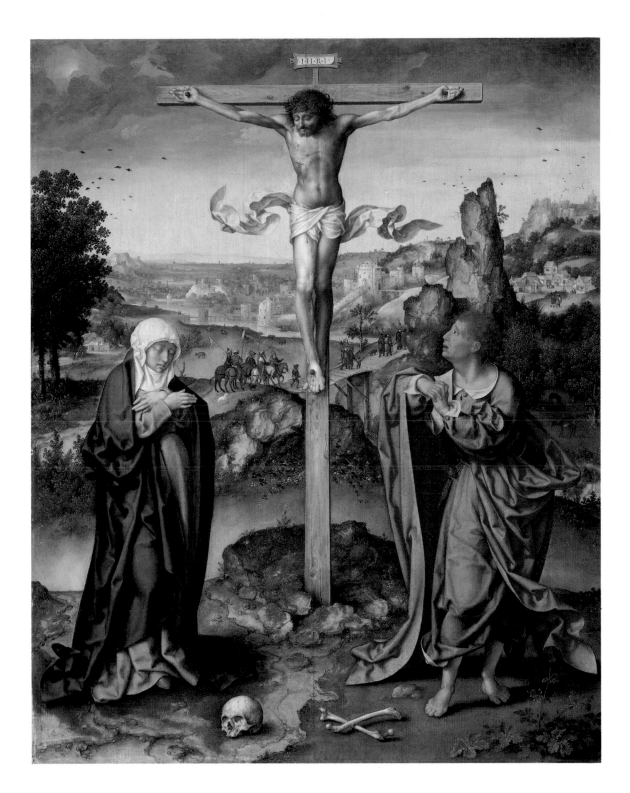

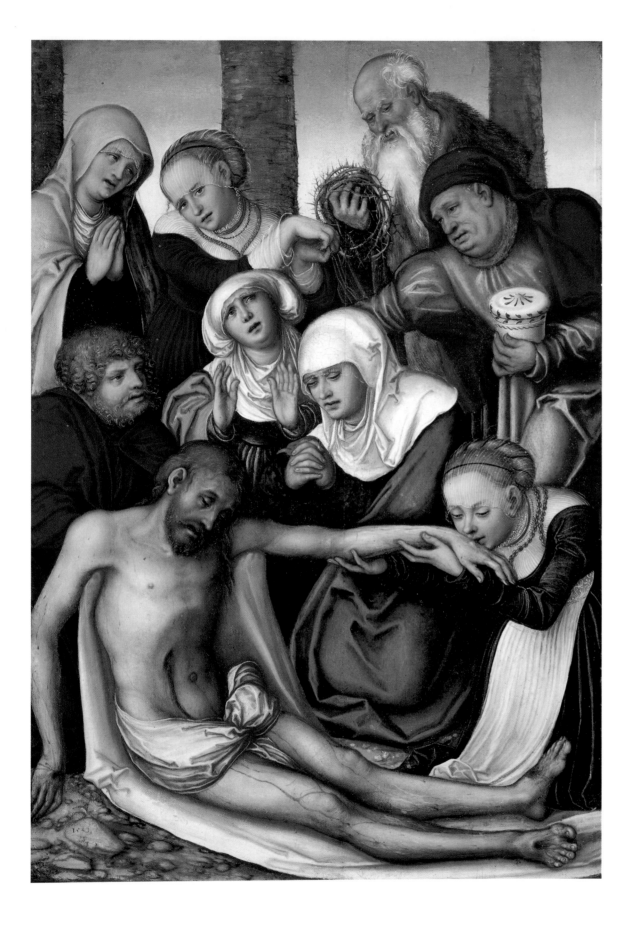

LUCAS CRANACH, THE ELDER
(German, 1472–1553)

The Lamentation. 1538
Oil on panel, 23¾ × 15¾ in.
Bequest of Charles Sumner. 74.28

Lucas Cranach was a leading figure of the Northern Renaissance who worked as a court painter at Wittenberg for Frederich the Wise and Johann Friedrich the Magnanimous. His art had its roots in the warm emotionality of the local Danube School and developed a more international, courtly sophistication related to the ideals of Dürer. A close friend of Martin Luther, Cranach painted portraits and mythological subjects as well as altarpieces, which reflect the strong Protestant convictions of his patrons.

This panel was probably part of a larger program depicting Christ's Passion, which would have included the Scourging of Christ, Christ Crowned with Thorns, and the Entombment. Here the body of the dead Christ, lying on a winding sheet, is supported in a sitting position by Saint John. On the right, Mary Magdalene kneels to kiss the wound on His hand. At the center, the Virgin appears surrounded by mourners, including Nicodemus, who holds the Magdalene's ointment jar, and Saint Joseph of Arimathea, who holds the crown of thorns. Typical of Cranach's mature manner are the painting's high emotional drama, intense palette, and mannered elegance. Signed with the winged dragon that was Cranach's device, the painting was one of the earliest to enter the Museum's collection; it was bequeathed by Charles Sumner in 1874, two years before the original Museum building was opened.

38

LUCAS VAN LEYDEN
(Dutch, 1494–1538)

Moses after Striking the Rock. 1527
Glue tempera on linen, 71⅜ × 93½ in.
William K. Richardson Fund. 54.1432

Like Dürer, Lucas van Leyden is known chiefly for his graphic works, above all his 172 engravings, but he was also a painter. As Carel van Mander observed as early as 1604, Lucas's paintings are rare; this work of 1527 is one of only three paintings from the artist's maturity and his only surviving painting on linen in tempera. A practice he is known to have favored, this technique, known as *tuechelein,* produces a decorative linearity achieved by

neither oils nor fresco. According to Van Mander, it was considered an inexpensive alternative to tapestry decorations, but he adds that many of these works had already suffered from the effects of age and moisture ("a great evil in the Netherlands"). This accounts for the darkened appearance of the Boston canvas. Indeed the fact that the painting was recorded in Italy as early as 1657 probably explains its very survival.

The subject is noteworthy for depicting not the climactic moment when Moses strikes the rock but the aftermath of the miracle. Identified by his rod and "horns" (here naturalistically stylized as curls in his hair), Moses stands

with the elders amidst a crowd of thirsting Israelites. Some gulp down the miraculous water while others share it or come forward with vessels. The variety of characters is unified by the figure-eight-shaped design and related to the rocky landscape beyond. Although the picture's meaning is debated, in Western art Moses striking the rock was a traditional Old Testament (Exodus 17:1–6 and Numbers 20:1–13) prefiguration of Christ's miracle of the Eucharist; Moses was seen as anticipating Christ's role as savior and his act was an allusion to Christian redemption.

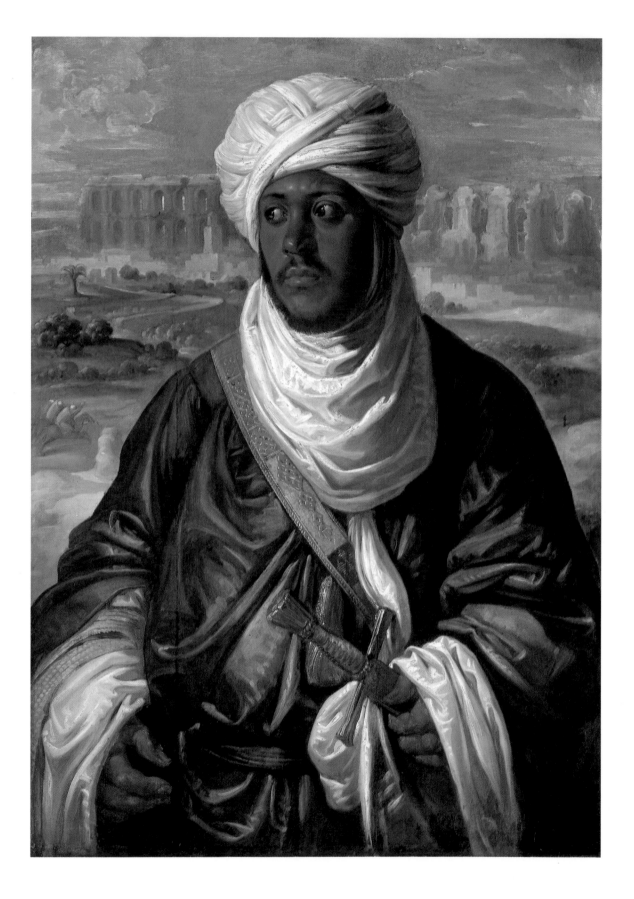

PEETER PAUWEL RUBENS
(Flemish, 1577–1640)

Mūlāy Ahmad. ca. 1610
Oil on panel, 39¼ × 28⅛ in.
M. Theresa Hopkins Fund. 40.2

Ironically, the alert-looking man portrayed here died many years before Rubens painted him. The portrait is a free copy after a lost painting, known today only through an engraving, by Jan Cornelisz Vermeyen (1500–1559). The lost painting was probably in Rubens's own collection but erroneously attributed to another artist. In 1535 Vermeyen had accompanied the catholic Emperor Charles V on his punitive expedition to Tunis. Charles's "crusade" successfully ousted the Turks and reinstated the Berber King of Tunis, Mūlāy Hasan, the father of the sitter. It is unlikely that Rubens himself knew much about Mūlāy Ahmad, who had brutally seized power about seventy years earlier in his father's absence, offering the deposed king a choice between lifelong incarceration and blinding; his father chose the latter. For Rubens, Mūlāy Ahmad was an idealized champion of Christianity who battled the heathens, an African hero with the exotic resonance of history and literature.

It is scarcely surprising, therefore, that Rubens should have used his "King of Tunis" as a model for the Black King Balthasar in several paintings of the theme of the Adoration of the Magi. Like his contemporary, Rembrandt, Rubens sought in the exotic world of the Levant and North Africa the residue of the biblical past. Here too, he also demonstrated his willingness and capacity to absorb other artists' prototypes while imaginatively transforming his sources in their application. Even in a copy, Rubens asserted his own irrepressible originality.

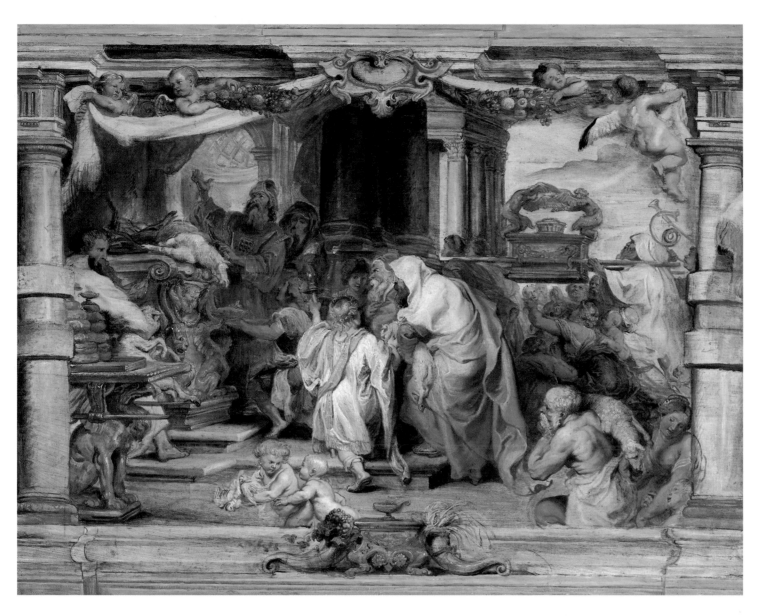

PEETER PAUWEL RUBENS
(Flemish, 1577–1640)

The Sacrifice of the Old Covenant. ca. 1626
Oil on panel, 27¼ × 34½ in.
Gift of William A. Coolidge. 1985.839

This splendidly well-preserved oil sketch was painted by Rubens as a *modello* for one of the scenes in the tapestry cycle known as the *Triumph* or *Apotheosis of the Eucharist*. The largest and most ambitious cycle of tapestries ever designed by Rubens, it was commissioned by Archduchess Isabella Clara Eugenia for the Convent of Descalzes Reales in Madrid, where the original tapestries are still preserved today. As was Rubens's practice, he began work on

the series with tiny, rapidly executed oil sketches, or *bozetti* (no drawings for the series are known). He next painted larger panels in full color, which served as models for the final full-scale cartoons on canvas.

The theme of the Eucharist is alluded to here by the loaves of bread and the contents of the cornucopiae in the lower center. The subject depicted is not a specific biblical event but a conflation of several passages in the Old Testament. Identified by his breastplate, Aaron is the high priest standing at the altar and gesturing heavenward. Behind him bearers carry the ark of the covenant. This scene is one of four Old Testament prefigurations of the Eucharist

in the series; completing the full cycle are five allegorical scenes of virtues and triumphs, two scenes of witnesses and defenders of the Eucharist, and a composite scene of the universal worship of the Eucharist.

In the visual conceit of the scene the action appears, as it were, on a tapestry within the tapestry attached to the framing architecture by a cartouche at the top center and held up at either side by a pair of putti. Thus, in the true spirit of the Baroque, Rubens delights in illusionism and the visual confusion of real and imagined thresholds of pictorial space.

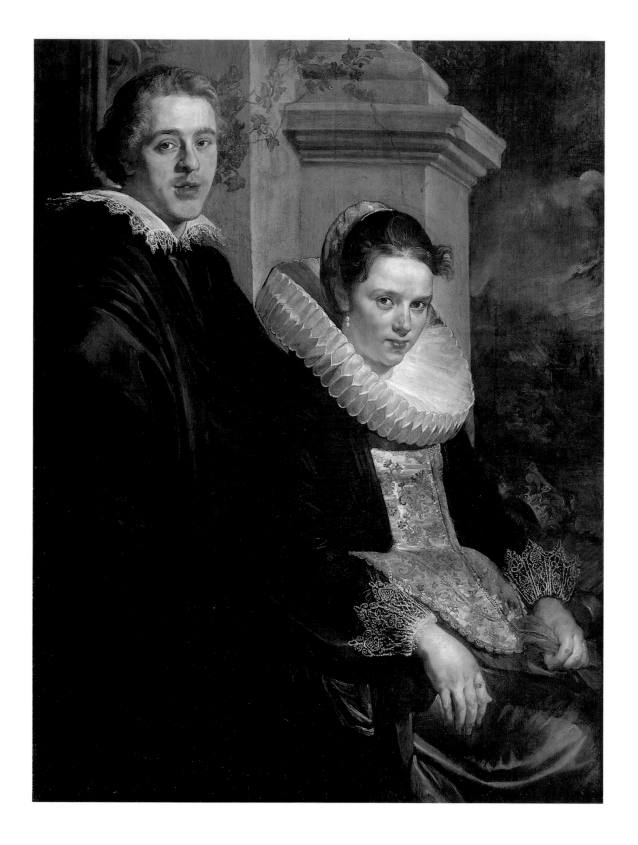

JACOB JORDAENS
(Flemish, 1593–1678)

Portrait of a Young Married Couple. ca. 1615–20
Oil on panel, 49 × 36⅛ in.
Robert Dawson Evans Collection. 17.3232

Jacob Jordaens worked in his native Antwerp in Rubens's studio, collaborating with his teacher. He not only absorbed Rubens's generous and animated style but also aspects of his thematic repertoire. Here the master's influence is evident not in a sensually abundant history painting but in a tender portrait. A couple are viewed three-quarter length, the woman with a warm smile seated, her standing companion jauntily posed with hand on his hip. His intricate lace collar and her millstone ruff and embroidered dress are elegant attire, attesting to an elevated social station, or at least aspirations thereto.

About a decade earlier Rubens had painted himself and his young bride seated together outside in a garden. While some have speculated that Jordaens's painting is also a self-portrait with his wife, the sitters are unidentified. In all likelihood, however, they were husband and wife. We deduce this not simply from their companionable air but from the traditional typologies of double portraits and details like the ivy clinging to the column and pilaster behind them. Ivy, like the grapevine, was a symbol of love and fidelity, especially in marriage (see Psalms 128). While the darkened landscape in the background is scarcely Rubens's more traditional love garden, the broken capital visible there may reiterate these notions of steadfastness, since paradoxically ruins in Dutch poetry might prompt thoughts of permanence as readily as decay. The gloves held by the woman are not simply a convention of fashion but another potential symbol, specifically of candor and sincerity; these associations explain why one often encounters figures holding their gloves or even wearing just one glove.

JAN FYT AND ERASMUS QUELLINUS
(Flemish, 1611–1661 and 1607–1678)

Still Life in an Architectural Setting. ca. 1642–50
Oil on canvas, 44¼ × 32⅝ in.
Ernest Wadsworth Longfellow Fund. 50.2728

Anonymous collaboration is not the fashion in our contemporary art world, but the notion of working in double harness once enjoyed broader acceptance. In Renaissance and Baroque studios, and nowhere more successfully than in Rubens's atelier, artists collaborated, wedding their strengths and specialties to create works that were greater than the sum of their parts. As gifted an administrator as an artist, Rubens retained the services of a large group of assistants, co-workers, and students whose varied skills he orchestrated in his huge commissions. Some executed the figures, others still-life details or animal motifs, while others contributed landscape or architectural elements.

In this unsigned painting the still life and architecture have been attributed respectively to two specialists in Rubens's circle, Jan Fyt and Erasmus Quellinus. Documents of 1642 and 1660 record that these two painters worked together and several paintings have been assigned to them jointly, but no certain examples of their collaboration are known. The sumptuous subject, with its noble colonnade set before a parklike setting, the swag of drapery, and the still life of fruit, game, and live animals befit a grand banquet hall; yet the scale of the work remains domestic. Rather than using grand proportions it evokes an aristocratic world with such details as the pets—slim whippets, rare parrots, and nimble simians—and the rich array of game, the hunting of which was strictly limited to the nobility and regulated by the court. Surely there can have been little sport in shooting swans and peacocks, but their inclusion verifies the work's ambitions to luxuriant excess.

43

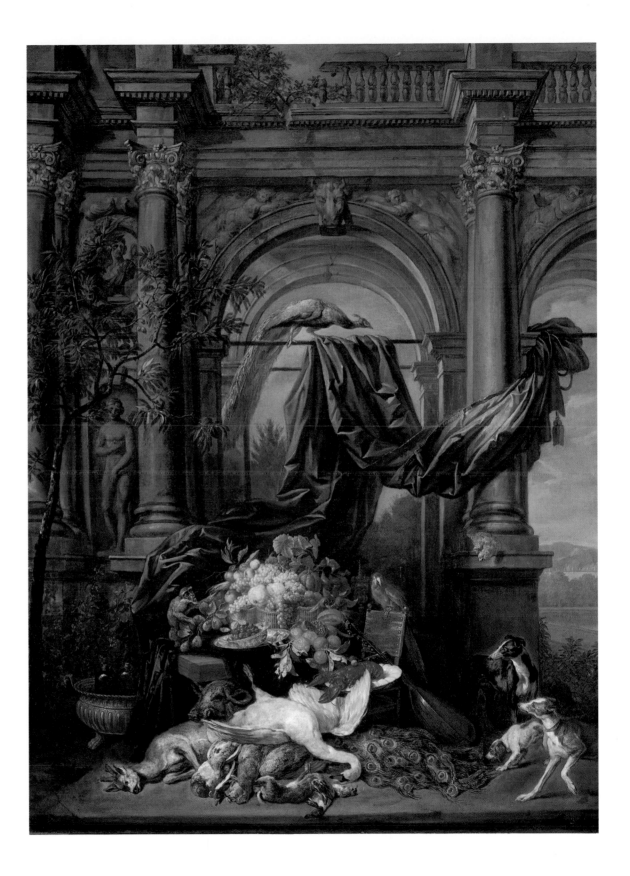

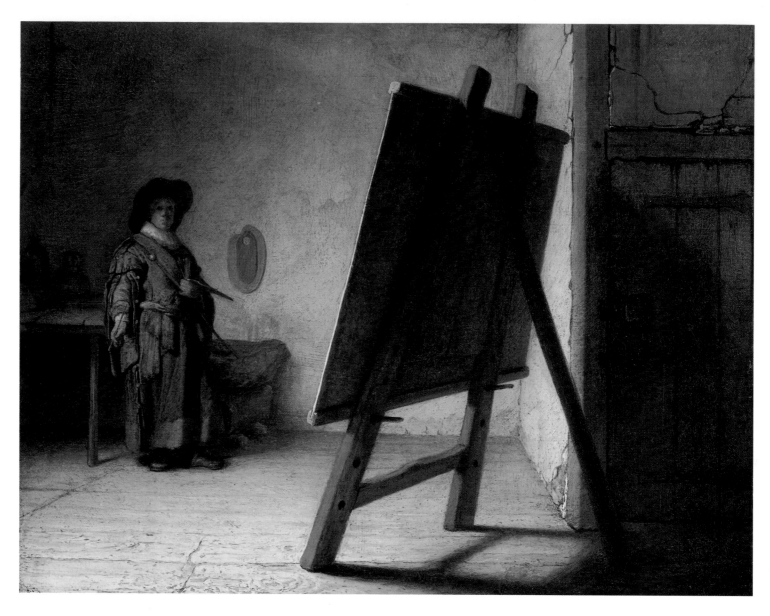

REMBRANDT
(Rembrandt Harmensz. van Rijn, called Rembrandt;
Dutch, 1606–1669)

Artist in His Studio. ca. 1629
Oil on panel, 9¼ × 12½ in.
Zoë Oliver Sherman Collection given in Memory of Lillie
 Oliver Poor. 38.1838

The theme of the artist in his studio was a common subject in Baroque art, but rarely was it treated as dramatically as in this little painting by the young Rembrandt. Dominating the foreground is the darkened silhouette of the easel; the painter himself stands to the far side of the room before a white plaster wall. The juxtaposition of the near and far view creates a monumental effect that belies the panel's small size. Historians of techniques and materials note the picture's exacting record of the tools of the seventeenth-century artist's trade: the easel, grinding stone, bottles of spirits, malstick, palette, and brushes.

Despite Rembrandt's fidelity to fact, aspects of the work suggest that it is more than a portrait of a studio or its owner. (The tininess of the figure of the painter will not permit confirmation, but he has sometimes been identified as Rembrandt himself.) Notwithstanding Rembrandt's taste for fanciful garb, the artist's heavy, untailored tabard is not early-seventeenth-century attire. Further it would be uncommon practice to paint standing up; the worn rung of the easel proves that artists sat down to work. A new interpretation holds that the painting illustrates a theory of art. In his *Groote Schouburgh* (1678), the Rembrandt pupil Samuel van Hoogstraten described a painting competition that was won by an artist who "first formed an idea of the entire work before placing paint on panel." For Rembrandt, who distinguished himself not only by his painterly originality but also by his compelling portraits of thought and contemplation, Dutch art theory's stress on preconception no doubt was appealing.

REMBRANDT
(Rembrandt Harmensz. van Rijn, called Rembrandt;
Dutch, 1606–1669)

Portrait of a Woman Wearing a Gold Chain. 1634
Oil on panel, 27⅜ × 20⅞ in.
Gift of Mrs. Frederick L. Ames in the name of Frederick L.
 Ames. 93.1474

If the twenty-six-year-old Rembrandt left his native Leiden in 1631–32 for the possibility of personal advancement in Amsterdam's burgeoning art market, his strategy worked. In his first year in Amsterdam he received more portrait commissions than in his entire previous career, and the second year surpassed the first. He lived initially in the home of his future in-law, the international art dealer Hendrick Uylenburgh, with whom he set up an art school and a profitable art business fueled chiefly by portrait commissions. Rembrandt undoubtedly espoused the seventeenth-century notion that the painting of biblical, mythological, or allegorical subjects was the highest goal to which an artist could aspire, but like so many of his contemporaries, he recognized that portraits were his most practical means of support. The year in which this portrait was painted, 1634, was arguably Rembrandt's most successful year for commissioned private portraits. It produced three pairs of full-length portraits, of which the Museum of Fine Arts's *Portrait of Reverend Johannes Elison and His Wife, Maria Bockenelle* is one. Indeed so great was Rembrandt's success in these years that he was tempted to incur debts that many years later brought him financial ruin.

The sitters in the oval *Woman Wearing a Gold Chain* and its pendant, the *Man Wearing a Black Hat* also owned by the Museum, are un-identified. The woman's lace collar, costly gold chain, and pearls attest to the wealth that enabled her to commission the most fashionable young portraitist of the day. Rembrandt's work is scarcely routine face painting; his sympathetic rendering suggests an alert and personable subject, and his technique is wonderfully daring. Note the use of the butt end of the brush to scratch the highlights of the hair into the wet paint.

45

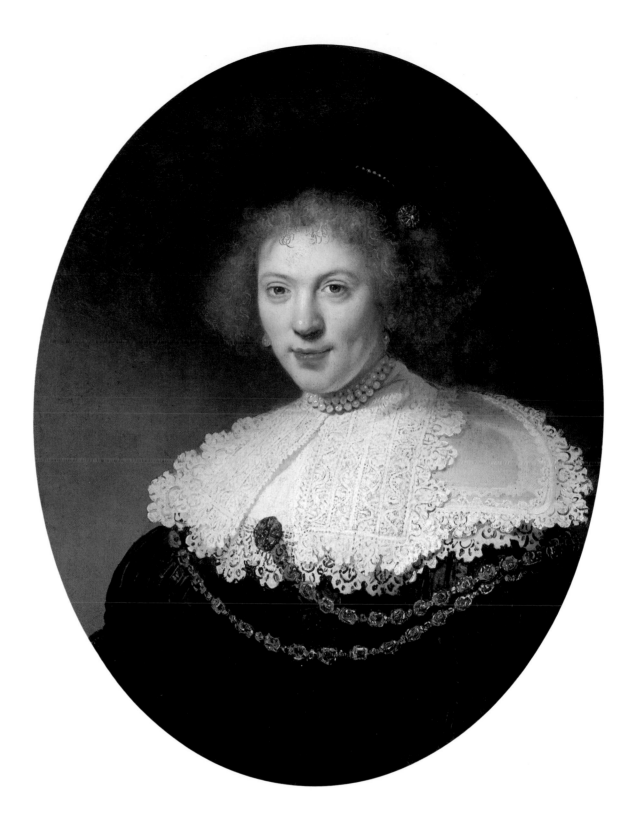

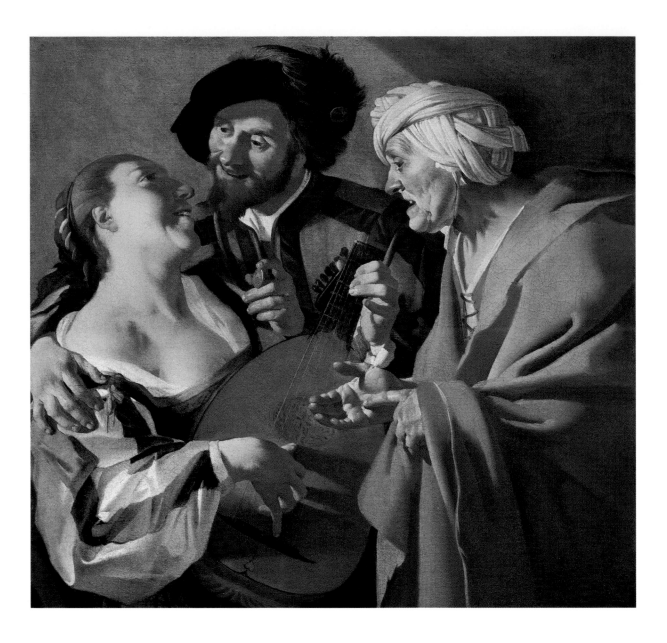

DIRCK VAN BABUREN
(Dutch, 1590/95–1624)

The Procuress. 1622
Oil on canvas, 40 × 42⅜ in.
M. Theresa B. Hopkins Fund. 50.2721

Along with Hendrick Terbrugghen and Gerard van Honthorst, Dirck van Baburen was one of the leaders of a group of early-seventeenth-century Dutch artists known as the Utrecht Caravaggisti. The old bishopric of Utrecht retained close ties with Rome even after the northern Netherlands became an independent Protestant republic. Many local painters heeded the call of the art theorist Van Mander to visit what he called the "capital of Pictura's School." The Utrecht artists' debt to the influential Italian Baroque painter Caravaggio was reflected not only in their use of strong contrasts of light and shade (*chiaroscuro*) but also in a preference for life-size, half-length, genre figures.

Here a pliant young lady with a lute and her smiling male admirer are approached by an elderly woman, probably a gypsy, dressed in a blanket and turban. The costumes worn by the young couple are fictionalized attire, scarcely the modest black-and-white dress favored by respectable burghers of the day; rather, their pseudoburgundian dress suggests the colorful costumes of street entertainers or figures from the theater. Though probably not illustrating an actual episode from a play, the work evokes an exotically piquant world with a time-honored genre subject. The coin held by the young man accounts for the title's reference to mercenary love. Baburen appears to have been the first Netherlandish artist to treat this traditional theme in a manner derived from Caravaggio and his Roman followers.

An interesting feature of the work's provenance is its early ownership by the Delft painter Johannes Vermeer; this painting or a copy appears in the background of two genre scenes by Vermeer, and a painting of a "Procuress" was mentioned in a family inventory.

JAN VAN HUYSUM
(Dutch, 1682–1749)

Vase of Flowers in a Niche. ca. 1732–36
Oil on panel, 35 × 27½ in.
Bequest of Stanton Blake. 89.503

As no other people before them, the Dutch in the seventeenth century made a specialty of the flower still life. Previously flowers had served as attributes and symbols in history paintings and portraits, but the Dutch honored them as an independent category of art. With the early-eighteenth-century paintings of Jan van Huysum, the decorative flower piece reached its zenith, never to be surpassed in sheer technical brilliance, profusion of detail, and subtlety of design, color, and tone. Boston's painting, a tour de force, offers a splendid calamity of blooms intertwined as artfully as the tussling putti that decorate the vase. Yet, to the delight of the botanist and gardener alike, each blossom is a faithful record of a living specimen. Among the identifiable flowers are blooms which were then rare and much sought after, including the striped hybrid tulip, hyacinth, yellow rose, and the "rosa huysumiana," named for the artist and now only known from his paintings.

Following the lead of earlier Dutch flower painters, Van Huysum has included blossoms from different seasons. He freely mixes spring flowers, such as the auricula on the ledge, with later blooms, such as the morning glory, offering an impossible but visually plausible arrangement. Thus like his predecessors he must have composed his arrangements from individual studies. Yet despite details suggesting growth and decay (the closed, partially opened, and fully opened poppies at the top of this composition), allusions to the transience of life, the fugitive nature of existence, and *vanitas* symbolism generally seem less central to the meanings of Huysum's art than they had been to earlier seventeenth-century flower paintings. Of increasing importance was the dazzling record of prize specimens and the creation of a diverting but durable opulence.

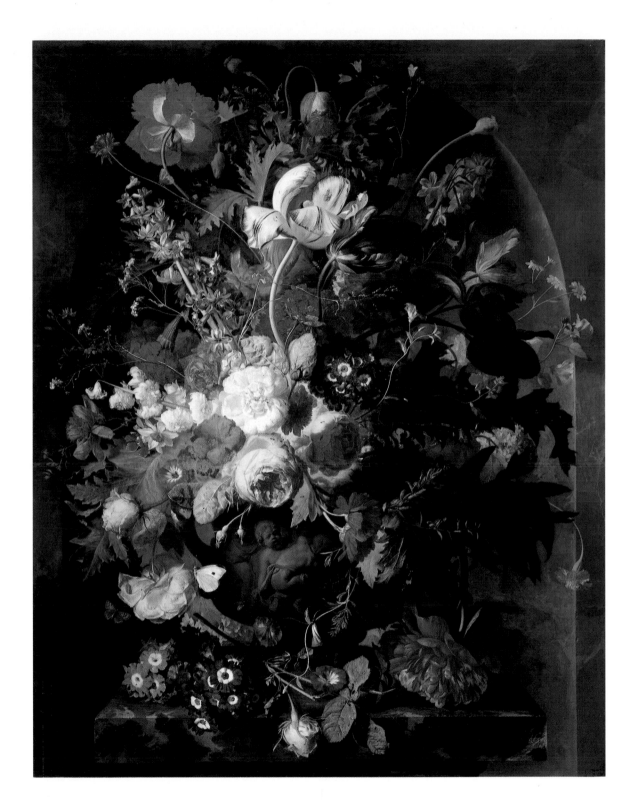

47

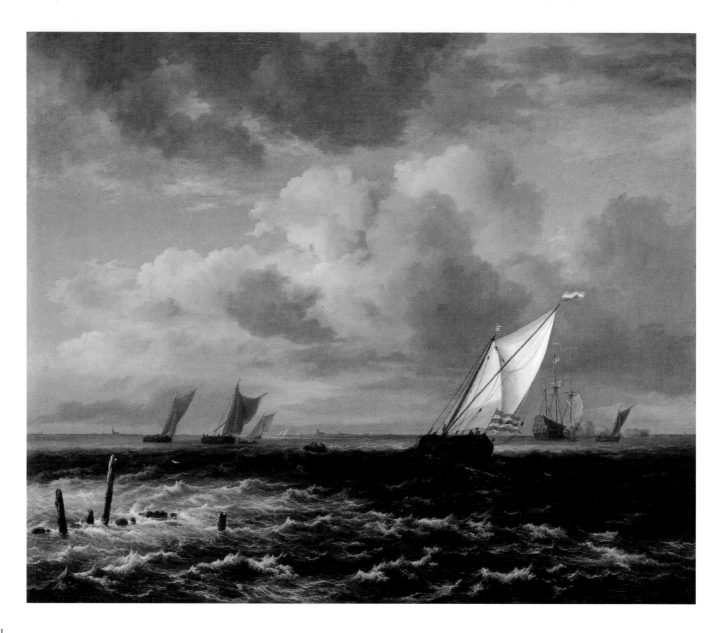

JACOB ISAACKSZ. VAN RUISDAEL
(Dutch, 1628/29–1682)

Rough Sea. ca. 1670
Oil on canvas, 42⅛ × 49½ in.
William Francis Warden Fund. 57.4

Although he distinguished himself as the greatest Dutch landscapist of the seventeenth century, Ruisdael painted only about a dozen seascapes. Moreover, there are no authentic drawings by his hand of the open sea or ships. Yet if no other seascapes were known, this work alone would certify his stature as one of the greatest marine painters.

Dutch art is renowned for its naturalistic effects. Here the compelling record of the frothy, storm-tossed sea and the dramatic commotion of the sky want nothing for fidelity to nature. Yet with its tall, glowering sky silhouetting vessels in the middle and far distance, the composition follows the preferred design of Ruisdael's marines. The painting has been dated around 1670; thus it would have originated about the same time as Ruisdael's panoramic views of his native Haarlem, which reveal a similar concern with grand effects of space and strong contrasts of light and shade. Though his dramatic view of nature attracted the praise of the great German poet Goethe, the romantic appreciation of Ruisdael has often obscured his objective restraint; the nineteenth century's notion of the projection of human emotion on the landscape was foreign to Ruisdael's devotion to the record of fact and nature's innate grandeur.

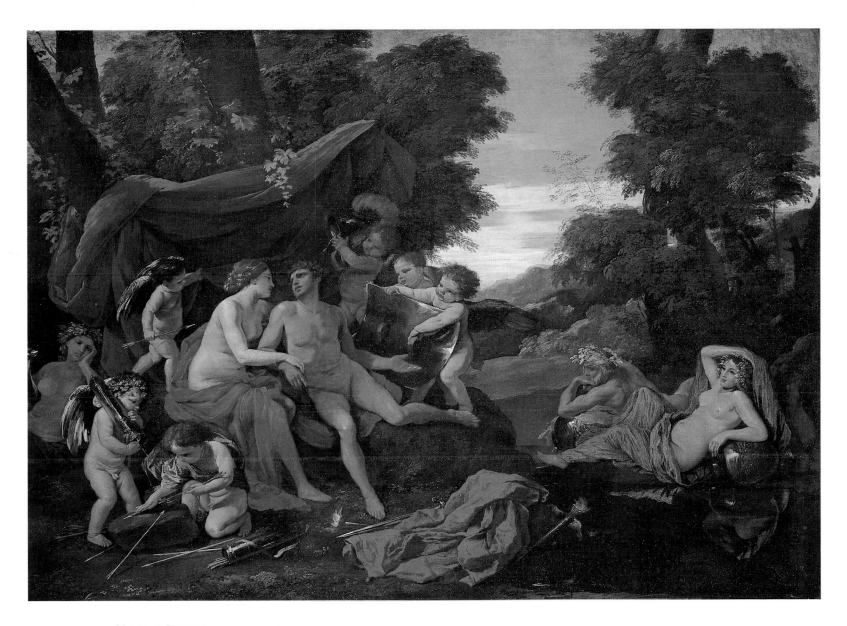

NICOLAS POUSSIN
(French [worked in Rome], 1594–1665)

Mars and Venus. ca. 1627–29
Oil on canvas, 61 × 84⅛ in.
Augustus Hemenway Fund and Arthur William Wheelwright
 Fund. 40.89

The greatest French painter of the seventeenth century, Nicolas Poussin actually spent most of his life and nearly his entire career in Italy. His distinctive classical style and profound literary sensibilities made him one of the most sought-after artists among cultivated private collectors in Rome, especially among the more powerful Princes of the Church, and one of the most admired and imitated painters of all time. Poussin drew most of his subjects from the poetry of Greek and Roman antiquity, and even his few religious pictures are cast among the buildings of ancient Rome, a practice that became almost standard for religious painters after his time.

Mars and Venus is an important early work by Poussin, painted shortly after he settled in Rome following a stay in Paris and Venice. It shows the strong influence on Poussin of Venetian painting—of Titian and Veronese in particular—in its color and in the bucolic treatment of its subject. Frequently interpreted as a whimsical portrayal of Mars, God of War, disengaging himself from the illicit embraces of Venus, Goddess of Love, it seems instead that Poussin has painted Mars succumbing to the attractions of Venus and disarmed by her attendant Cupids: a poetic allegory of the triumph of Love over War.

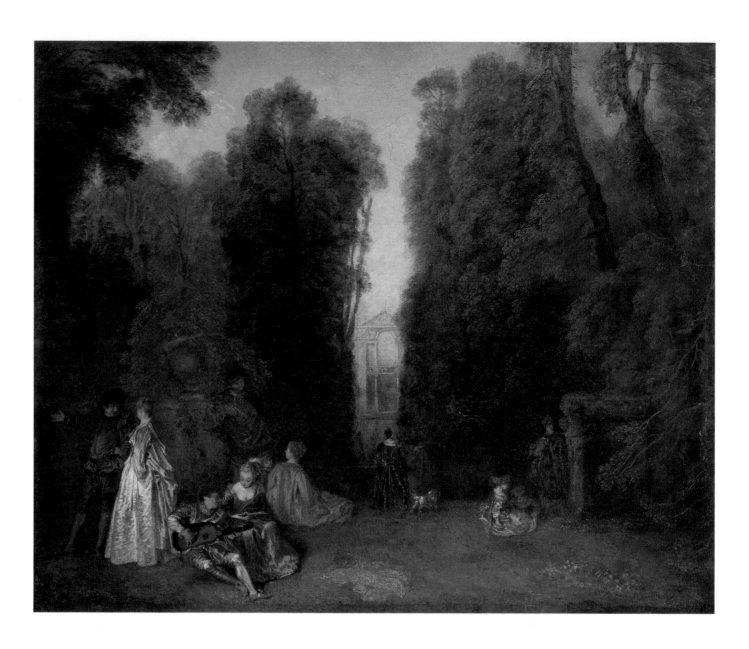

JEAN ANTOINE WATTEAU
(French, 1684–1721)

*View Through the Trees in the Park of Pierre
Crozat (La Perspective).* 1714–16
Oil on canvas, 18⅜ × 21¼ in.
Maria Antoinette Evans Fund. 23.573

Traditionally called *The Perspective*, Watteau's painting is a superb example of Watteau's greatest theme, the *fête galante*, a genre of painting he developed and which dominated his oeuvre at this time. Although he lived in Paris from the age of eighteen, Watteau's roots were really Flemish, his birthplace of Valenciennes having been captured by France from Flanders only seven years before his birth. And it is from Flemish paintings, like Rubens's depictions of lovers in gardens, as well as the outdoor scenes of lovers and musicians painted by the Venetians Titian and Giorgione, which he saw in Parisian collections, that Watteau created his poetic vision of love and artifice. A contemporaneity was added by understood references to the current fashion of outdoor courtship, and to the modern theater of the *commedia dell'arte*.

The Museum's picture is one of the few paintings by Watteau with an identifiable site. The painting is set in the magnificent parklike gardens of the Château de Montmorency, located outside of Paris and owned since 1709 by Watteau's friend and patron, the great collector Pierre Crozat. Although he included the recognizable central portion of the building's facade at the end of his vista, Watteau, a frequent visitor to the château, transformed the familiar site into a world of his own making, as different from reality as were his figures—the women dressed in contemporary fashion, the men in costumes of the seventeenth century. For Watteau's paintings are not transcriptions of actual events. Instead, the idyllic outdoor setting, the lovers, the music, and the children absorbed in play combined to create a fantasy of love that only touched on the world of reality.

NICOLAS LANCRET
(French, 1690–1745)

Luncheon Party. ca. 1735
Oil on canvas, 21⅞ × 18⅛ in.
The Forsyth Wickes Collection. 65.2649

Born in Paris, Nicolas Lancret was the best of
the followers of Watteau, and a gifted painter
of the *fête galante*, a genre which combined
theatrical fantasy and fashionable diversions in
idyllic pastoral settings. After Watteau's death
Lancret became a favorite in court circles, and
his works were collected by many noted con-
noisseurs, including Pierre Crozat and Freder-
ick the Great of Prussia.

This delightful small painting demonstrates
Lancret's considerable ability to portray the
moods and manners of an informal courtly so-
ciety. It is a detailed study for a much larger
painting, now in the Musée Conde, Chantilly.
Set in a picturesque park, the painting details
the end of an elegant though raucous meal.
Only the servants to the left are properly at-
tired; their masters carry on in complete disar-
ray and informal dress, having what seems to
be a delightful time. Before becoming the
centerpiece among the paintings of the For-
syth Wickes collection of eighteenth-century
French art, the painting was owned by La Live
de Jully, the brother of the king's mistress,
Madame de Pompadour, a renowned collector
and influential figure in the arts.

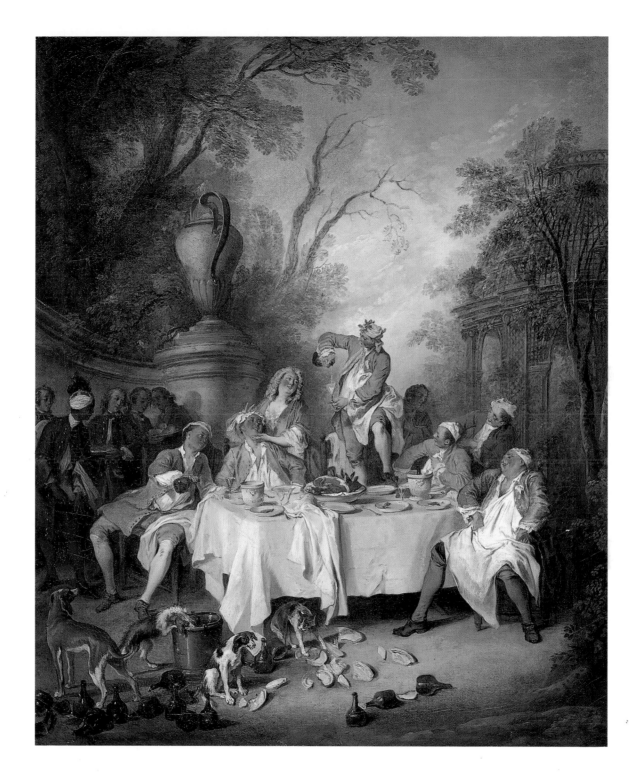

51

NICOLAS DE LARGILLIERRE
(French, 1656–1746)

François Armand de Gontaut, Duc de Biron. 1714
Oil on canvas, 54⅝ × 42 in.
Juliana Cheney Edwards Collection. 1981.283

Although he received commissions from the court, Largillierre was primarily the painter of the affluent Parisian *haute bourgeoisie*, which included city officials, bankers, and lawyers. He successfully transformed the grandiose and hieratic portrait types of Louis XIV's seventeenth-century France into the less formal, more intimate and sensual portraiture of Louis XV and the Rococo.

A brilliant colorist and virtuoso painter, Largillierre was at the height of his powers in this stunning military portrait of the young Duc de Biron, painted one year before Louis XV became king and one year before the sitter was married. He has transformed a Baroque prototype favored by such artists as Van Dyck, into the informal presentation of the eighteenth century. The portrayal has been softened by his having placed the figure before an atmospheric landscape background and by the inclusion of delicate details such as the luxuriously painted leopard skin lined in red satin and the sitter's softly flowing hair.

Largillierre delighted in contrasting different textures—the soft flesh of the face, the reflections on the hard metal of the armor, the leopard skin, and the lace. Exquisitely crafted, this portrait vividly and sensitively characterizes the sitter while placing him within his social milieu.

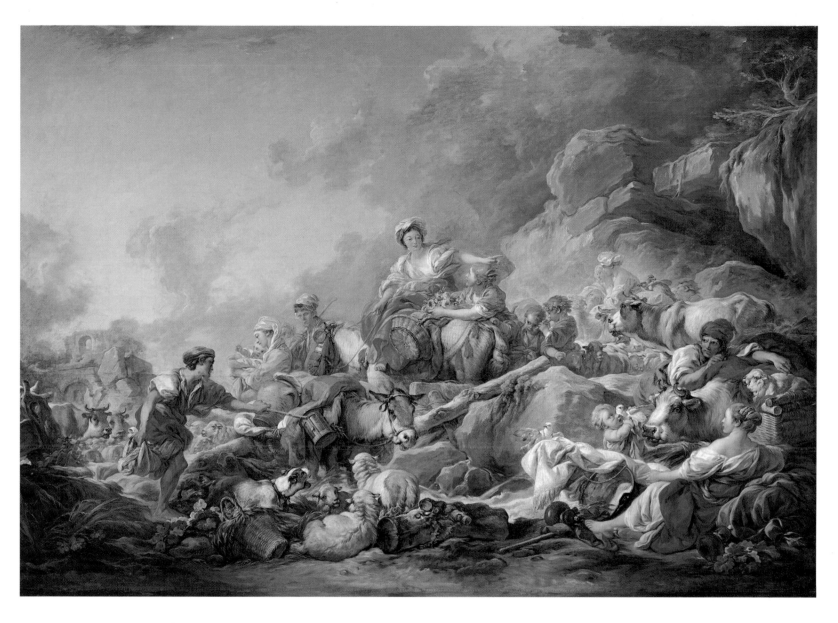

FRANÇOIS BOUCHER
(French, 1703–1770)

Returning from Market. 1767
Oil on canvas, 82½ × 114⅛ in.
Gift of the Heirs of Peter Parker. 71.2

François Boucher is the painter most closely identified today with the height of the Rococo in France. Working for Madame de Pompadour, the powerful mistress of Louis XV and an active patron of the arts, from 1745 to 1764, he executed portraits, decorative ensembles, tapestry designs, and opera sets. His talents were considerable in other areas as well: he produced delightful smaller paintings of landscape, mythology, and genre scenes, and was a gifted engraver, draftsman, and designer for the Sèvres china manufactury. A brilliant technician, he exploited the lushness of his paint to heighten the sensuous nature of his subject matter.

Returning from Market is a late work, originally part of a decorative cycle commissioned for the Hôtel de Richelieu in Paris. With its pendant, *Halt at the Spring,* it was purchased by Edward Preble Deacon in 1846 to decorate the dining room of his house in Boston. These were the first European paintings to enter the Museum's collection, when they were given in 1871. The pastoral subject of the scene is really, as is often the case with Boucher, an opportunity for the artist to delight us with his bravura brushwork, flowing, luscious paint, richly delicate palette, and cascades of charming children, animals, and young women. The tumult of this boisterous scene is somewhat deceptive, however, for Boucher's large figural compositions are always controlled, as here, by a strong underlying geometry.

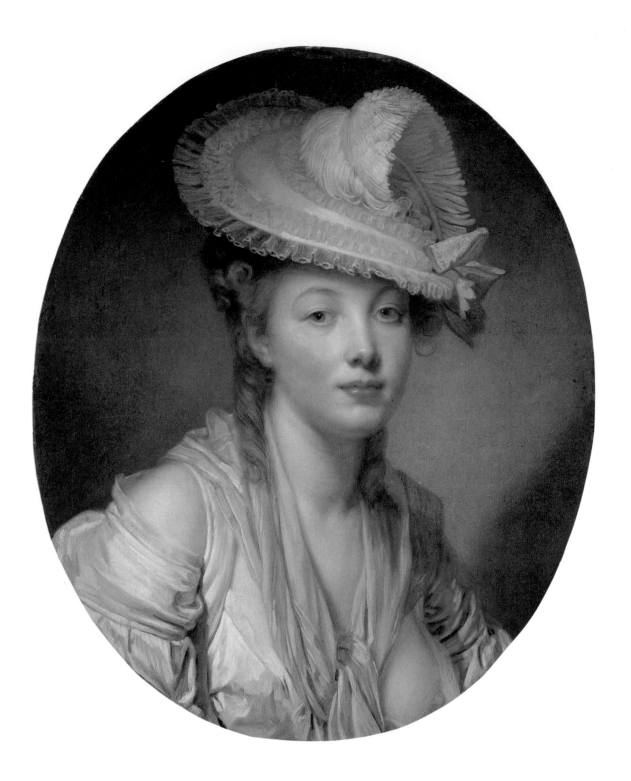

JEAN BAPTISTE GREUZE
(French, 1725–1805)

Young Woman in a White Hat. ca. 1780
Oil on canvas, 22⅜ × 18¼ in.
Gift of Jessie H. Wilkinson, Grant Walker Fund,
 Seth K. Sweetser Fund, and Abbott Lawrence Fund.
 1975.808

Although Greuze achieved fame through his moralizing genre scenes of family life, he was also the painter of some of the most beautiful and compelling portraits of eighteenth-century France. He settled in Paris after his early training in Lyon and a brief trip to Italy, and became a prominent figure of the Parisian art world into the rule of Napoleon.

This portrait of an unidentified young woman exemplifies a type of painting Greuze popularized in pre-Revolutionary France—that of a beautiful child-woman whose ambiguous sensuality fuses voluptuousness and innocence, modesty and display. There is a langorous softness about the painting which is derived in part from the restricted palette of atmospheric grays and pale pink flesh tones. Curves echo curves, as the oval of the painting itself is repeated in the undulating lines of the plume, hat, ringlets, and face, as well as the serpentine wrapping of scarves and light muslin around the sitter's body. The formality of the pleated organdy hat and the sad eyes contrasts with the sensuality teasingly promised in the full but closed lips, loose garment, and partially revealed breast. The provocatively casual attire reflects a "natural" *déshabillé* mode favored by Marie Antoinette herself.

54

LOUIS LÉOPOLD BOILLY
(French, 1761–1845)

Young Woman Ironing. ca. 1800
Oil on canvas, 16 × 12¾ in.
Charles H. Bayley Picture and Painting Fund. 1983.10

The intimate, anecdotal paintings of Boilly
stand in sharp contrast to the heroic public art
of the French Revolution, Empire, and Resto-
ration by official painters such as Jacques-
Louis David. The son of a wood sculptor,
Boilly was born near Lille and moved to Paris
in 1785. His style was inspired by the exqui-
sitely detailed, smoothly finished genre works
of seventeenth-century Dutch painters such as
Gerrit Dou, a type of painting that was avidly
collected in late-eighteenth-century France.
By catering to this vogue Boilly found a ready
market for his prodigious output.

This small, moderately erotic painting of a
Young Woman Ironing is one of Boilly's most
beautiful and best preserved works. Dating
from around 1800, it is a typical subject for
Boilly, and is executed in his characteristically
precise and detailed manner. His mastery of
textural subtlety, nuances of color, and the
rendering of still life are immediately evident.
Care is lavished on chair caning, the water in
the carafe, the glaze of the ceramic jug, and the
dull glow of the fire heating the iron. Boilly's
dignified portrayal of the girl at her work an-
ticipates interests of later French artists such
as Edgar Degas.

55

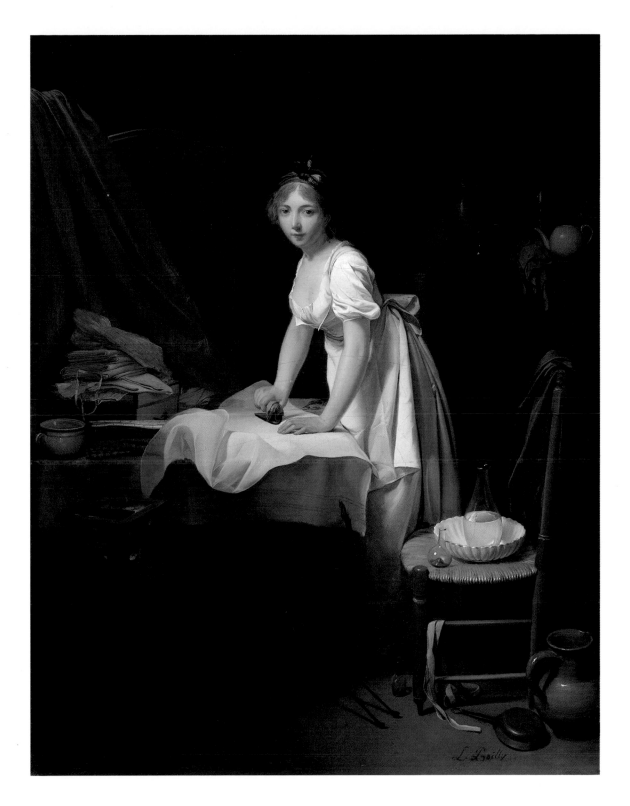

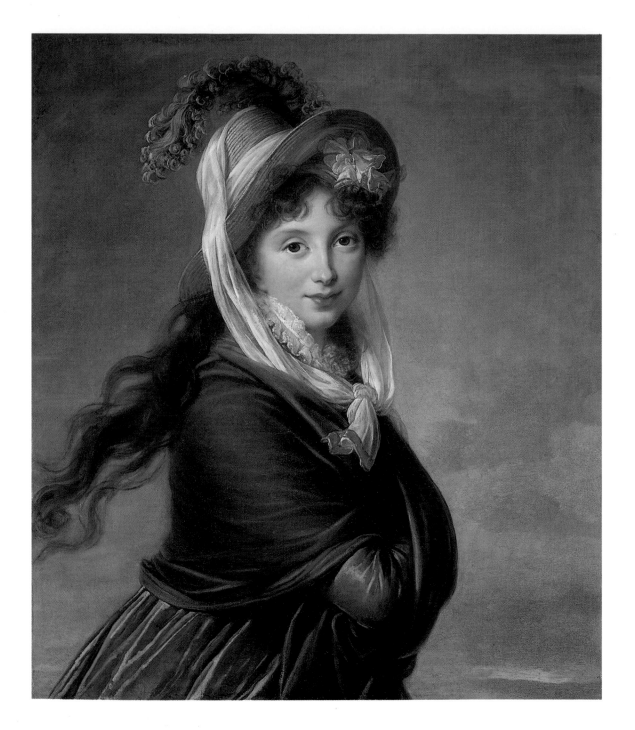

ELISABETH LOUISE VIGÉE-LE BRUN
(French, 1755–1842)

Portrait of a Young Woman. ca. 1797
Oil on canvas, 32⅜ × 27¼ in.
Robert Dawson Evans Collection. 17.3256

Vigée-Le Brun, born in Paris in 1755, was one of the most celebrated portraitists in French court circles in the years preceding the Revolution. Her artistic and social success was assured in 1778 when she received a commission to paint the queen, Marie Antoinette. By the beginnings of the French Revolution, however, this association made it dangerous for her to remain in France, and in 1789 she fled with her daughter first to Italy and then to Saint Petersburg, Vienna, and other European capitals. She was lionized by the upper classes wherever she went. Her most interesting work is from these years of travel, before her return to Paris in 1802.

This charming *Portrait of a Young Woman*, once thought to be the artist's daughter Julie, is usually dated about 1797, when Vigée-Le Brun was in Russia. The girl, who may have been a Russian aristocrat (the Countess Worontzoff is often suggested), seems to have been interrupted while briskly walking or skating. Several other paintings by the artist show animated figures and carry the suggestion of arrested motion. The repetition of curves in the hat, scarf, and shawl enhance the image of a rounded female form. But the unassuming directness of the pert face, the simplicity of the costume, and the solidly designed figure placed against a subdued cloudy background relate this portrait more to works of the nineteenth century than to the more coyly provocative portraits of earlier eighteenth-century France.

HIPPOLYTE DELAROCHE
(called Paul Delaroche; French, 1797–1856)

Marquis de Pastoret. 1829
Oil on canvas, 61⅛ × 48¼ in.
Susan Cornelia Warren Fund and the Picture Fund. 11.1449

Although he began as a landscape painter, it was as a history painter and portraitist that Paul Delaroche distinguished himself. He was best known for his paintings illustrating popular historical romances. By the 1830s, though never attaining the fame or success of his more gifted contemporaries Ingres and Delacroix, he had become a leading figure of a group of artists who steered a middle course between the more extreme positions of classicism and romanticism.

Delaroche was still a relatively young man when this portrait of Claude-Emmanuel-Joseph-Pierre Pastoret was commissioned by the son of the sitter. The portrait dates from 1829, the year Pastoret was made chancellor of France—the culmination of a brilliant forty-year career in public life. After the Revolution of 1830 Pastoret withdrew from politics, becoming in 1834 tutor to the royal family. This portrait, however, shows him at the peak of his power, in the billowing robes of the chancellorship; the cross of the order of Saint-Esprit hangs from his neck, and the Saint Andrews Cross and the Legion of Honor medal decorate his lapel. It is a large portrait, impressive both in its size and in its treatment. Despite the realistic handling of the face and thoughtfully relaxed pose, the painterliness of the sitter's richly appointed garments links the portrayal to earlier Baroque prototypes, which Delaroche apparently thought were appropriate models for the portrait of such a powerful political figure.

ANTOINE JEAN GROS
(French, 1771–1835)

General Bonaparte Visiting the Plague-Stricken at Jaffa. 1804
Oil on canvas, 46¾ × 64½ in.
S. A. Denio Collection. 47.1059

One of Napoleon's great propagandistic triumphs was the active use he made of the best French artists of the day, particularly Jacques-Louis David and his pupils Girodet, Gerard, and Gros. Antoine-Jean (later Baron) Gros was the official chronicler of Bonaparte's Egyptian campaign, and as such he was commissioned to paint the *Pesthouse of Jaffa* for the Salon of 1804, now in the Louvre. The smaller version of the same subject now owned by the Museum of Fine Arts is an autograph replica of this picture said to have been painted at the behest of Marshall Mortier, first Duc de Trevise.

General Bonaparte Visiting the Plague-Stricken at Jaffa commemorates, or rather idealizes, an event of March 11, 1799. In a successful effort to reassure his troops made restive by an outbreak of plague in Jaffa (the modern-day city of Tel-Aviv, Israel), Bonaparte courageously made a personal visit to sick men at a makeshift hospital set up in the courtyard of a mosque. Gros has portrayed him actually touching one of the sick men, standing in a pose that reminds viewers of Christ in the act of miraculous healing: in this way Gros created one of the most memorable images of Napoleonic history.

58

FERDINAND VICTOR EUGÈNE DELACROIX
(French, 1798–1863)

Lion Hunt. 1858
Oil on canvas, 36⅛ × 46¼ in.
S. A. Denio Collection. 95.179

After study of Renaissance and Baroque paintings in the Louvre, and inspired by recent painters such as Géricault, Eugène Delacroix developed a style at odds with his traditional training—a free and expressive technique which conveyed the emotional power of his subjects. In the 1820s his passionate color and turbulent style made him a leader of the Romantic movement and an opponent of Ingres and other classicists. The color and intensity of

his work have influenced painters well into this century.

From as early as the fifteenth century, Western artists held a fascination for the Middle East, an interest that peaked in the nineteenth century. Many artists actually traveled to the Near East and North Africa, lured by the promise of romantic adventures, while others stayed at home and re-created in their work the exoticism of their dreams. Delacroix was of the former group, and in 1832 he began a six-month trip to Morocco, Algeria, and Spain, which provided a lasting inspiration for his work. Sixteen years later he painted the *Lion Hunt*. While memories from his North Af-

rican trip are evident, a more direct source can be found in the hunt paintings by the great Baroque painter Peeter Pauwel Rubens, mentioned by Delacroix in his *Journal* as early as 1847. In this painting Delacroix corrected what he considered to be a confusion or lack of clarity in Rubens's work by creating a more balanced and controlled composition centered on the ferocious lion.

JEAN BAPTISTE CAMILLE COROT
(French, 1796–1875)

Forest of Fontainebleau. ca. 1846
Oil on canvas, 35½ × 50¼ in.
Gift of Mrs. Samuel Dennis Warren. 90.199

Before Impressionism took hold of the imagination and pocketbooks of Boston's collectors, the landscapes of the nineteenth-century French Barbizon painters captured their hearts. Bostonians in the second half of the nineteenth century filled their homes with these works; one of the most important collectors was Mrs. Samuel D. Warren, who gave the Museum this marvelous painting by Corot.

The *Forest of Fontainebleau* was a watershed in Corot's career. Partially based on studies of 1834, it was accepted by the Salon of 1846 and was perhaps the impetus for his receiving, shortly thereafter, the Legion of Honor, bringing him the official recognition he had long sought. Corot had painted in the Forest of Fontainebleau, located just south of Paris, since the 1820s. He would spend the warm summer months sketching there or in other parts of the French countryside, and then during the winter months rework these impressions in his Paris studio into more classical and polished compositions for the Salon. That the Salon would accept this painting—a pure landscape of a French site without classical or thematic allusions—demonstrates the advances that landscape painting had made in the first half of the nineteenth century. The smoothly modulated paint and the clarity and luminosity of color and light distinguish this work from his later, silvery, poetic landscapes, with which he is identified today. Corot was central to the revitalization of landscape in the nineteenth century and was an inspiration to later artists, including the Impressionists.

JEAN DÉSIRÉ GUSTAVE COURBET
(French, 1819–1877)

The Quarry (La Curée). 1857
Oil on canvas, 82¾ × 72¼ in.
Henry Lillie Pierce Fund. 18.620

Courbet's monumental *Quarry* was the first of his paintings to come to America. Painted in 1857, it was purchased for five thousand dollars by Boston's Allston Club, a group of young artists, prompting Courbet, the self-styled leader of French realism, to declare: "What care I for the Salon, what care I for honors, when the art students of a new and great country know and appreciate and buy my works?"

Unlike Courbet's more controversial works of starkly realistic contemporary subjects, *The Quarry* belongs to another part of his oeuvre, that of landscape painting, which was generally better received by the critics and the public. It was painted in his characteristic bold and vigorous technique, and utilized the somber palette, monumental forms, and subordination of landscape to figures familiar from his other work. His first large hunting painting, and the first in a series of woodland scenes, *The Quarry* was probably set in the Jura Mountains near his birthplace of Ornans; it includes a self-portrait of the artist, an accomplished hunter himself, leaning in the shadow against the tree. The painting is actually a masterful synthesis of separate parts added onto the original painting of the hunter and the roebuck. Thus, the beautifully rendered hunting dogs and then the figure of the horn-blower were joined to the original composition, as were later additions to the top and left side.

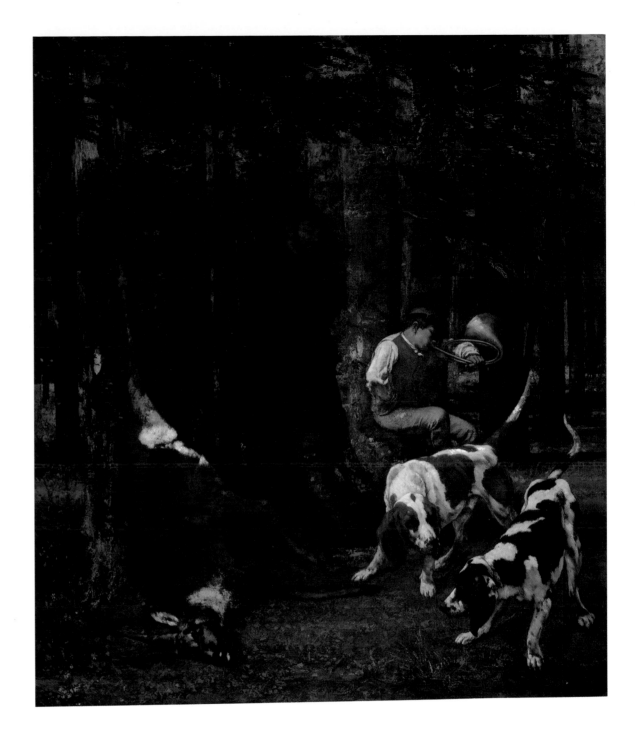

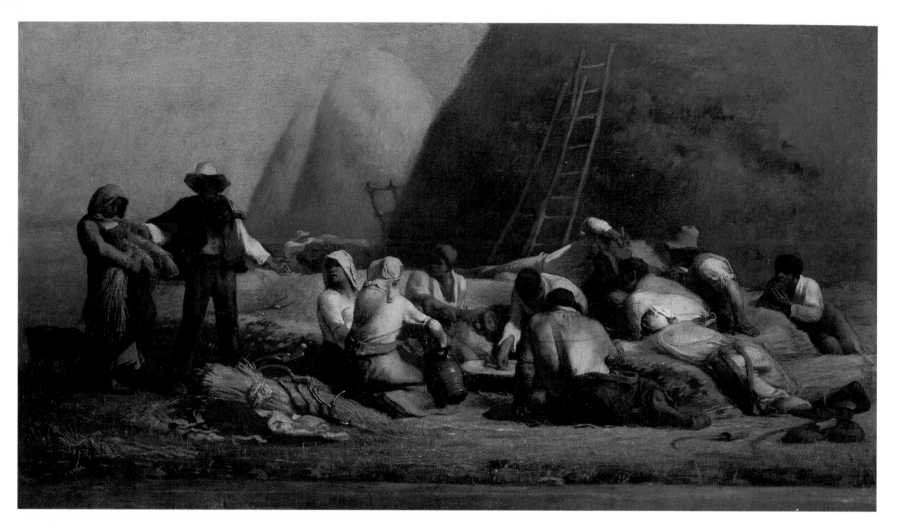

JEAN FRANÇOIS MILLET
(French, 1814–1875)

Harvesters Resting (Ruth and Boaz). 1850–53
Oil on canvas, 24¾ × 47⅛ in.
Bequest of Mrs. Martin Brimmer. 06.2421

Begun in 1850 and submitted to the Salon of 1853, where it won him a second-class medal and his first official recognition, *Harvesters Resting* is Millet's most ambitious figural composition, created within the grand studio tradition of great history painters of the past—a process that he learned as a student in Paris. Over fifty preparatory figural and compositional studies were made for this work, more than for any of his other paintings.

Like earlier French painters who chose to clothe contemporary historical events in the guise of Roman history, Millet has portrayed his peasants as figures from the Old Testament, using the story of Ruth and Boaz. After being widowed herself, an impoverished Ruth took care of her widowed mother-in-law by gleaning—picking up bits of grain overlooked or dropped by the harvesters—until the landowner Boaz, after learning of her goodness and self-sacrifice, married her. Although Millet claimed not to be political in his work, most agree that his version of this story was a thinly veiled plea for the prosperity of the second empire to be shared by even the poorest of

France. This message of class reconciliation and acceptance of the rural poor did not remain for long in Paris. It was bought in 1853 by Martin Brimmer, later first president of the Museum, at the urging of the Boston painter William Morris Hunt, and was exhibited by Brimmer the following year: the first Millet to be publicly shown in Boston. Millet continued his paintings of heroic enobled peasants, but he never again attempted such an ambitious composition.

62

JEAN FRANÇOIS MILLET
(French, 1814–1875)

The Sower. 1850
Oil on canvas, 40 × 32½ in.
Gift of Quincy Adams Shaw through Quincy A. Shaw, Jr., and
 Mrs. Marian Shaw Haughton. 17.1485

Boston collectors of the second half of the
nineteenth century loved the Barbizon painters,
and the Barbizon painter they most appreciat-
ed was Millet, whose works figured promi-
nently in collections of the time. Millet's friend
Boston artist William Morris Hunt was re-
sponsible for fanning this interest, and he was
the first owner of *The Sower,* which he pur-
chased from Millet in 1851 for sixty dollars and
later sold to Quincy Adams Shaw. By the 1880s
Shaw had amassed the finest and most repre-
sentative collection of Millet's works any-
where—a collection that formed the
cornerstone of the Museum's now world-fam-
ous holdings with the donation of fifty-four oil
paintings and pastels in 1917.

The Sower has been called Millet's first great
masterpiece, and indeed the power of this
well-known figure striding across the field of
the canvas is still undiminished. Investing a fig-
ure like the sower with the dignity and atten-
tion hitherto reserved for the upper classes,
mythological, or religious figures made his
work controversial, and when this painting ap-
peared at the Salon in 1850 it received a great
deal of attention. Millet claimed he portrayed
peasants as they were, without political over-
tones, and in 1863 he refuted his critics in a
letter to his friend and later biographer, Alfred
Sensier: "Some people tell me I deny the
charms of the countryside . . . I see very clearly
the haloes of the dandelions and the sun, far
away beyond the villages, suffusing the clouds
with its glory. But I also see the steaming,
straining horses on the plain, and the stoney
place where a man has been toiling and pant-
ing since morning, and now tries to straighten
up for a short breather. . . ."

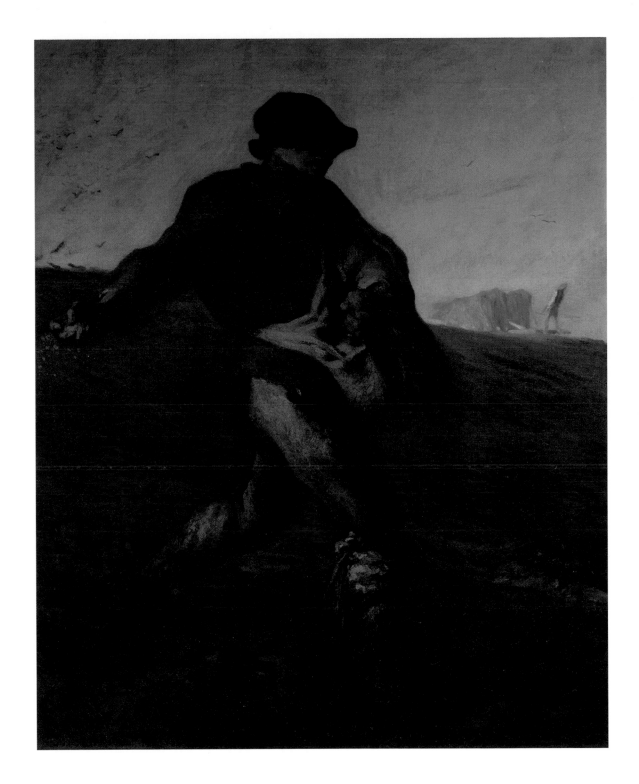

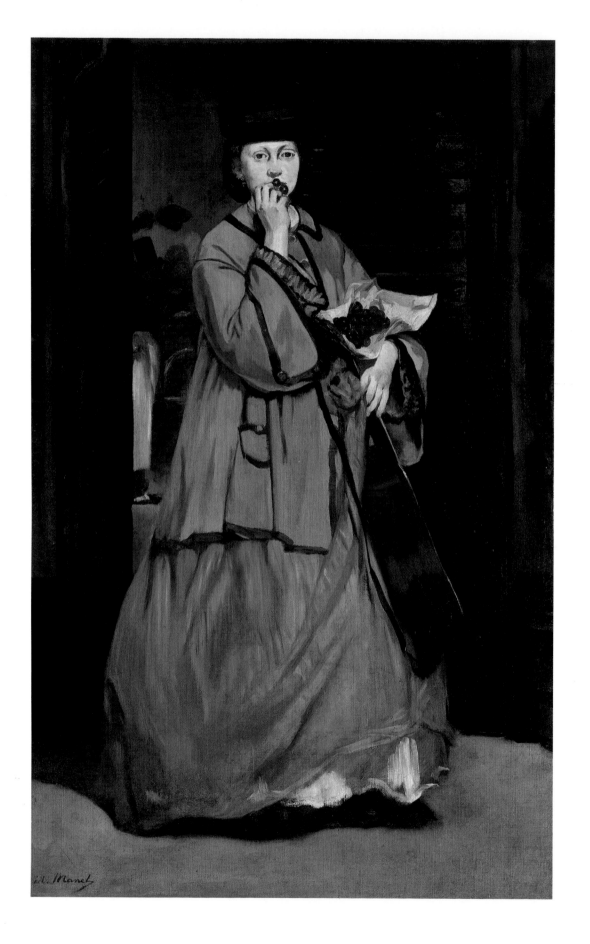

EDOUARD MANET
(French, 1832–1883)

Street Singer. ca. 1862
Oil on canvas, 67⅜ × 41⅝ in.
Bequest of Sarah Choate Sears in Memory of her husband,
 Joshua Montgomery Sears. 66.304

The foremost pioneer of Impressionism, Edouard Manet developed not only a revolutionary repertoire of themes based on the modern life of Paris, but also a complementing style of unprecedented directness and candor. According to Antonin Proust, Manet was inspired to paint the *Street Singer* by the sight of a woman with a guitar emerging from a sleazy café in the rue Guyot in Paris. He approached the woman and asked her to pose, but she went off laughing. "I'll catch up with her again," cried Manet, "and if she still won't pose, I've got Victorine"—a reference to Manet's favorite model in these years, Victorine Meurend, who in fact did pose for the *Street Singer*. Thus for all its momentary effect—the figure passing through the swinging door, unselfconsciously raising her skirt while gripping her instrument under one arm and bringing a handful of cherries to her mouth—the work was very consciously composed; the spontaneity of Impressionism was not, of course, achieved with the speed of the camera lens but through deliberate artifice. The life-size scale and humble subject also reflect the Impressionist conviction that, contrary to the academic principles of the official Salon, themes from everyday life were worthy of treatment on a scale and in a manner traditionally reserved for "history" paintings, or those works dealing with religious, mythological, or literary subjects. Many observers have noted the probable influence of Japanese prints on this work, especially in the unmodulated highlights and the linear patterning of the dress.

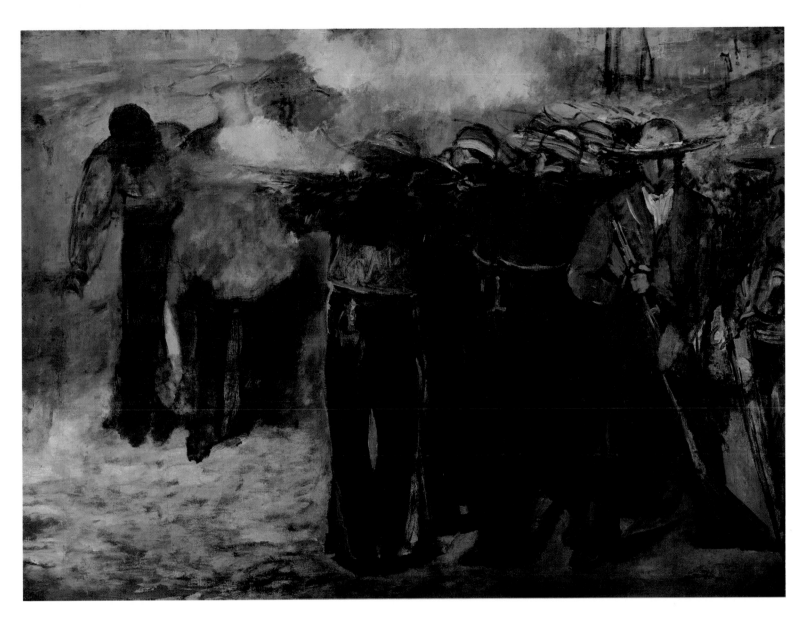

EDOUARD MANET
(French, 1832–1883)

Execution of the Emperor Maximilian. 1867
Oil on canvas, 77⅛ × 102¼ in.
Gift of Mr. and Mrs. Frank Gair Macomber. 30.444

The execution on June 19, 1867, of the Mexican emperor Maximilian of Austria was a tragedy felt keenly in France. The outrage was directed first at the Juarist rebels who actually shot the emperor, then at France's own Napoleon III, who, after imposing Maximilian's reign, withdrew the French forces that could have maintained it. Eager to demonstrate his capacity to paint a grand historical piece in his own fashion, Manet seized on this dramatic event as a subject from contemporary history befitting commemoration on a monumental scale.

The earnestness with which he took up the challenge is reflected in the fact that he devoted more than a year's work to the project, producing four oil paintings and a lithograph. The Museum of Fine Arts painting is undoubtedly the first and freshest version, its sketchy, painterly style and many changes of design (sombreros that become short-brimmed caps, figures superimposed on one another, and countless alterations of gesture and pose) testifying to the heat of invention. In the later versions the dramatic emotion of the Boston painting is mitigated. Yet despite the painting's immediacy and power, Manet had not personally witnessed the event; rather, he reconstructed it in his studio from newspaper accounts and borrowed his overall design from the great eighteenth-century Spanish painter Goya. Thus while his technique and sources were very consciously modern in their concern with reportage, Manet followed the grand Salon tradition in acknowledging the authority of the art of the past.

No less prescient a connoisseur of Impressionist art than Mary Cassatt recommended the purchase of this work when it was sold to a Boston collector in 1909.

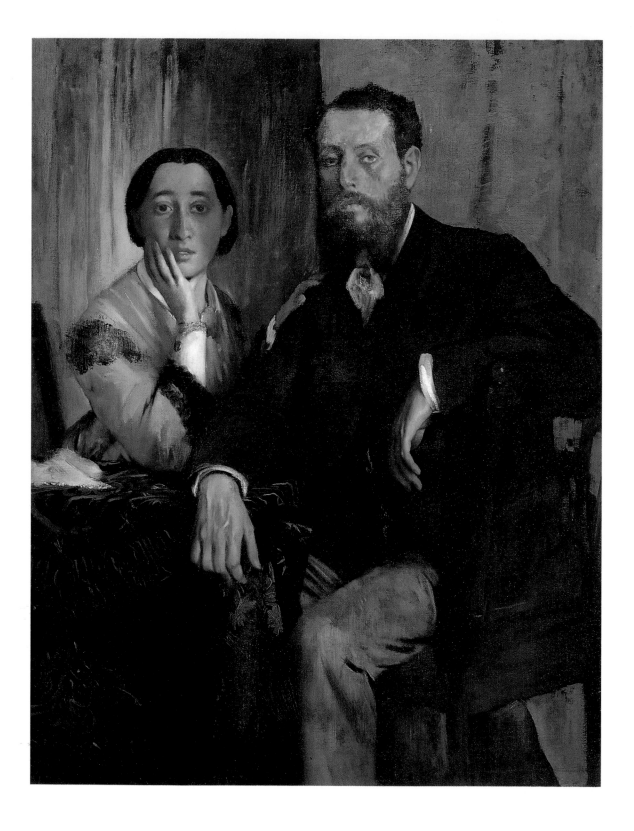

HILAIRE GERMAIN EDGAR DEGAS
(French, 1834–1917)

Edmondo and Thérèse Morbilli. 1867
Oil on canvas, 45⅞ × 34¾ in.
Gift of Robert Treat Paine, 2nd. 31.33

Like many a mid-nineteenth-century French artist, Degas began his career painting subjects from classical antiquity and literature. His earliest treatments of contemporary subjects took the form of portraits. While Degas never became a portrait painter in the professional sense, he painted numerous images of relations and friends. Among his earliest and most successful portraits were the images of his Neapolitan relatives, the Bellelis and the Morbillis.

Portrayed in this work are Degas's sister and their first cousin Edmondo, to whom Thérèse Degas (1840–1897) was married through special papal dispensation in Naples in 1863. Duke Edmondo Morbilli was a banker. The consumate portraitist, Degas here demonstrates his extraordinary sensitivity to pose, gesture, and the subtleties of facial expression. Edmondo dominates the work not simply by occupying more of the pictorial space but also by his attitude of self-assurance and ease. Both sitters are posed three-quarter length and fix the viewer with their gaze. However, the pale Thérèse draws one vaguely distraught hand to her cheek while hesitantly extending the other to her husband's shoulder. In the couple's counterpoint of confidence and uncertainty, repose and anxiety, authority and entreaty, the portrait speaks volumes not only about the Morbillis' unhappy marriage but also about the institution generally in nineteenth-century France. Degas left unfinished another, earlier, full-length seated portrait of the newly married couple (National Gallery of Art, Washington); he never sold any of his many family portraits, preserving them in his studio until his death. A drawing of Thérèse and a preliminary study for the head of Edmondo are also preserved in the Museum.

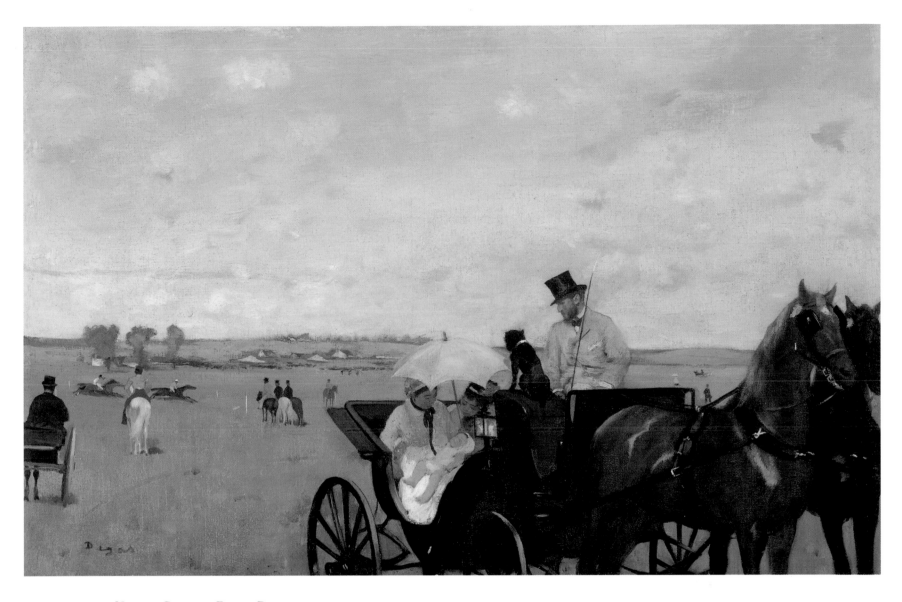

HILAIRE GERMAIN EDGAR DEGAS
(French, 1834–1917)

Carriage at the Races. ca. 1870–72
Oil on canvas, 14⅜ × 22 in.
1931 Purchase Fund. 26.790

The Impressionists were attracted to subjects taken from contemporary life as opposed to traditional themes from history or literature. Like Manet, Degas was an aristocrat who recorded the amusements of the well-to-do—visits to cafés, the theater, the ballet, art galleries, and the race track. Horse racing was then newly imported from England and very fashionable. The French Jockey Club was founded in 1833, and the race track at Longchamps out-

side Paris was opened in 1857. Although not an equestrian himself, Degas was the only Impressionist to devote himself to the theme, choosing not the salient aspects of the subject, namely the racing, but other casual interludes in or tangents to the action.

Here Degas depicts Paul Valpinçon and his family in a carriage, their backs turned to the competition. Degas was first exposed to race horses during a visit to the Valpinçons' Normandy estate in the fall of 1861. In a notebook of 1869 Degas expressed his desire to make paintings of this type, namely "portraits of people in familiar and typical positions." The high regard in which he held this picture is

reflected in a letter that he wrote to Tissot inquiring after its reception when first exhibited at the Durand-Ruel gallery in London in 1872 and in Degas's decision to include the work in the first Impressionist exhibition in 1874. The painting's boldly cropped, asymmetrical design reminds us of Degas's admiration for Japanese art and contributes to the momentary quality of the scene. Despite their compelling informality, Degas's depiction of horses and jockeys resulted from very deliberate working methods, involving many preparatory sketches.

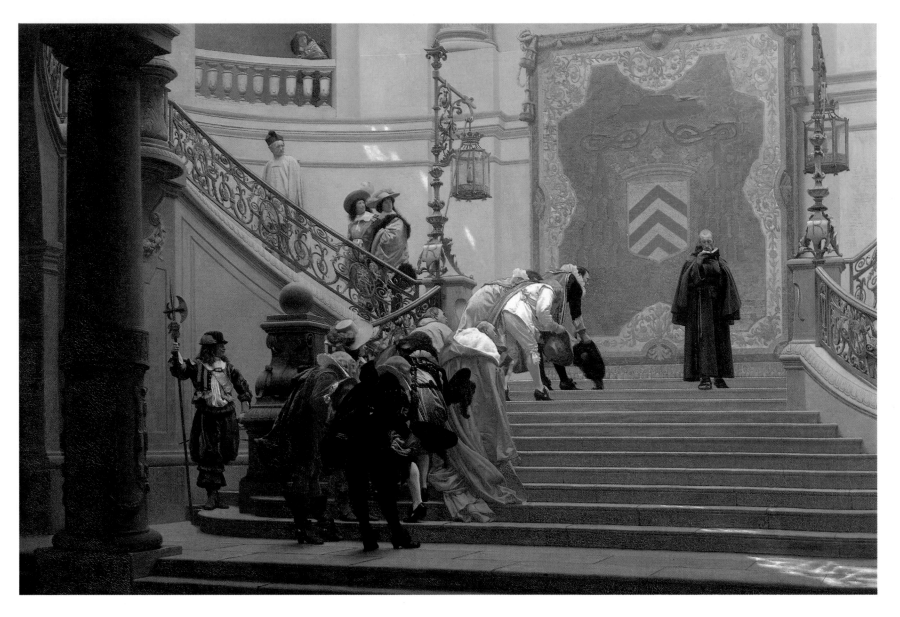

The modern taste for Impressionism often obscures styles that held greater popular and official sway in the latter half of the nineteenth century. Jean Léon Gérôme, a leading practitioner of the polished, academic manner, specialized in historical genre subjects in the tradition of Delaroche and Meisonnier. The nineteenth century delighted in exacting, anecdotal re-creations of events from the literary past. Here Gérôme gives definitive pictorial form to the popular expression "l'Eminence Grise" (The Gray Cardinal), or by inference, "the power behind the throne."

On the fastidiously reconstructed staircase of the Château Richelieu, which was destroyed in the French Revolution, the Gray Cardinal (François Le Clerc du Trembly, 1577–1638) descends from his morning parlay with Cardinal Richelieu. Le Clerc du Trembly was a Capuchin Friar, known as Père Joseph, who, by his severe intellect and shrewd political acumen, won Richelieu's confidence. Père Joseph became the latter's secretary and coadjutor, shaping as much as Richelieu himself the foreign policy that would sow discord throughout Europe and strengthen France's hand. Despite his rise to power, the Gray Cardinal maintained his abstemious manner, earning the respect and fear of others at Court. In Gérôme's painting the obsequious and colorful courtiers and the ecclesiastical figures who meet the barefooted friar on the stair express a full spectrum of response. They bow not only to the friar but also to Cardinal Richelieu's absent authority, in the form of the coat of arms on the tapestry. The studied way in which Père Joseph ignores their niceties lends the chill of reality to the story.

JAMES JACQUES JOSEPH TISSOT
(French, 1836–1902)

Women of Paris: The Circus Lover. ca. 1883–85
Oil on canvas, 58 × 40 in.
Juliana Cheney Edwards Collection. 58.45

Like the Impressionists, James Tissot recorded the diversions of modern urban life but in a style that retained much of the polish of the academic painting that the Impressionists eschewed; Tissot was not one to indulge in the painterly liberties of a *plein air* palette and touch. His works are more tightly executed and anecdotal in the best sense of this nineteenth-century concept.

This work belongs to a series of eighteen large paintings entitled *La Femme à Paris* which Tissot created between 1883 and 1885. They record Parisian women of different social classes encountered as if by chance at various occupations and amusements, often openly acknowledging the viewer's observations, as does the young lady with the fan at the right. When this picture was first exhibited in Paris in 1885 it was entitled *Les Femmes de sports*, while the following year in London it was called the *Amateur Circus*. In the catalogue of the latter show the subject was explained as a sort of "Cirque du High Life," then in vogue in Paris, in which the performers were aristocrats. "He on the trapeze facing you, with the glass in his left eye, with tights and a red jersey, is no less a person than the Duc de la R[ochefoucauld?] and his companion is a person of the same blue blood. And all the gentlemen in evening dress, and the ladies in brilliant morning toilettes, are members of the same great world." The specific circus has not been identified, but one candidate, the Cirque Molier, was unusual in providing a ladies' night to what was otherwise mostly a male, upper-class preserve. It proved so popular that for propriety's sake two ladies' nights were scheduled, one for the *haut* and one for the *demi-monde*. However, the curious sexual segregation of the audience in this picture has yet to be explained.

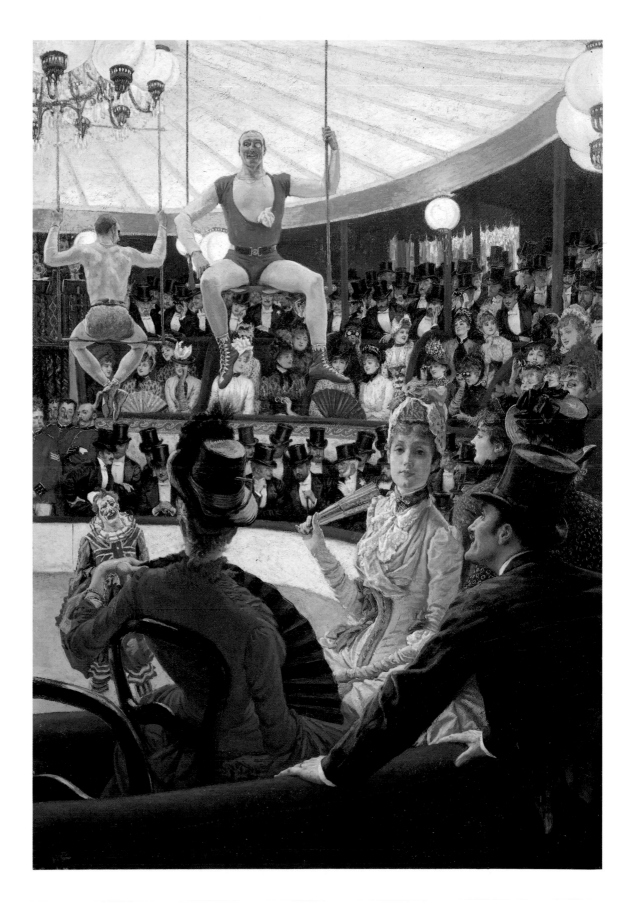

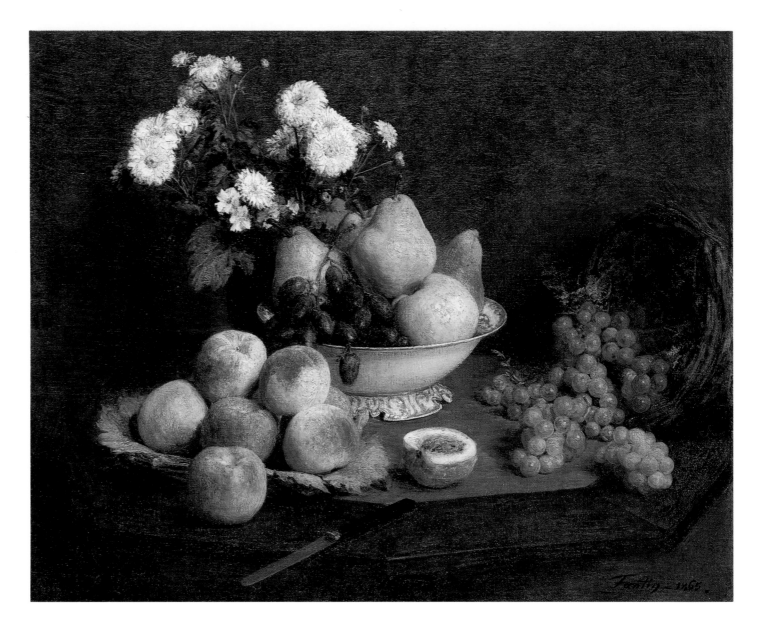

IGNACE HENRI JEAN THÉODORE
FANTIN-LATOUR
(French, 1836–1904)

Flowers and Fruit on a Table. 1865
Oil on canvas, 23⅝ × 28⅞ in.
Bequest of John T. Spaulding. 48.540

Friend to Manet and the Impressionists but an independent artist with his own idiosyncratic style, Fantin-Latour made specialties of portraits, still lifes, and the occasional history painting of Wagnerian subjects. On an early trip to England in 1861 he began to devote himself in earnest to flower pieces, which subsequently found a welcome and lucrative market, via the painter James McNeill Whistler's introductions, among the wealthy Greek community residing in London. Still life in the 1860s was enjoying a new respectability after an extended period of disfavor in the official Salon. Manet, Courbet, Cézanne, Renoir, Monet, and later artists such as Redon, Van Gogh, and Matisse all would make a specialty of the painting type. But none of them was as devoted to the flower piece as Fantin.

Although a relatively early work by Fantin, this lovely painting reveals an exceptional confidence and resolution. Indeed the design is one of the most complex and animated of his career. The simple objects are recorded with cool observation, yet their complicated assembly is a triumph of forethought. Several objects—the china bowl, the basket, and the illusionistically extended knife—recur in other still lifes, testifying to Fantin's constant permutational study of a stock of motifs. Yet as Fantin rings the changes there is no flagging of invention or watchfulness: the glint of the porcelain is as true, the flesh of the peach as plump, and the flower's bloom as rich with each new variation of design. The single constant is Fantin's odd personal detachment, which is detected not so much in the intellectual rigor of his designs as in the curious effect of smoky lens interposed, as it were, between the viewer and the subject.

70

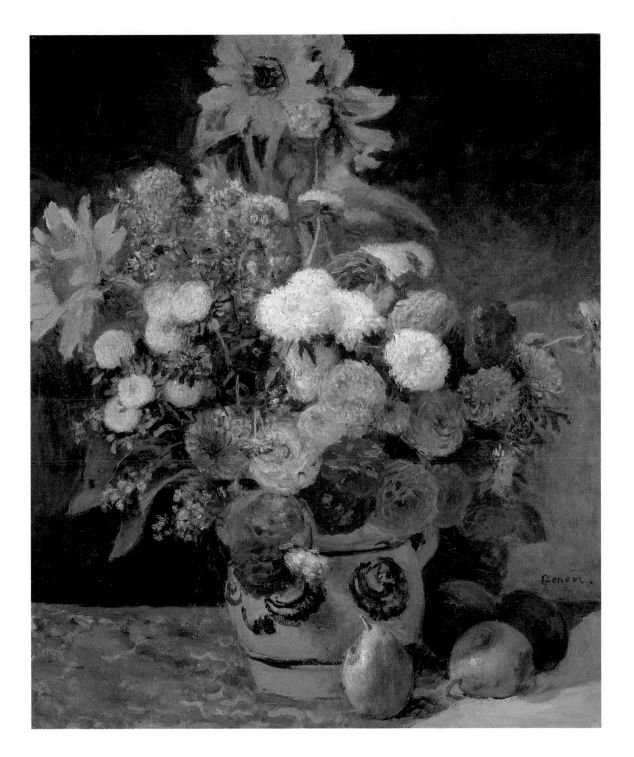

PIERRE AUGUSTE RENOIR
(French, 1841–1919)

Mixed Flowers in an Earthenware Pot. ca. 1869
Oil on paperboard mounted on canvas, 25½ × 21⅜ in.
Bequest of John T. Spaulding. 48.592

Renoir was primarily a figure painter, the nude playing a central role in his art. As this work clearly attests, however, he also was an accomplished still-life painter. The luscious arrangement of flowers and fruit evokes the Ile de France in late summer. A logical sequel to a series of bouquets that Renoir painted for the Le Coeur family in 1866, this painting has been dated 1869, the summer during which Renoir and Monet were neighbors and worked together in Bougival. Monet, in fact, painted that same year a still life (J. Paul Getty Museum, Malibu) in the identical vase and with the same fruit. The execution of Renoir's painting shows the spirited, stabbing stroke and brilliant palette associated with Impressionism. Although artists like Courbet and Fantin-Latour had painted very similar subjects in the years immediately preceding this work, neither achieved Renoir's coloristic clarity or painterly verve.

Still life remained a recurrent theme throughout Renoir's career. He once observed, "Painting flowers is a form of mental relaxation. I do not need the concentration that I need when I am faced with a model. When I am painting flowers I can experiment boldly with tones and values without worrying about destroying the whole painting."

71

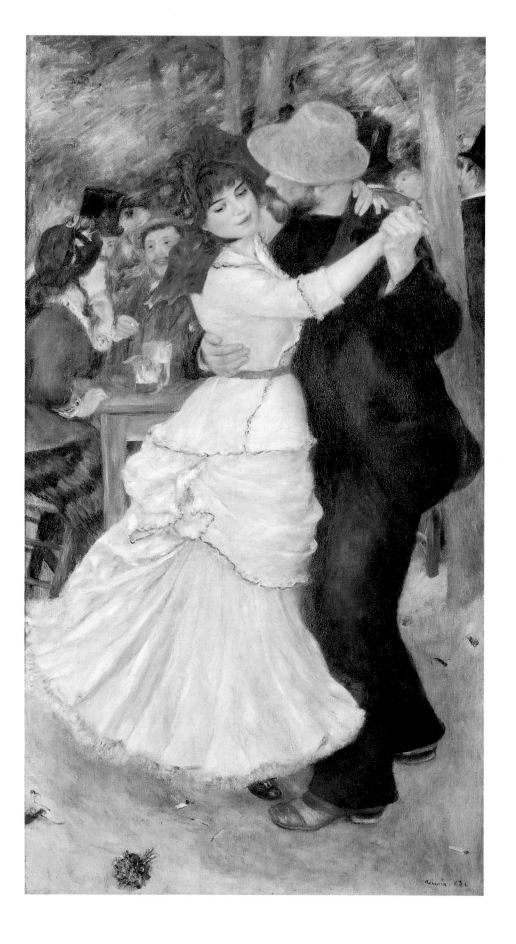

PIERRE AUGUSTE RENOIR
(French, 1841–1919)

Dance at Bougival. 1883
Oil on canvas, 71⅝ × 38⅝ in.
Picture Fund. 37.375

Of all the Impressionists, Renoir most consistently celebrated life's moments of pleasure and recreation. Although his own life was scarcely free of hardship, he did not dwell on sadness or loss; rather he projected a perenially optimistic outlook. The *Dance at Bougival* conveys this sunny point of view, depicting a dancing couple whirling in an exhilarating *pas de deux*. The pretty girl in the scarlet bonnet festooned with plums turns slightly from her companion's attentions. A drawing for the composition bears Renoir's inscription: "She was waltzing, deliciously abandoned in the arms of a fairhaired man with the air of an oarsman." But the painting tells no clear story; Renoir was more concerned with the evocation of mood than with explicit narration.

One of his largest and most ambitious works, this painting marks the culmination of Renoir's investigations of themes of urban and suburban recreation. Often accompanied by his fellow Impressionists, Renoir had visited places along the Seine such as Chatou, Asnières, Bougival, and La Grenouillère, where he recorded the shimmering landscape or the diversions of Parisians on a day in the country. His brother Edmond characterized Bougival as "quite select and expensive"; however, the open-air garden in the background suggests a social mix, with gentlemen in top hats and their country cousins in straw *chapeaux*.

The painting is part of a series of three life-size canvases depicting dancing couples painted in 1882–83; the other two are pendants now preserved in the Musée d'Orsay, Paris. These companion pieces, *Dance in the City* and *Dance in the Country*, juxtapose urban and suburban recreations, but Renoir characteristically did not comment on the relative virtues of the city and country; pleasure was not confined by locale.

CLAUDE MONET
(French, 1840–1926)

La Japonaise (Camille Monet in Japanese Costume).
1876
Oil on canvas, 91½ × 56 in.
1951 Purchase Fund. 56.147

Monet, the consummate landscape painter among the Impressionists, executed only a handful of major figure paintings. The monumental *La Japonaise*, first exhibited at the second Impressionist exhibition in 1876, is the exception in his production of the mid-1870s. With its brilliant palette, tilted perspective, and wealth of Oriental motifs, this painting has often been regarded as Monet's tribute to Japanese art, which had such a demonstrable influence on Impressionist painting. Yet there is as much parody as homage in this curiously double-edged painting: the muscular samurai who tussles illusionistically about the lady's hips, and the geisha decorating one of the fans in the back wall who looks back askance at this blond imposter.

The model, in fact, was Monet's first wife, Camille, here outfitted with a wig and blood red, richly brocaded kimono. Camille turns and offers a coquettish smile from behind her rainbow fan, the whole an oddly flirtatious and splendidly gaudy costume piece. Monet's abiding ambivalence toward the picture was expressed in his reaction to the news of its resale in 1918. Hearing that the painting had fetched a large price, he denounced it as an "obscenity," claiming that he had only whipped it up to make a sensation at the exhibition. Yet he immediately exclaimed, "Look at those fabrics!" as if to acknowledge that he was still seduced by the exotic concept and embroidered splendor of it all.

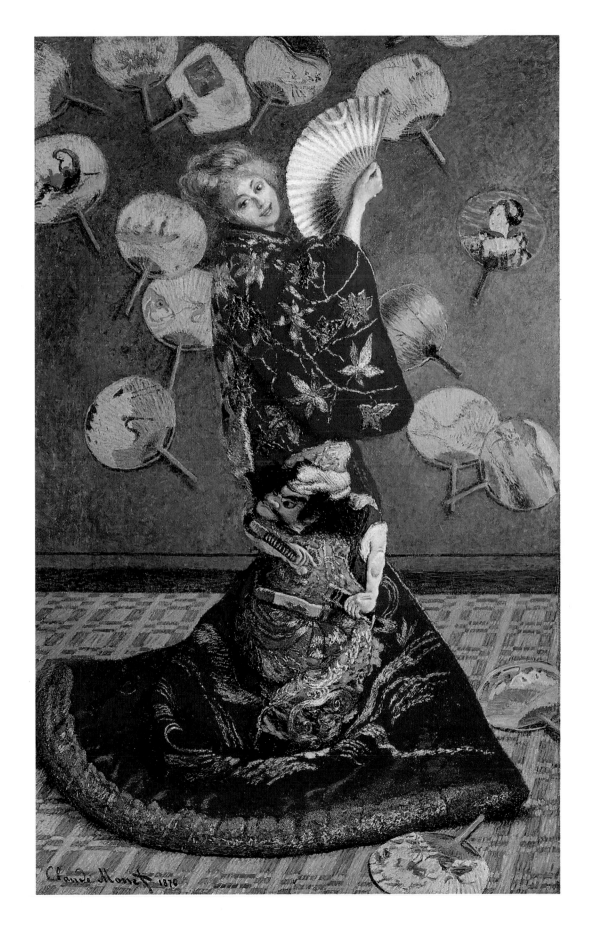

73

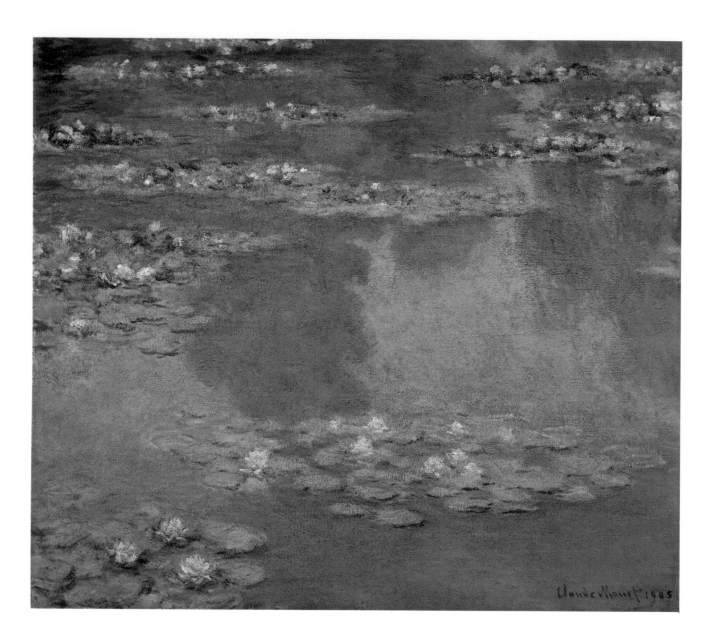

CLAUDE MONET
(French, 1840–1926)

Water Lilies (I). 1905
Oil on canvas, 35¼ × 39½ in.
Gift of Edward Jackson Holmes. 39.804

Monet almost always had small gardens wherever he lived, but in Giverny, where he settled in 1883, he had the space and money to indulge himself to the fullest. In 1893 he bought a tract of land containing a stream and with a pond bordering his property there. He modified the pond, and by 1895 had built a Japanese-style bridge, probably inspired by Oriental prints he owned. Monet began to paint his gardens in these years, marking his first serious interest in his property as a subject for painting; planting, planning, and caring for his gardens became an obsession that dominated his art.

In 1901 Monet began to enlarge his lily pond, and by 1903, with most of the work complete, he immediately began a series of paintings of water lilies and reflections on water, of which this 1905 painting was a part. Work progressed slowly on the series, but in 1909 he finally exhibited forty-eight of these paintings at the Durand-Ruel Gallery in Paris. In this painting Monet was able to cut himself free of all references to land and allow just the shifting surface of the pond, with its water lilies and reflections of clouds, to fill his canvas. In its small size and delicate coloration it is reminiscent of the artist's earlier work, but as one of Monet's first attempts to concentrate on the shifting surface of his pond it also looks ahead: it marks a preliminary step toward the vast and exhaustive water landscapes which consumed his final years and for which he built a large and separate studio.

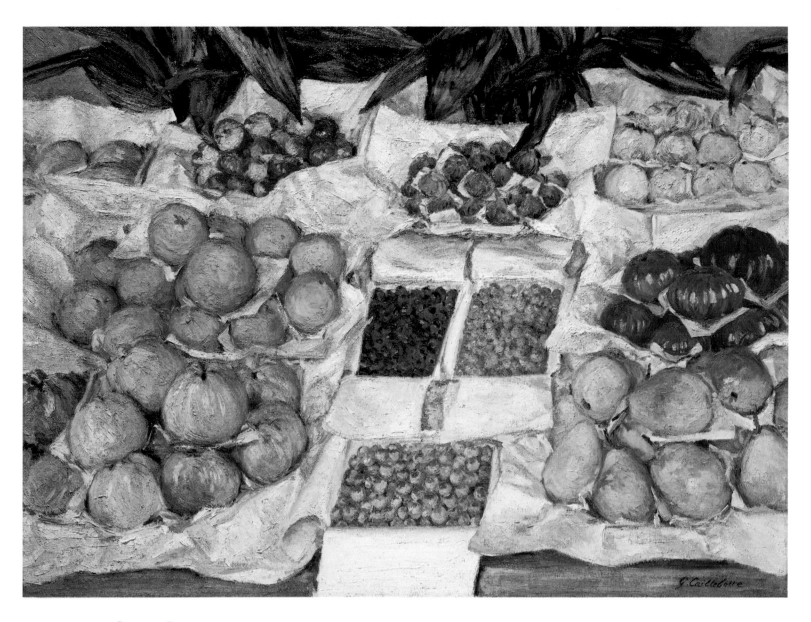

GUSTAVE CAILLEBOTTE
(French, 1848–1894)

Fruit Displayed on a Stand ca. 1881–82
Oil on canvas, 30⅛ × 39⅝ in.
Fanny P. Mason Fund in Memory of Alice Thevin. 1979.196

Although less well known than other French Impressionists, Gustave Caillebotte was one of the style's most original practitioners, an important organizer of the independent Impressionist exhibitions, and a major collector of Impressionist art. The son of affluent parents, Caillebotte first studied law before turning to painting following the Franco-Prussian War. While adopting the light tonality and pure palette of the Impressionists, he favored more structured designs and greater spatial manipulation than his fellows.

This brightly colored, orderly composition was executed around 1881–82 for the dining room of Maître Courtier, a notary at Meaux and personal friend of the artist. Caillebotte exhibited it in the seventh Impressionist group exhibition held in 1882, where it received a cool reception from all reviewers except Huysmans, who commended its unconventional design. Two years earlier, another still life by Caillebotte had caught the eye of this critic, who exclaimed, "This is how still life should be done...there are no false contrasts...the fruit is neither over- or under-emphasized, not sharpened into little bright points spread around for nothing....Caillebotte's technique is simple, without fuss. This is the modern program as envisaged by Manet."

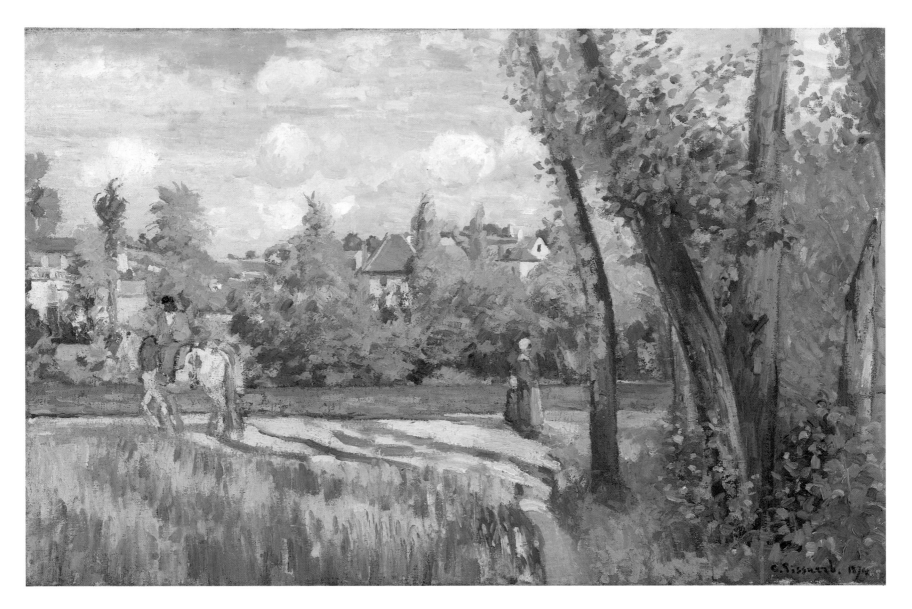

CAMILLE PISSARRO
(Danish [worked in France], 1830–1903)

Sunlight on the Road, Pontoise. 1874
Oil on canvas, 20⅝ × 32⅛ in.
Juliana Cheney Edwards Collection. 25.114

The year in which this painting was executed, 1874, marked the first Impressionist exhibition in Paris, a show in which Pissarro played an instrumental role both as organizer and contributor. This was the moment of the greatest unity of purpose and style among the diverse group of artists who assembled under the banner of Impressionism. With its lighted landscape observed directly from nature, *Sunlight on the Road, Pontoise* is virtually a textbook ex-ample of the style. Characteristic of Pissarro's works of the middle 1870s, the palette is sunny, the touch broad and creamy, and the overall effect sensuous. There is no black in the painting; the shadows are indicated in subtly nuanced shades of silver blue, green, and gray. Yet the design is also highly ordered, with its series of horizontal spatial bands and balanced motifs such as the profiled woman and rider moving in opposite directions along the road. The style of the painting simultaneously looks back to the Roman landscapes of Pissarro's teacher, Corot, and ahead to the achievements of his friend and colleague Paul Cézanne.

The simple beauty of this picture antici-pates Pissarro's remark to his son, Camille, about Corot in 1893: "Happy are those who see beauty in the modest spots where others see nothing. Everything is beautiful, the whole secret lies in knowing how to interpret."

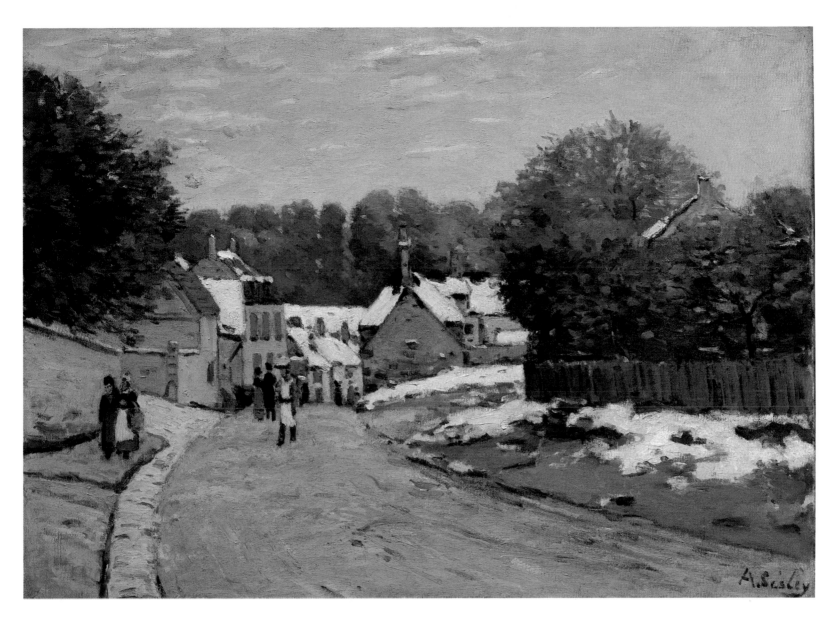

ALFRED SISLEY
(British [worked in France], 1839–1899)

Early Snow at Louveciennes. ca. 1870–71
Oil on canvas, 21⅝ × 29 in.
Bequest of John T. Spaulding. 48.600

Sisley was perhaps the one Impressionist who was most purely a painter of landscape, and who rejected the crowded resorts and cities that attracted his colleagues. Views of sky, water, and perhaps a quiet road were given a gentle lyricism that remained constant throughout his career. Sisley's life was somewhat less idyllic. The son of an English family who had settled in France, he was supported by his family through the 1860s, when his father was fi-nancially ruined, leaving Sisley a virtual pauper who struggled to sell his paintings for the rest of his life.

In 1870, at the onset of the Franco-Prussian War, Sisley moved to Voisins-Louveciennes outside of Paris. Here, in that first winter, he painted this snowy scene of the rue de la Paix, the road joining the two villages. The winter landscape, or streetscape, was an effective ve-hicle for Sisley's investigations of light and weather effects, and the composition too—of an open road leading the viewer into the pic-ture—was a familiar perspectival device used by all the French Impressionists. The moment chosen by Sisley for this work is not the dead of winter, but the more ambiguous time of an autumn day (note the leaves still on the trees) surprised by an early snowfall. Thus there is still a warmth and richness in the color of this simple but powerful work that otherwise might have been lacking.

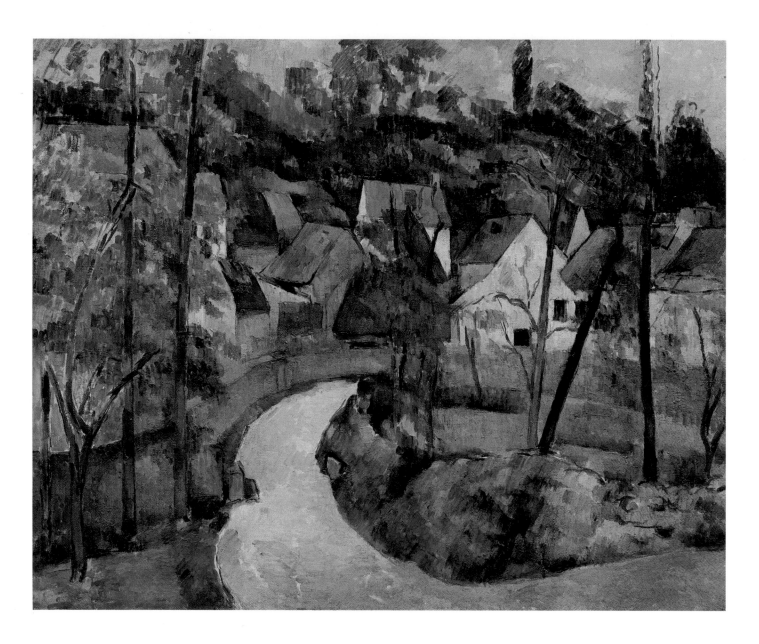

PAUL CÉZANNE
(French, 1839–1906)

Turn in the Road. 1879–82
Oil on canvas. 23⅞ × 28⅞ in.
Bequest of John T. Spaulding. 48.525

The site of this work has recently been identified as the village of Valhermay, situated in the hills along the Oise River nearly halfway between Pontoise and Auvers. Cézanne and his close friend and colleague Camille Pissarro painted many landscapes in this and the surrounding villages around 1879–82. Apparently the picturesque dwellings with curving, unpaved roads appealed to both artists' sense of rural beauty.

For Cézanne, the scene inspired a characteristic pictorial struggle between the contending values of two-dimensional design and spatial depth; the road sweeps into the painting, bending behind a tree, then disappearing, compressed, as it were, by the surface of the picture plane. Thus, while the viewer stands on the edge of the village, he is denied access to the landscape. The road is not only a metaphor for the paradox of Cézanne's analytical detachment from his subject matter but also the straightest route to the formal dilemmas of twentieth-century painting. Another great Impressionist forerunner of modern art, Claude Monet, was the first owner of *Turn in the Road*.

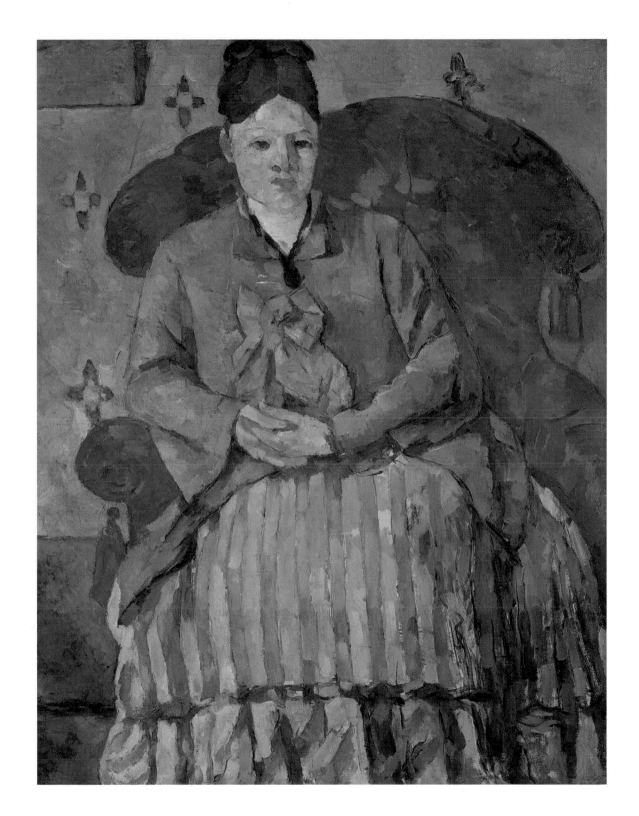

PAUL CÉZANNE
(French, 1839–1906)

Madame Cézanne in a Red Armchair. 1877
Oil on canvas, 28½ × 22 in.
Bequest of Robert Treat Paine, 2nd. 44.776

More than two dozen portraits by Cézanne exist of Marie-Hortense Figuet, with whom he was living by 1870 but only married in 1886. Although the dating of Cézanne's work is difficult, this painting can be firmly dated on the basis of its style and the appearance in the background of the gold and blue wallpaper that decorated the Parisian apartment that the couple occupied in 1877, at 67 rue de l'Ouest; thus, contrary to the painting's title, the sitter was not yet officially Madame Cézanne.

Cézanne's wife did not share much in her husband's public life; he once said scornfully of her superficial enthusiasms, "My wife likes only Switzerland and lemonade." Nonetheless, like so many of Cézanne's portraits of his wife, this work achieves a classical repose and monumentality. Her generous, Buddha-like form is as much deposited as constructed. One sympathetic critic in 1877 evoked Western metaphors: "M. Cézanne is . . . a Greek of the great period, his canvases have the calm and heroic serenity of the paintings and terra cottas of antiquity, and the ignorant who laugh [at his works] impress me like barbarians criticizing the Parthenon." Yet for all his emphasis on structure, Cézanne achieves brilliant effects of design. The emphatic, faceted stripes of Madame Cézanne's dress are offset by the comfortable abundance of her armchair.

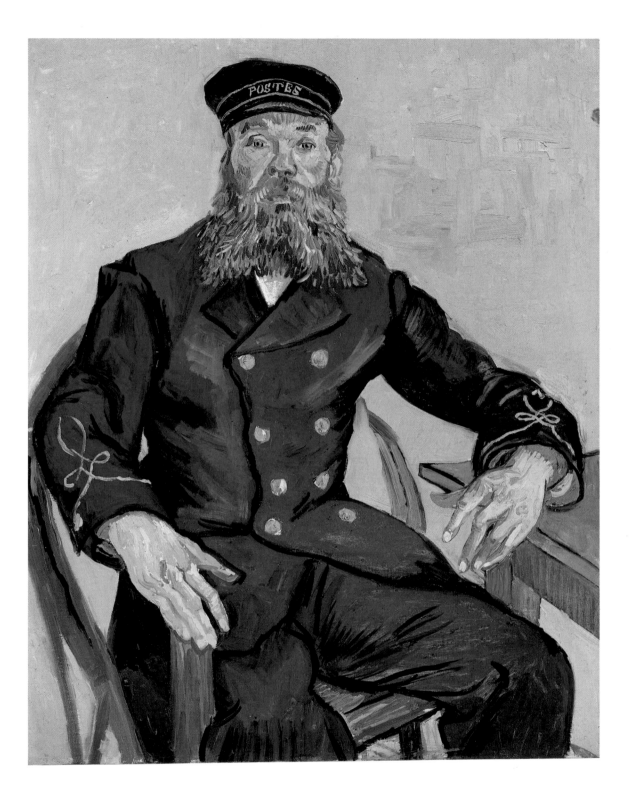

Vincent van Gogh left Paris in 1888 to travel south to Arles, a provincial town at the head of the Rhône delta that had been recommended to him by Toulouse-Lautrec. There he sought the warmth and sun of the *Midi*, while vainly hoping to establish a brotherhood of artists. Though ill and on the verge of penury, he worked incessantly, painting landscapes, still lifes, figure paintings, and portraits. In the absence of artistic colleagues, one of his closest friends and favorite sitters was the local postman, Joseph Roulin.

While painting this work in August of 1888, Van Gogh wrote to his brother, "I am now at work with another model, a postman in a blue uniform, trimmed with gold, a big bearded face, very like Socrates." Indeed the modest postman has all the authority of an admiral. Van Gogh expressed gratitude that his friend had posed for free but allowed that he had probably cost him more in food and drink than he would have spent on modeling fees. "My friend the postman . . . lives a great deal in cafés and is certainly more or less a drinker. . . . But he is so much the reverse of a sot, he is so natural, so intelligent in excitement, and he argues with such sweep in the style of Garibaldi." For the Dutchman Van Gogh, Roulin was a sort of spiritual countryman "straight from the old Dutch," and, indeed, his painting recalls the style of the seventeenth-century Dutch portraitist Frans Hals. Van Gogh also painted the postman's wife, teenage son, child, and baby, delighting in the opportunity to portray "a whole family." More than mere likenesses, portraiture for Van Gogh, like his Dutch forebears, asserted the sanctity of recorded fact, that "great, simple thing: the painting of humanity, or rather, of a whole republic, by the simple means of portraiture."

VINCENT VAN GOGH
(Dutch [worked in France], 1853–1890)

Houses at Auvers. 1890
Oil on canvas, 29¾ × 24⅜ in.
Bequest of John T. Spaulding. 48.549

In 1889, after attacks of mental illness, Vincent van Gogh committed himself to an asylum in Saint-Rémy near Arles, but in May of the following year he left the hospital against his doctor's objections and moved to Auvers-sur-Oise, northwest of Paris. There he entered the care of Dr. Gachet, an eccentric physician and art lover befriended by Van Gogh's colleagues Pissarro and Cézanne years before. *Houses at Auvers* offers a fairly accurate depiction of a view from a street not far from Dr. Gachet's house. The tiled roofs form a dazzling quilt of color. Van Gogh wrote to his brother Theo from Auvers of the town's beauty: "I find the modern villas and middle-class country houses almost as pretty as the old thatched cottages that are falling into ruin." In his brief Auvers period, Van Gogh painted prodigiously with a heightened, almost shrill palette of pure unmixed hues, his brushwork a fluid impasto.

As with many of his relationships in these last years, Van Gogh soon had a falling out with Dr. Gachet, and on a painting excursion in late July of 1890, scarcely two months after his arrival in Auvers, he shot himself, dying two days later at the age of thirty-seven. Far from being a stimulus to Van Gogh's art, as is sometimes suggested in romantic biographies, his madness was only a disruption to his work and a source of great pain and sorrow. The achievement of Van Gogh's art grows coherently out of what went before; in turn, it had a lasting impact on twentieth-century art, first in the creation of the coloristically brilliant style Fauvism and subsequently in various expressionist movements.

81

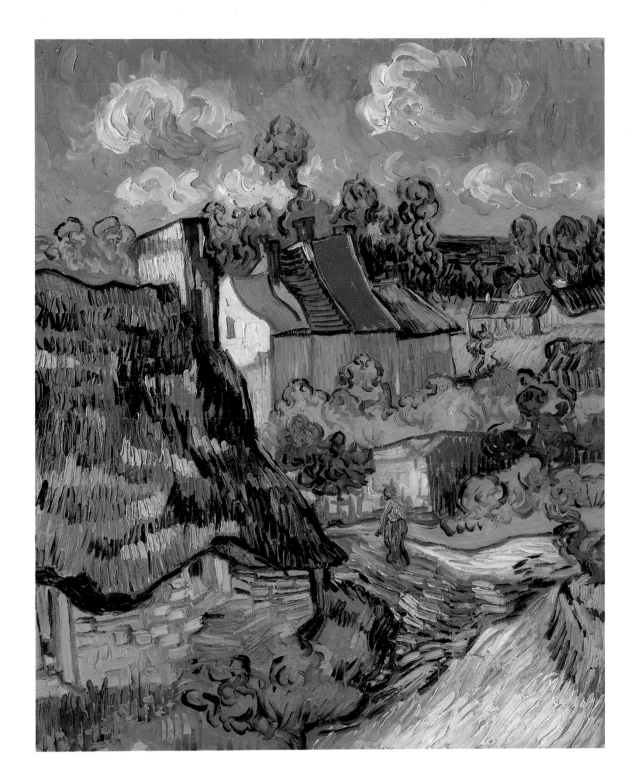

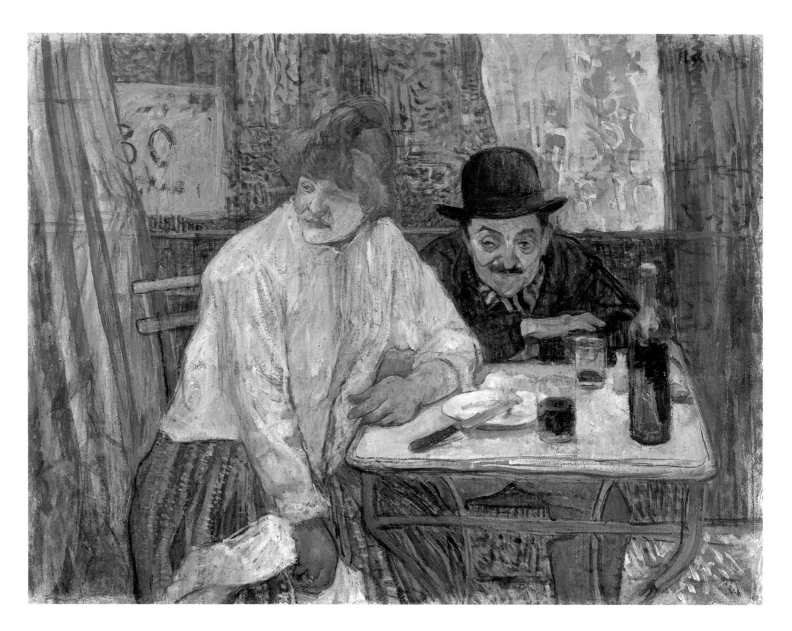

HENRI RAYMOND DE TOULOUSE-LAUTREC-
 MONFA
(French, 1864–1901)

At the Café La Mie. 1891
Watercolor and gouache on paper mounted on millboard
 mounted on panel, 20⅞ × 26¼ in.
S. A. Denio Collection and General Income. 40.748

The son of French nobility, Henri de Tou-
louse-Lautrec was left a dwarf by an early acci-
dent, which precluded the sporting life he
might otherwise have pursued. He turned in-
stead to art and became an assured draftsman
in the tradition of Degas. Toulouse-Lautrec
shared the latter's delight in acute social ob-
servation, but developed a more calligraphic

style which was at once less restrained and
more decorative than Degas's tensile manner.
As did earlier works by such artists as Dau-
mier, Degas, and Jean-François Raffaelli, this
work depicts a derelict couple in a café, in this
case supposedly a small tavern known as La
Mie in the suburbs of Paris. The work's under-
tone of narrative drama is unusual for Tou-
louse-Lautrec, who, though a great observer
of gesture and expression, usually maintained
greater emotional detachment from his sub-
jects. The sodden expression of the drinker in
the derby and the blind stupor of the redhead
in the filthy smock could be taken for social
commentary if it were not for the work's ex-

ceptional nature in Toulouse-Lautrec's oeuvre.

 This vague sense of drama may reflect the
work's origins: it was based on a photograph of
his close friend Maurice Guibert (a champagne
salesman, renowned *roué*, and the first owner
of *A la Mie*) and a professional model. A prac-
tice he favored from the late 1880s onward, the
use of photography as an aid to composition
was always subsumed in the final product. In-
deed nothing in this splendidly free image sug-
gests the mechanized intercession of the
camera. A late entry to the 1891 Salon des In-
dépendents, this work apparently was one that
Toulouse-Lautrec sent fresh from the easel,
impatient to set it before the public.

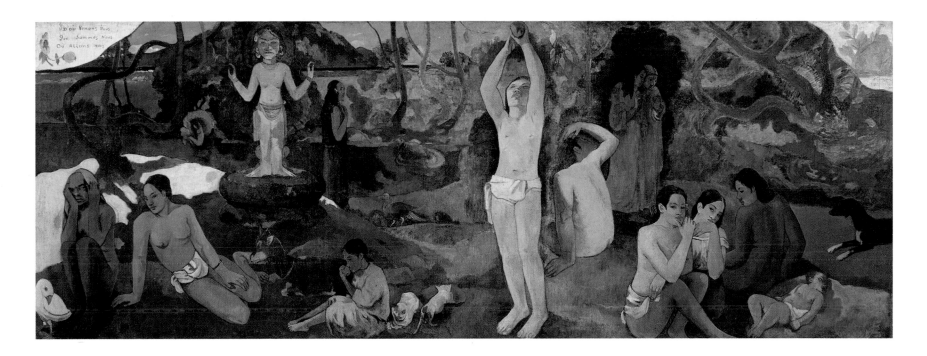

PAUL GAUGUIN
(French, 1848–1903)

Where Do We Come From? What Are We? Where Are We Going? (D'où venons-nous? Que sommes-nous? Où allons-nous?). 1897
Oil on canvas, 54¾ × 147½ in.
Tompkins Collection. 36.270

With its momentary light and color and fleeting themes of modernity, Impressionism had inherent limits; to many it seemed an impermanent art, one that lacked form and substance. The Post-Impressionists variously sought more timeless themes and styles. Convinced that a more universal permanence resided in myth and legend, Paul Gauguin wedded Western classicism and native art forms of a type patronizingly known today as "primitive" art. He considered this painting the culmination of his career and the summation of his ideas—indeed his last will and testament, since he attempted suicide by drinking arsenic soon after its completion.

Born in Paris the son of a journalist, Gauguin worked as a banker before turning to art in his late twenties. Increasingly restive, he traveled first to Panama and Martinique and then in 1891 to the South Pacific, where he executed this enormous painting in Tahiti.

Gauguin's letters suggest that it is to be read from right to left. While its precise meaning is much debated, the painting's three major figure groups signify the questions posed in the title: on the right, a group of three women and a child are the beginning of life (*D'où venons-nous?*); the central group symbolizes daily existence, the figure picking fruit recalling the familiar Christian symbol of man's search for the meaning of life (*Que sommes-nous?*); the final group embodies man's tragic fate (*Où allons-nous?*)—"an old woman approaching death appears reconciled and resigned to her thoughts"; at her feet, "a strange white bird . . . represents the futility of words." This entire elaborate symbolic program is united by Gauguin's friezelike design and smoldering palette of deep, saturate hues.

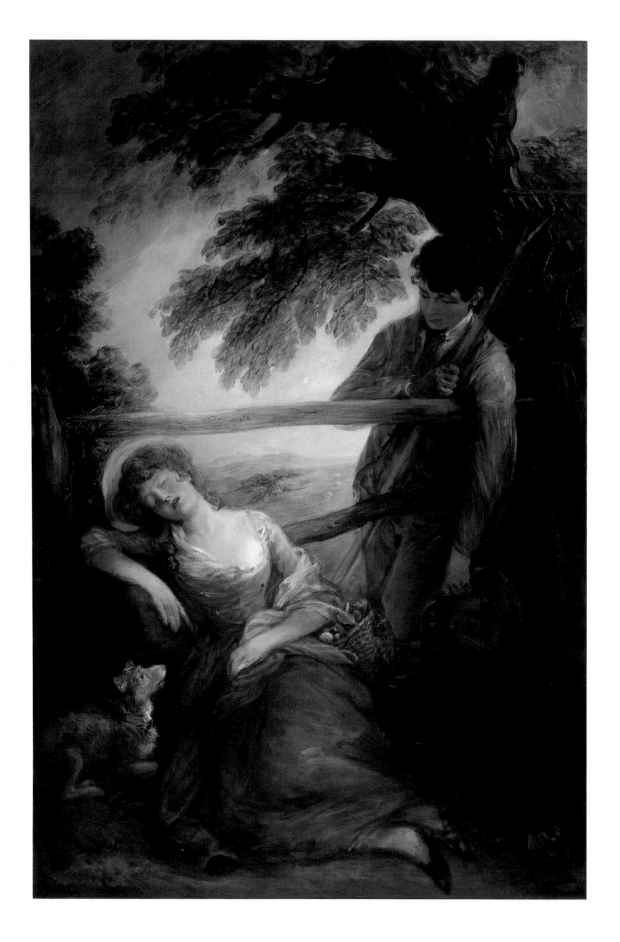

THOMAS GAINSBOROUGH
(British, 1727–1788)

Haymaker and Sleeping Girl (Mushroom Girl).
ca. 1785
Oil on canvas, 89½ × 59 in.
M. Theresa B. Hopkins Fund and Seth K. Sweetser Fund.
53.2553

Thomas Gainsborough made his living as a portraitist, first in rural Suffolk in the 1750s, then in the more fashionable milieu of Bath, and eventually in London after 1774. But his real love was landscape painting, which is evident from the backgrounds of his portraits, and which he combined with figure painting in his late so-called fancy pieces. In these pastoral depictions, the rural poor are treated with the same seriousness as the sitters in his commissioned portraits.

The *Haymaker and Sleeping Girl* is one of Gainsborough's last fancy pictures. It was painted about 1785, in the sketchy, unfinished style of which Reynolds, his contemporary, disapproved.

The subject matter of a boy enraptured by a sleeping peasant girl whom he has come across at the edge of a field, her basket of mushrooms and a terrier by her side, suggests the story of Cymon and Iphegenia. The visual sources on which Gainsborough drew were the works of such Italian and Flemish Old Masters as Correggio and Rubens, especially in the figure of the girl, whose pose recalls earlier depictions of the sleeping Venus. The fluid brushwork and glowing, soft, warm colors of this bucolic painting remind one of the works of Gainsborough's French contemporary Boucher. It is one of the finest expressions of the Rococo in English eighteenth-century art.

SIR THOMAS LAWRENCE
(British, 1769–1830)

William Lock of Norbury. 1790
Oil on canvas, 30 × 25⅛ in.
Gift of Denman W. Ross as a Memorial to Charles G. Loring.
02.514

The leading portraitist in England of the generation after Joshua Reynolds and Thomas Gainsborough, Lawrence at an early age gained a reputation for his flamboyant paintings of members of fashionable London society and their children. By 1790, the year *William Lock* was painted, Lawrence had already obtained a royal commission to paint the portrait of Queen Charlotte, although he was only twenty-one.

Not only were Lawrence's portraits proof of his skill as a draftsman and manipulator of paint, they also revealed his ability to capture the character of his sitters. His paintings, in his own words, took on a "living, personal existence." The less formal studies of his friends, actors, and connoisseurs are especially sympathetic. *William Lock* is a brilliant, unfinished work which by tradition was painted in a single sitting. The sitter apparently was so pleased with the result that he immediately removed the painting from Lawrence's studio, although pentimenti around the head and shoulders are visible, and the languid right hand is only sketched in with underpainting. The palette is limited to white, gray, and black, relieved only by the warmth of the flesh tones. The sympathetic nature and fragile health of Lock, who was one of Lawrence's first patrons, are sensitively suggested in this portrait.

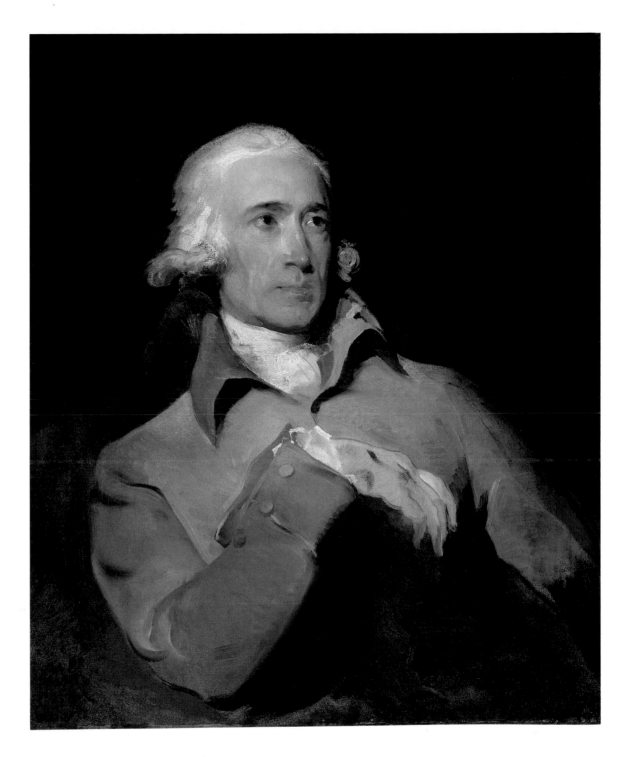

85

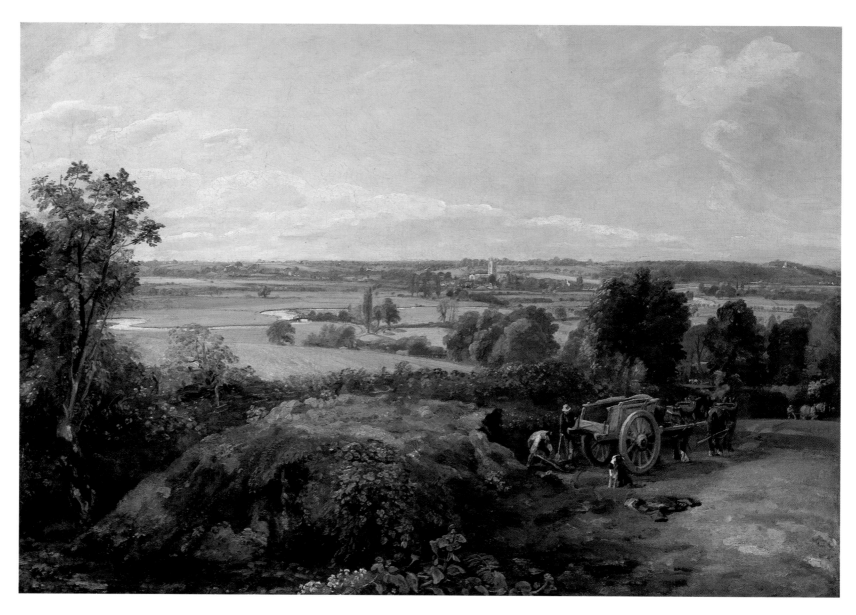

JOHN CONSTABLE
(British, 1776–1837)

Stour Valley and Dedham Church. 1814
Oil on canvas, 21⅞ × 30⅝ in.
Warren Collection. 48.266

The *Stour Valley and Dedham Church* is one of a long series of vignettes Constable painted of the East Anglian countryside around Dedham and East Bergholt in Suffolk. From the very beginning of his career in 1800 until 1828, when the large, upright *Dedham Vale* was exhibited at the Royal Academy, the artist recorded in detailed drawings and oil paintings the topography and agricultural activities of his native region.

This painting was commissioned by Thomas Fitzhugh as a wedding present for his bride, Philadelphia Godfrey, so that she would have a memento of the countryside once she had moved to London. It is an accurate description of the view of the Stour Valley and Dedham Village as seen from her home, the Old Hall estate in East Bergholt. Letters and dated sketchbooks record that Constable began the painting in September 1814 and suggest that he was actually painting on this canvas outdoors, as well as making drawings and sketches of details of the composition directly from nature.

Based on the classic formula of Claude Lor-raine's landscapes, which Constable admired and copied, the painting is not only a topographical description of a view, but a great agricultural landscape. Constable here commemorated the farming activities of autumn, when the fields are plowed and fertilized (from the dunghill in the foreground) in preparation for the next year's crops.

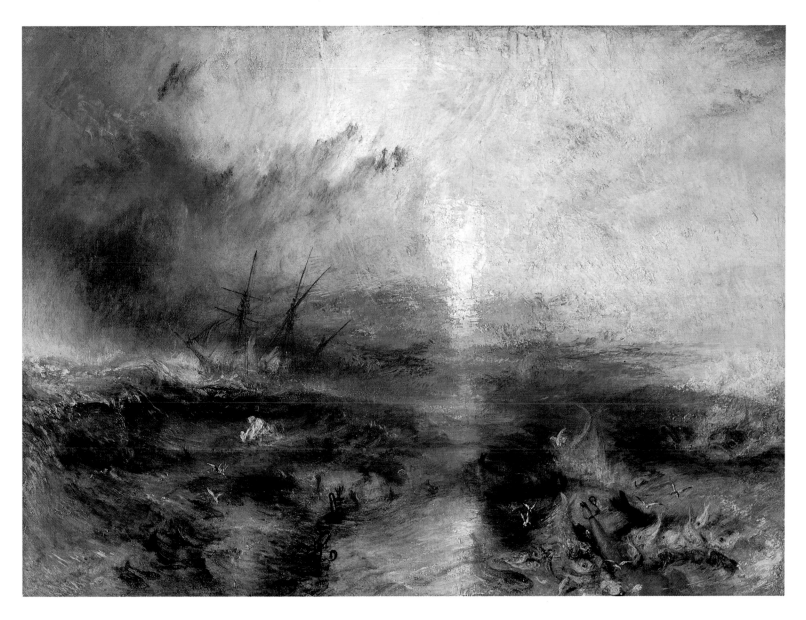

JOSEPH MALLORD WILLIAM TURNER
(British, 1775–1851)

Slave Ship (Slavers Throwing Overboard the Dead and Dying, Typhon Coming On). 1840
Oil on canvas, 35¾ × 48¼ in.
Henry Lillie Pierce Fund. 99.22

Probably the most celebrated painting by the brilliant romantic landscapist J. M. W. Turner outside Britain, the *Slave Ship* was owned first by John Ruskin, the English art critic, who considered it "the noblest sea ever painted by man." Eventually, feeling that the subject matter had become too painful for him to bear and that America was the proper home for such a painting, he sold it to a New York collector. By 1876 the painting was in a Boston collection; it was bought by the Museum in 1899.

The painting is a synthesis of two ideas: Turner used as a source the description of a slave ship caught in a typhoon in "Summer," part of Thompson's long poem *The Seasons*, combining this with the true story of the slave ship *Zong*, whose captain in 1783 had thrown overboard dying slaves infected by an epidemic, so that he could collect insurance on them by claiming they had drowned at sea.

When the *Slave Ship* was exhibited at the Royal Academy in 1840 soon after it was painted, however, the work was ridiculed by most critics. This sentiment apparently followed it across the Atlantic, for Mark Twain recorded in 1880 a Boston critic's description of the painting as "a tortoise-shell cat having a fit in a platter of tomatoes." Today the painting is admired as one of the greatest examples of Turner's late sublime style. The turmoil of the churning sea filled with limbs, fish, and chains and the threat of approaching storm clouds are emphasized by Turner's use of vivid oranges, yellows, reds, and blues, drawn into a vortex toward the setting sun.

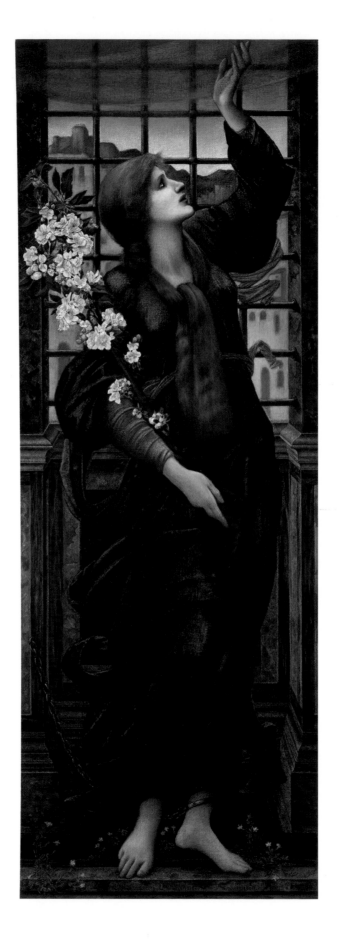

Sir Edward Coley Burne-Jones
(British, 1833–1898)

Hope. Finished 1896
Oil on canvas, 70½ × 25 in.
Given in Memory of Mrs. George Marston Whitin by her four
daughters, Mrs. Laurence Murray Keeler, Mrs. Sydney Rus-
sell Mason, Mrs. Elijah Kent Swift, and Mrs. William Carey
Crane. 40.778

A disciple of Dante Gabriel Rossetti, Edward Burne-Jones carried on the Pre-Raphaelite tradition well into the late decades of the nineteenth century, drawing on the cult of medievalism and the romance of an imaginary past that characterized the circle's work. Many of Burne-Jones's designs, including this figure of *Hope*, were translated successfully into cartoons for the stained glass windows and textiles produced by his close friend William Morris.

Commissioned directly from the artist by Mrs. Whitin of Whitinsville, Massachusetts (who was also a patron of John Singer Sargent), *Hope* is one of the last of the aging Burne-Jones's large paintings, and was in fact finished in 1896 with the help of his studio assistant, T. M. Rooke. It is a reworking of a large watercolor version of the same subject Burne-Jones had painted in 1871.

The shackled figure of the woman, standing in a nichelike cell and holding a symbol of hope in the form of a branch of apple blossom, reaches up to pull down the blue cloud of sky, a promise from heaven. Reflecting Burne-Jones's professed preference for works by painters of the Florentine Quattrocento, the figure of *Hope* is strongly influenced by the graceful forms of Botticelli's women.

FREDERICK LORD LEIGHTON
(British, 1830–1896)

Painter's Honeymoon. ca. 1864
Oil on canvas, 32⅞ × 30¼ in.
Charles H. Bayley Picture and Painting Fund. 1981.258

The *Painter's Honeymoon* was probably painted in 1864, when Leighton had finally settled in England after years of study in Italy, Germany, and France. In that year his success as a painter was first acknowledged by his election as an associate of the Royal Academy in London. Later, he was to become president of that institution.

Although stylistically distinct from the work of the Pre-Raphaelite artists (with whom he was nonetheless closely associated), Leighton's theme of lovers was popular with those painters, as was the emulation of the rich color and composition of such sixteenth-century Venetian artists as Palma Vecchio and Lorenzo Lotto. In this painting, where the features of the dark Italianate draftsman contrast with those of his blonde bride, the subject is love expressed through art, just as in Leighton's almost contemporary, highly acclaimed, and popular painting *Golden Hours* love is expressed through music. The woman's folded and crumpled dress is one of the earliest examples of Leighton's virtuosity as a drapery painter.

Lost from public view and untraced since 1878, the *Painter's Honeymoon* appeared at auction in London in 1981, discolored by a coat of darkened varnish; subsequent cleaning at the Museum revealed the painting's original glowing, rich colors.

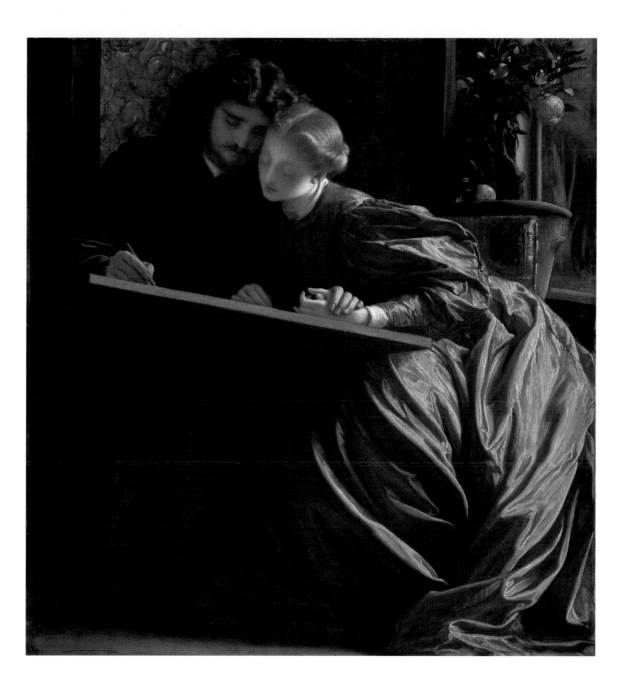

NIELS EMIL SEVERIN HOLM
(Danish, 1823–1863)

*View of the Straits of Messina from a Country
House.* 1859
Oil on canvas, 32½ × 51½ in.
Tompkins Collection and Gift of John Goelet. 1980.209

The early nineteenth century in Denmark saw
a brief but intense flowering of artistic talent
that has come to be called the Danish Golden
Age of painting. Emil Holm trained initially in
his hometown of Aarhus, and then at the Roy-
al Academy in Copenhagen. Lured by the light
of the Mediterranean, like many Northern art-
ists before him, Holm visited Southern Italy in
1857 and 1863, staying mostly in Sicily.

This painting offers a panoramic view from
the terrace of a country house north of Mes-
sina in Sicily. Beyond the vineyards and olive
groves, and the outlying buildings of Messina
in the middle distance, lie the Straits of Scylla
and Charybdis and part of the shoreline of Ca-
labria on the Italian mainland.

Holm's meticulous technique, where every
leaf is bathed in a clear pure light, has parallels
with the work of his English contemporaries,
the Pre-Raphaelites. Although the scene is un-
peopled, there are hints of earlier activity on
the terrace, which is bathed in deep afternoon
shadow: a child's abandoned toys, the open
books and embroidery on the table, and the

plate of fruit on the balustrade all suggest in-
terrupted pastimes. The pervading stillness
and mysterious, introspective mood of the
scene is characteristic of much Danish nine-
teenth-century art.

American Paintings

JOHN GREENWOOD
(American, 1727–1792)

The Greenwood-Lee Family. ca. 1747
Oil on canvas, 55⅝ × 69¼ in.
Bequest of Henry Lee Shattuck in Memory of the late Morris
 Gray. 1983.34

The Greenwood-Lee Family is an extraordinary document of the aspirations of a young American artist. Greenwood's two predecessors in Boston, the English-trained John Smibert and the American-born Robert Feke, had each produced a great group portrait already well-known in Boston when Greenwood attempted this complex picture, based on their example, about 1747. The twenty-year-old artist showed himself, palette in hand, presiding over the women of his family: his two sisters and mother (seated) at left, his first cousin at center, and directly below him, his fiancée, Elizabeth Lee, coquettishly holding a fan. From Smibert and Feke, Greenwood bor-

rowed the device of grouping his sitters in a shallow space around a cloth-covered table. His method of knitting the figures together with a rhythmic pattern of arms and tilted heads arrayed across the picture surface was his own naive, if charming, invention.

Greenwood enjoyed great popularity as a portrait painter in Boston for another five years, and then traveled to Surinam and Amsterdam, finally settling in London in 1762, where he became a successful art dealer as well as painter. This portrait remained in the artist's family and was given to the Museum by a descendant in 1983.

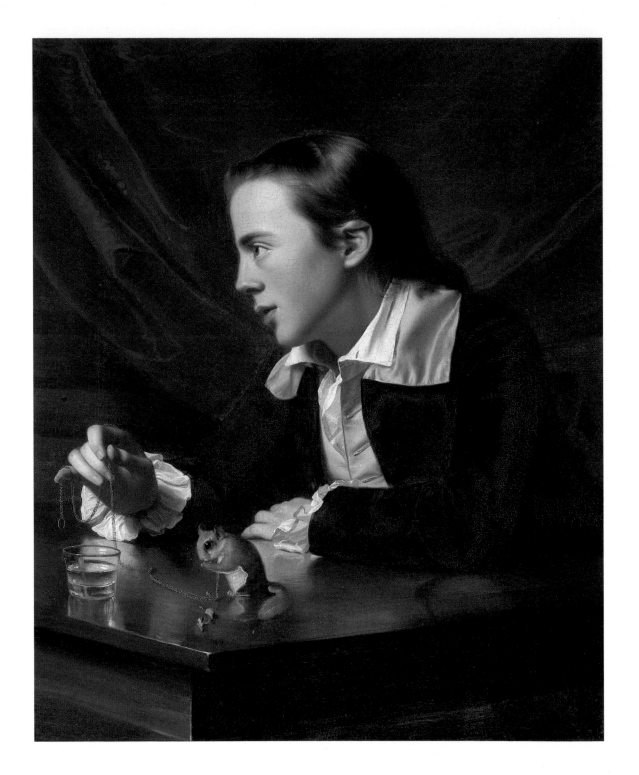

JOHN SINGLETON COPLEY
(American, 1738–1815)

Henry Pelham (Boy with a Squirrel). 1765
Oil on canvas, 30¼ × 25 in.
Anonymous Gift. 1978.297

The first American painter to achieve great artistic and financial success on both sides of the Atlantic, Copley was essentially self-taught. Though the son of humble Irish immigrants, by the eve of the War of Independence he had become a wealthy gentleman with a large, impressive house near to that of John Hancock on Boston's Beacon Hill. Copley was twenty-seven when he painted this portrait of his half-brother Henry Pelham (1749–1806); he made the picture for an exhibition in London, in order to learn how leading English artists such as Joshua Reynolds would rank his talents. *Boy with a Squirrel* was thus a showcase for the artist's great skills—his sensitivity to mood and personality, his gifts as a colorist and composer, and his painstaking attention to detail. The picture's unusual intimacy and its rich evocation of boyhood's innocence and promise are not found among his commissioned portraits, which are usually frontally posed and generally more formal in tone. Although produced at the beginning of Copley's long career, it has always been ranked as one of his finest achievements.

JOHN SINGLETON COPLEY
(American, 1738–1815)

Mrs. Ezekiel Goldthwait. 1771
Oil on canvas, 50⅛ × 40¼ in.
Bequest of John T. Bowen in Memory of Eliza M. Bowen. 41.84

Copley's Boston sitters included a broad spectrum of types—members of the merchant aristocracy, clergymen, lawyers, and such important figures in the revolutionary war as Paul Revere and Samuel Adams (his portraits of the latter two are now at the Museum of Fine Arts, Boston). Elizabeth Lewis Goldthwait (1715–1794) possesses the look of prosperity and dignity typically favored by such Bostonians, but her portrait is also one of the finest examples of the last, most fully evolved style practiced by the artist in Boston. At this point in his career he turned increasingly to dark tonalities and classically simple compositions. As befits the wife of a city official—Boston's registrar of deeds—Mrs. Goldthwait is presented against a dark, imposing background with columns. Her clothes and upholstered chair follow the latest rococo fashion, but their colors are more subdued and subtle than those found in Copley's earlier portraits of younger women. The sitter's simple gesture of reaching toward an ample dish of fruit was probably intended as an emblem of her fertility, for she bore thirteen children (five of whom lived to adulthood). In Copley's pendant portrait (*Ezekiel Goldthwait*, 1771, Museum of Fine Arts, Boston) the husband turns away from his writing with an equally kind smile for the viewer, holding a quill in one hand and a letter in the other. Together these works express the sober, commanding, and virtuous tone that has characterized a large segment of Boston society from colonial days.

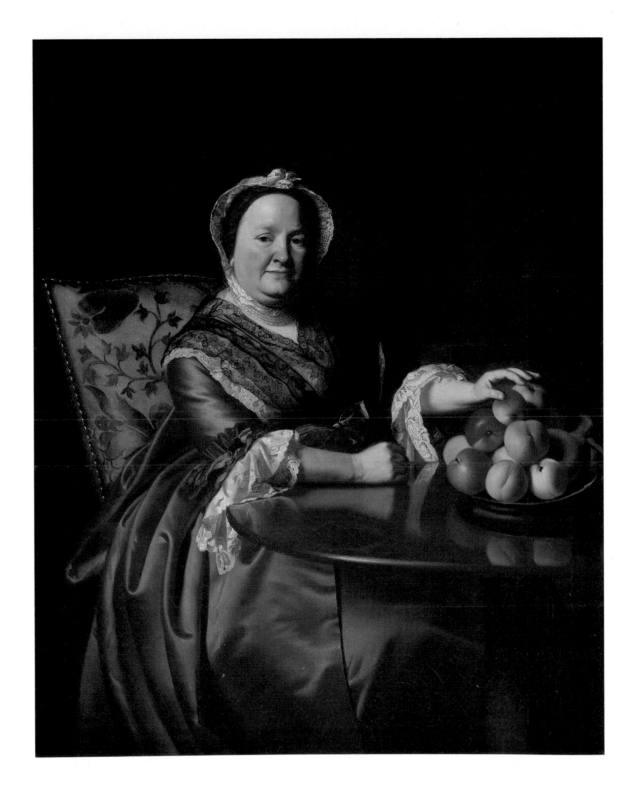

95

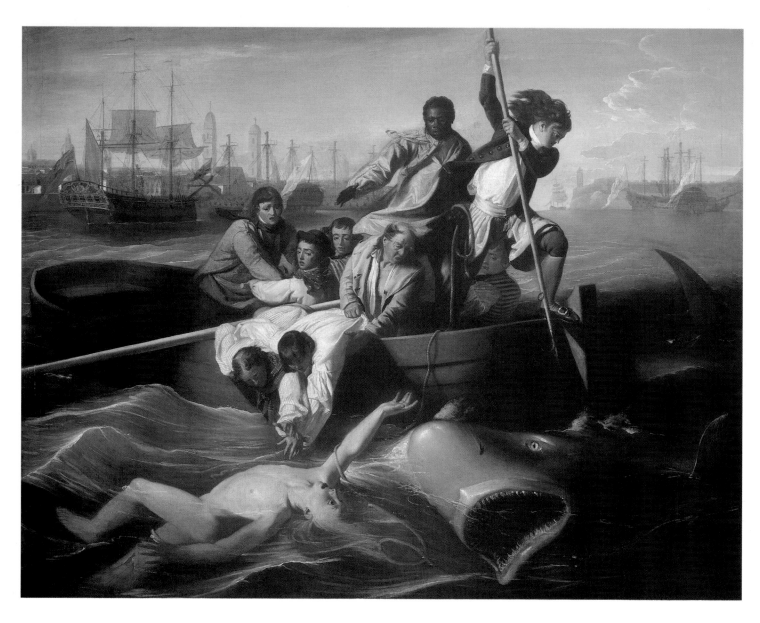

JOHN SINGLETON COPLEY
(American, 1738–1815)

Watson and the Shark. 1778
Oil on canvas, 72 × 90½ in.
Gift of Mrs. George von Lengerke Meyer. 89.481

"History painting"—the application of the grand manner of the Old Masters to events of moral and epic significance—became Copley's principal pursuit when he and his family settled in London in 1775. During his years in Boston he had regretted that the portrait was the only form of art with which he could make a living, but now he found he could devote himself to this more elevated art form. *Watson and the Shark* depicts an occurrence in Havana harbor in 1749 when a young Englishman was attacked by a shark while bathing; although he lost one leg, he later prospered as a merchant. Copley's re-creation of the event (which he did not witness) was formally indebted to the works of Raphael and Rubens, which he immediately studied on his arrival in Europe. This picture was particularly exciting to his new London audience since it captured all the violent emotions traditionally associated with mythic tales of life and death but placed them in a modern drama. Furthermore, the magnificent head of the black man, featured at the apex of Copley's composition, significantly enhanced the exotic American setting of the work.

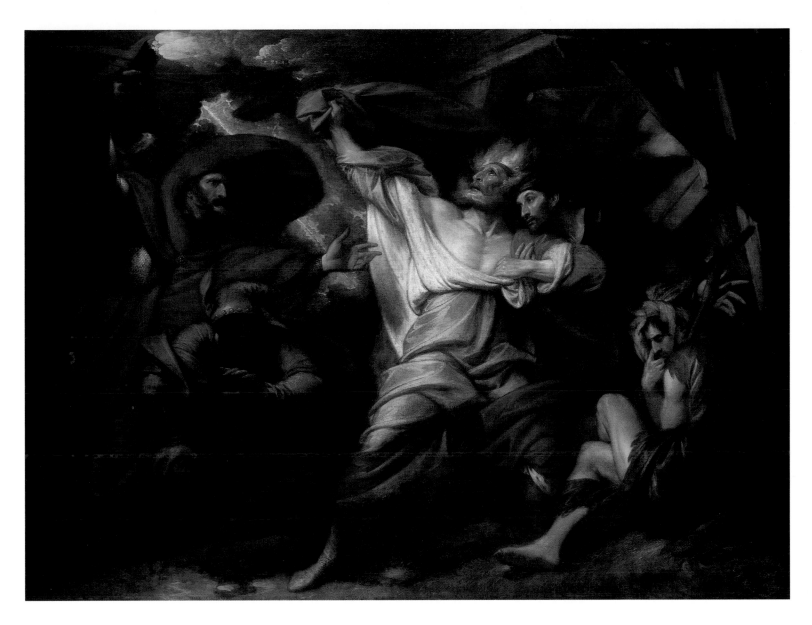

BENJAMIN WEST
(American, 1738–1820)

King Lear. 1788
Oil on canvas, 107 × 144 in.
Henry H. and Zoë Oliver Sherman Fund. 1979.476

Benjamin West was the son of a Pennsylvania innkeeper who left his native soil to win renown in Europe. Subsequently, the expatriate American artist was appointed history painter to King George III and served as president of the Royal Academy for twenty-eight years, until his death in 1820. West was the first American to study the art of the Renaissance, classical antiquity, and neoclassicism in Italy; traces of these influences persist in the master-piece *King Lear*, even as its theatrical lighting and unrestrained emotional verve anticipate nineteenth-century Romantic art. Commissioned for the establishment of Alderman J. J. Boydell's Shakespeare Gallery at Pall Mall in London in 1786, the painting illustrates act 3, scene 4 of the Elizabethan tragedy. A frenzied sovereign, his pose recalling the classical *Laocoön* statue, appears to tear off his flowing robes and cloak while supported by Kent. A mad, partially clothed Edgar, reminiscent of Michelangelo's *ignudi* of the Sistine Chapel ceiling, crouches at Lear's right, as the Fool squats to his left, formally establishing a pyramid structure in which Lear's brow becomes the pinnacle. At far left is Gloucester; his torch spotlights the old king, who pathetically curses both the tumult and his ungrateful daughters.

Two years after Boydell's death, the paintings amassed by the Shakespeare Gallery were auctioned; the Boston Athenaeum acquired *King Lear* in 1828. A turning point in West's oeuvre, a break from classical restraint for his late dramatic style, *King Lear* was one of very few works by West to have been located in this country shortly after his death, when West exerted a major influence upon artists working in this genre. The painting was placed on permanent loan to the Museum of Fine Arts in 1876 before it was accessioned in 1979.

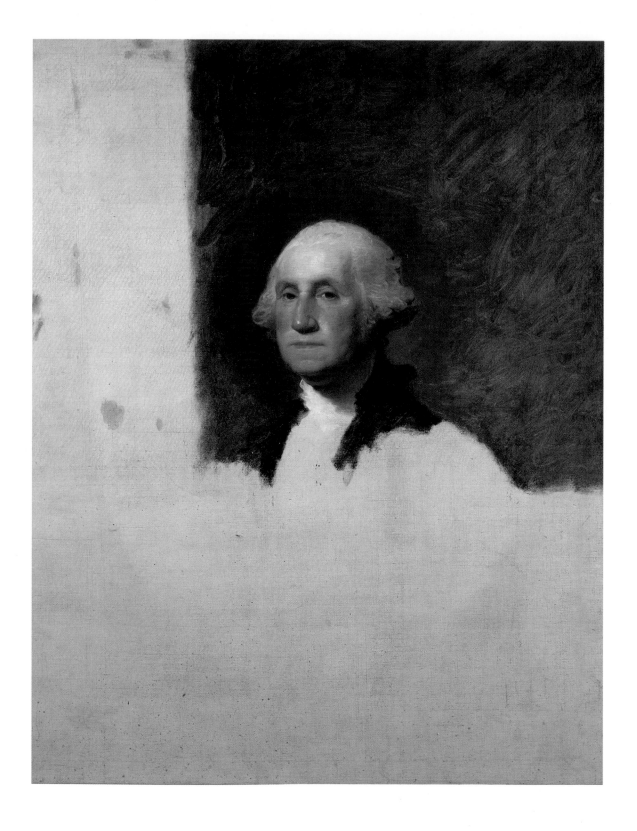

GILBERT STUART
(American, 1755–1828)

George Washington. 1796
Oil on canvas, 48 × 37 in.
Jointly owned by the Museum of Fine Arts, Boston, and National Portrait Gallery, Washington, D.C. 1980.1

After studying with Benjamin West in London, Gilbert Stuart established himself as a portraitist in the tradition of the English masters Joshua Reynolds and George Romney. He returned to the United States in 1792 and worked in New York, Philadelphia, and Washington before settling in Boston in 1805. Stuart was America's foremost portrait painter, and his works chronicle the leaders of the new republic.

This painting and a companion, *Martha Washington*, were commissioned by the president's wife the year before Washington retired to his Mount Vernon estate. The works were never delivered; instead, Stuart kept them in his studio and used them as models for the many images of Washington he created in later years—almost sixty copies of this portrait alone. Aside from Stuart's own replicas, the painting was copied many times by other artists; a printed version appears in reverse on the dollar bill. Stuart intended this to be a rectangular portrait, but he completed only the head and quickly sketched in the lace collar, jacket, and dark background; the familiar oval image was created by the painting's elaborate frame. It was the expression and character of his sitters that most interested Stuart, and here he has captured the dignity of an elder statesman. This painting was purchased from the artist's estate in 1831 and presented to the Boston Athenaeum, which loaned it to the Museum of Fine Arts from 1876 to 1979.

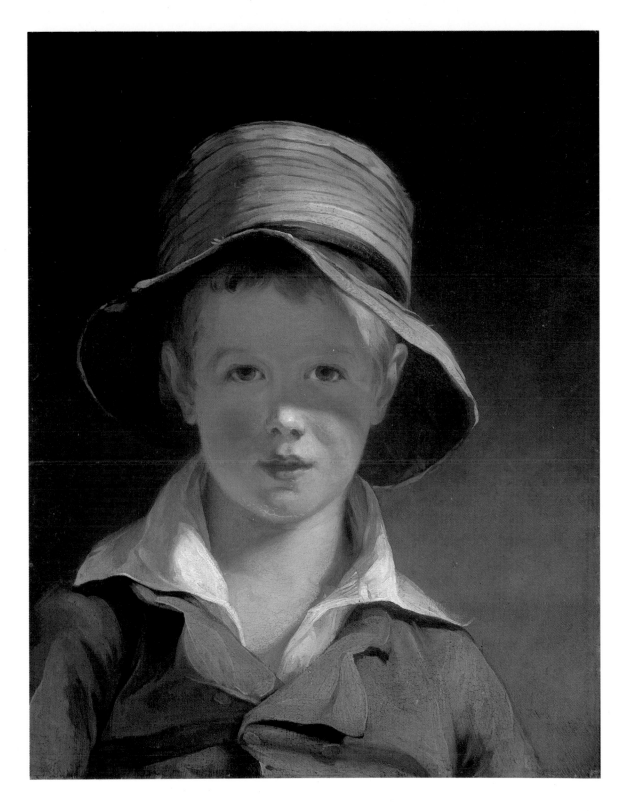

THOMAS SULLY
(American, 1783–1872)

The Torn Hat. 1820
Oil on panel, 19 × 14½ in.
Gift of Miss Belle Greene and Mr. Henry Copley Greene, in
 Memory of their mother, Mary Abby Greene. 16.104

Thomas Sully, the leading portrait painter in Philadelphia in the first half of the nineteenth century, imported the romantic manner from England, where he was trained. He painted his well-to-do sitters with a great deal of bravura and dash, lavishing much painterly attention on their luxurious garments and the elegant objects with which they surrounded themselves. He was particularly adept at painting children, a specialty he appropriated from his British mentor, Thomas Lawrence. In those works, rosy-cheeked children customarily are dressed in frilly clothes and are surrounded by adoring pets and garlands of flowers. Sully avoided such sentimentality, however, in this portrait of his nine-year-old son. Rather than showing him in the fashionable clothes and sumptuous surroundings befitting his own financial success and social position, Sully depicts him as a simple farm boy, in an open white shirt, rumpled jacket, and straw hat with torn brim. The skillful rendering of the child's high color and direct gaze as well as the small-scale, intimate format make this one of Sully's most appealing portraits.

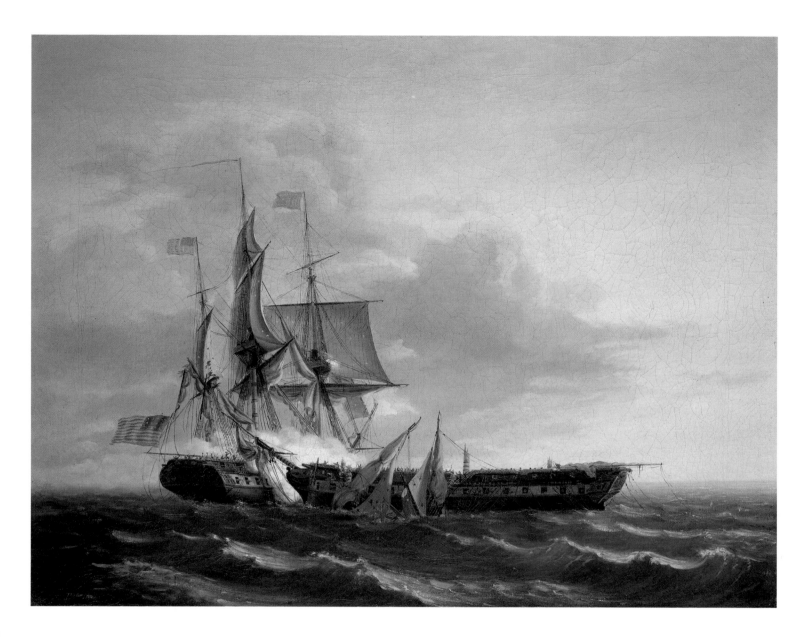

THOMAS BIRCH
(American, 1779–1851)

Engagement Between the "Constitution" and the "Guerriere." 1813
Oil on canvas, 28 × 36 in.
Ernest Wadsworth Longfellow Fund and Emily L. Ainsley
 Fund. 1978.159

In 1794, the British-born painter Thomas Birch emigrated to Philadelphia with his father, whom he later assisted in rendering city scenes before turning to the sea for his subject. The War of 1812 provided Birch the impetus for a spirited series of naval pictures, which made him the founder of the American tradition of marine painting. This is among Birch's most famous paintings. It documents the destruction of the British frigate *Guerriere* by the American *Constitution* on August 19, 1812. The *Constitution*, which came to be known as "Old Ironsides," pounds the British foe at close range from the left.

In depicting the first great American naval victory of the war, the painting displays the power of superior positioning: the American vessel unleashes a full line of cannon volleys upon a British ship which cannot maneuver to fully engage its target. Birch shows tiny American figures brandishing rapiers confidently; gunners spray the clustered British to advantage from a crow's nest as the last British mast falls under the onslaught. American flags flap triumphantly in the wind; a British one sinks in defeat before the indifferent roll of cresting swells.

A tightly organized painting, the medium is sparingly employed to factually record the event, but the tones are soft and modulated. The palette is a range of neutral blues, grays, and greens, with notes of ocher along the frigate apparatus and pinks that illumine sky against a grisaille of clouds. Birch encourages an identification with the American ship. By pointing the British cannon directly at the viewer, he subtly undermines viewer sympathy for the ill-fated *Guerriere*.

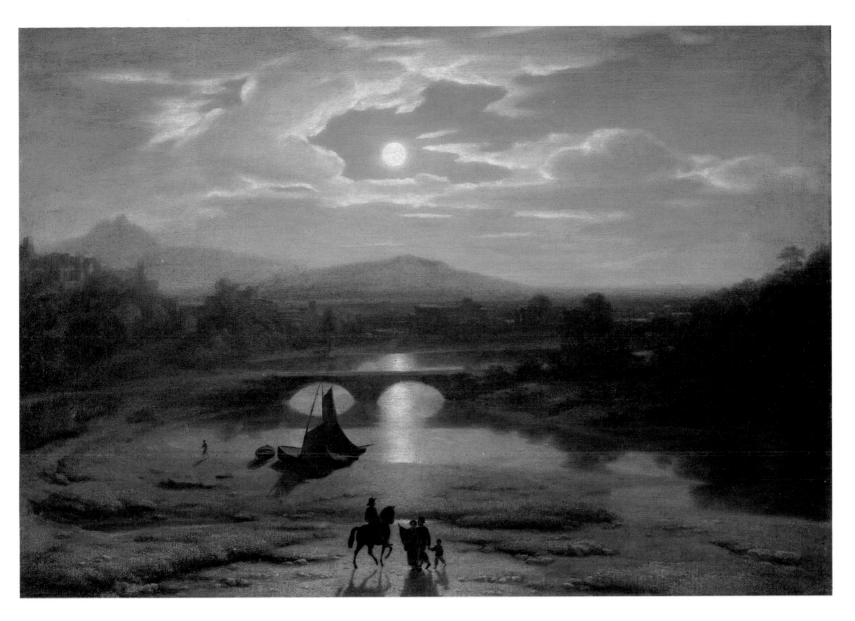

WASHINGTON ALLSTON
(American, 1779–1843)

Moonlit Landscape. 1819
Oil on canvas, 24 × 35 in.
Gift of William Sturgis Bigelow. 21.1429

Moonlit Landscape was painted shortly after Allston returned to Boston from Europe, where he had lived for seven years. While in London and Rome, he had immersed himself in the romantic painting tradition as practiced by J. M. W. Turner and others and became adept at the kind of landscape—with classically balanced forms, Arcadian settings, soft light, and warm atmosphere—first practiced by such seventeenth-century masters as Claude Lorrain and Gaspard Poussin and eagerly revived by the romantic generation. It was this rich, many-layered tradition that Allston, Boston's first and greatest romantic painter, brought to America.

The romantic imagery of *Moonlit Landscape* was unusual for American art of the time. The landscape is not an American view or any specific site, but rather is generally reminiscent of Allston's beloved Italy. The moonlight creates a mood of reverie, the bridge at the picture's center was universally understood in the romantic era as a symbol of transition, and the mysterious pilgrims in the foreground, with the empty boat beyond, are also suggestive of travel, of change, of movement from one world to another. *Moonlit Landscape* was a poetic, personal work, reflecting Allston's feelings on departing from Europe. The somber mood mirrors his sorrow at leaving that rich culture; the symbols of transition express his hope of bringing the European artistic tradition to America.

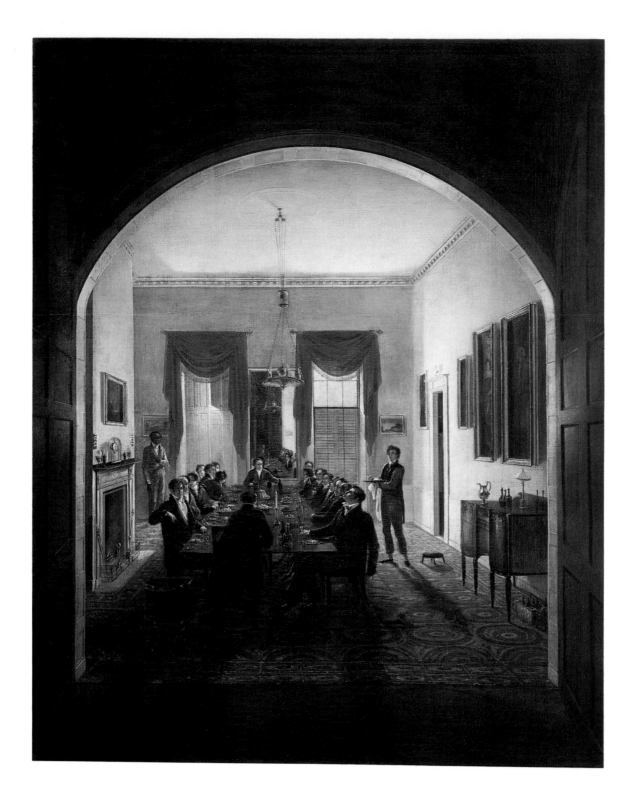

HENRY SARGENT
(American, 1770–1845)

The Dinner Party. ca. 1821
Oil on canvas, 59½ × 48 in.
Gift of Mrs. Horatio A. Lamb in Memory of Mr. and Mrs.
 Winthrop Sargent. 19.13

The essence of enlightened taste in Federal Boston is captured by this painting of men relaxing at dinner, while dessert is served. The setting may be the home of the artist, which was a neoclassical building in Boston's Tontine Crescent (elegant row houses built in 1793 by local architect Charles Bulfinch, but long since destroyed). The formality and clear, simple line of neoclassical style are as evident in Sargent's composition as they are in the fine objects and drapes that decorate the interior. It is thought that the occasion depicted is a gathering of the Wednesday Evening Club, a private club for gentlemen whose meetings consisted of dinner and conversation at the homes of different members.

This painting was exhibited in Boston, New York, Philadelphia, Salem, and Baltimore in the 1820s. For the artist, primarily a portraitist, it represented a new kind of subject matter, and for the American public it was an example of a native talent rivaling the similar productions of European artists. At this time it was noted that the dramatically shadowed arch that frames the principal scene had been influenced by a particular painting of an interior by Frenchman Francois Marius Granet, a work that Sargent could have seen exhibited in Boston.

102

JOHN NEAGLE
(American, 1796–1860)

Pat Lyon at the Forge. 1826–27
Oil on canvas, 93 × 68 in.
Henry H. and Zoë Oliver Sherman Fund. 1975.806

John Neagle was one of Philadelphia's leading portrait painters in the early nineteenth century; he was trained to produce works in the elegant, formal manner popularized by Gilbert Stuart. In 1825 the thirty-year-old artist received an important portrait commission from a leading Philadelphia businessman and inventor, Patrick Lyon (1779–1829). Rather than having himself painted in formal attire and posed against swags of drapery and fragments of classical architecture as was customary for men of his social position, Lyon chose to have Neagle represent him at the more plebeian outset of his career.

Lyon began as an ordinary blacksmith, and he is shown here in his shirtsleeves and leather apron, working at his forge with the tools of his trade scattered beside him on the floor. His apprentice stands behind him, and through the window at left is shown the steeple of the Walnut Street jail, where he was imprisoned briefly after having been falsely accused of theft by a group of Philadelphia bankers. Lyon may well have chosen this unconventional characterization as a proud reminder to the Philadelphia gentlemen who once had snubbed him. His artist, Neagle, rose to the challenge: the unusual attributes, grand scale, and opportunity for dramatic contrasts of texture and tone—the richly painted white shirt, bright flames, and the rosy light emanating from the forge—create an unforgettable image of the sitter and a masterpiece of romantic portraiture.

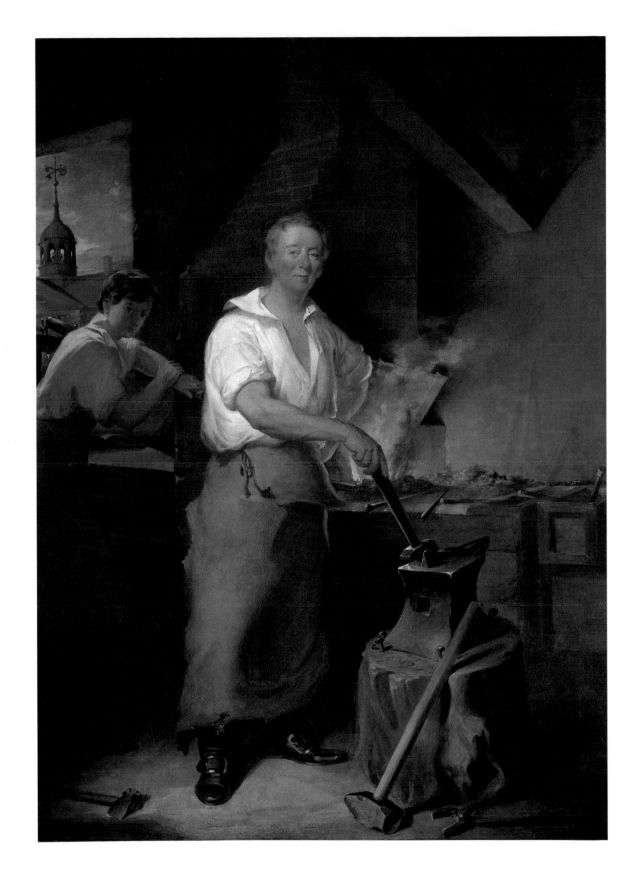

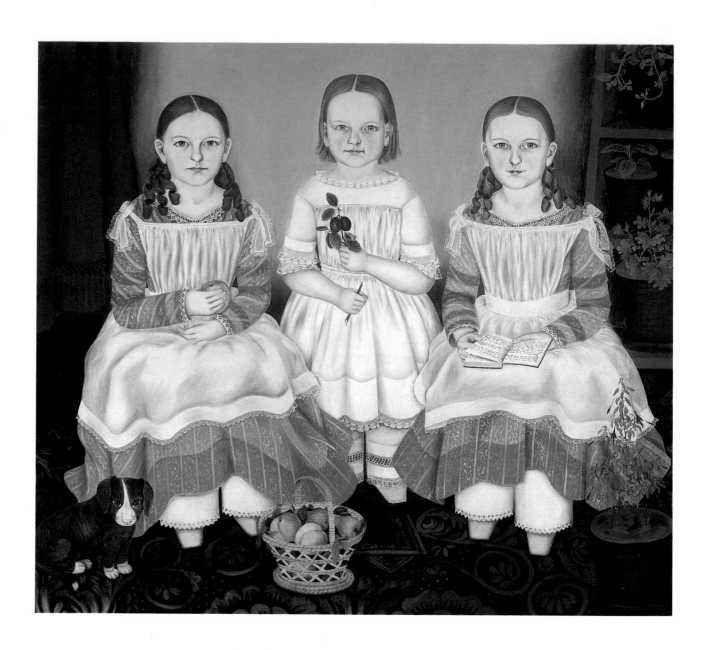

SUSAN C. WATERS
(American, 1823–1900)

The Lincoln Children. 1845
Oil on canvas, 50 × 45 in.
Juliana Cheney Edwards Collection, by exchange. 1981.438

The Lincoln Children was painted by the itinerant and self-trained portraitist Susan C. Waters during a tour of Tioga County (near Binghamton), New York, in 1845. Waters, whose education at the Friendsville (Pennsylvania) Boarding School for Females was the only possible source of her artistic training, began painting portraits in the Binghamton area about 1843, presumably to supplement the income of her ailing husband. Some thirty portraits by Waters are presently known, of which *The Lincoln Children* is the most ambitious. The portrait represents the three young daughters of Dr. and Mrs. Ottis Lincoln of Newark Valley, New York: Laura Eugenie, age nine; Sara, age three; and Augusta, age seven.

Although the props—the plant stand, basket of fruit, and little dog—that add to the charm of this portrait appear in several other of Waters's works of the period, few of those paintings possess the delicate drawing, pleasing color, and skillful rendering of patterns and fabrics that account for the extraordinary quality of *The Lincoln Children.* By the 1860s Waters had abandoned portraiture for humorous paintings of animals; *The Lincoln Children* established a standard of excellence she never again attained.

HENRY F. DARBY
(American, 1829–1897)

Reverend John Atwood and His Family. 1845
Oil on canvas, 72 × 96¼ in.
Gift of Maxim Karolik for the M. and M. Karolik Collection of
American Paintings, 1815–1865. 62.269

The subjects of this unusually large "folk" painting are a Baptist minister, his wife, and their six children, seen during their daily Bible study in the parlor of their home in Concord, New Hampshire. The seriousness of the occasion is evident in the profusion of massive Bibles and reinforced by the Old Testament print and the picture of an urn memorializing a dead son. Nonetheless, the family is clearly comfortably well-off, judging by the colorful furnishings of the room, dominated at the center by an elaborate lamp hung with cut-glass prisms.

Henry F. Darby, the creator of this monumental tribute to religious family life, was an untrained artist—a youth of seventeen—when he spent a summer with the Atwoods working on this portrait. His interest in painting had recently been inspired by watching an itinerant portraitist when he visited Adams, Massachusetts, the small industrial town where Darby grew up. Darby's *Reverend John Atwood* is his only surviving large family picture and an extremely rare example of his untutored genius at work: its imperfections in perspective are amply compensated for by the sheer vigor of execution and uninhibited delight in color emanating from the painted surface. By 1850 Darby had progressed in his artistic ambitions and was working and studying in New York: he achieved his goals, painting more tightly finished, academically conventional portraits, although to modern viewers the latter now seem mediocre and uninspired compared with the unbridled spirit of his emergent career.

THOMAS COLE
(American, 1801–1848)

Expulsion from the Garden of Eden. 1828
Oil on canvas, 38¼ × 53¼ in.
Gift of Mrs. Maxim Karolik for the Karolik Collection of
 American Paintings, 1815–1865. 47.1188

Expulsion from the Garden of Eden is one of a pair of pictures with which Cole, at the age of twenty-seven, established his reputation as one of the most adventurous painters in New York. Exhibited in 1828 at the National Academy of Design with its companion, *Garden of Eden* (now lost), the *Expulsion* was larger in scale than anything Cole had attempted previously, and, in its juxtaposition of a placid and a turbulent landscape in one canvas, it is an audacious and dramatic demonstration of a young artist's compositional skills.

Cole was the first of a whole generation of American painters who, drawing on tenets of the English romantic tradition, found their principal subject in the confrontation of man and nature. Here he tackles a universally known biblical subject and uses pictorial devices (including the arched rock) borrowed from the English romantic painter John Martin. But Cole communicates the emotional impact of the Fall of Man not through the key figures (who are tiny and pushed to the side of the composition) as was traditional; rather, it is the contrast between the sublime grandeur of the tropical paradise from which they have been expelled and the barren, unyielding landscape through which they must now make their way that tells the story.

106

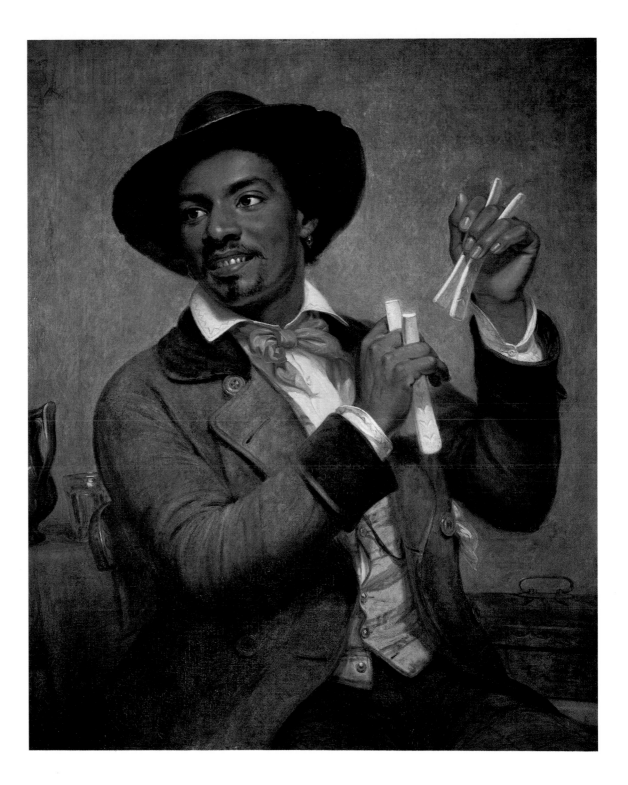

WILLIAM SIDNEY MOUNT
(American, 1807–1868)

The Bone Player. 1856
Oil on canvas, 36 × 29 in.
Bequest of Martha C. Karolik for the Karolik Collection of
 American Paintings, 1815–1865. 48.461

Although Mount's *Bone Player* is what the nine-teenth-century Long Island genre painter termed a "comic picture," it is rendered with all the exactitude and sensitivity of a commissioned portrait, and indeed Mount notes in his journal that it took him seven days, or fourteen half-day sessions with his model, to complete the picture. *The Bone Player* is one of a series of paintings of blacks playing musical instruments (bones are thin bars of ivory or bone clicked together to create lively rhythms) that Mount painted on commission in the 1850s. He received two hundred dollars for each painting, and another hundred for copyright: lithographs of these pictures were made in Paris, where they enjoyed a wide circulation. The images' appeal to the French was part of a larger vogue for exotic "types" of all sorts: representations of Arabs and Orientals as well as American blacks were eagerly sought after by collectors. To Mount's considerable American public, the popularity of this picture reflected the nationalism of the Jacksonian era, which prompted interest in indigenous subjects. And to contemporary audiences, it is the painting's artistry—the warm, harmoniously blended color, animated composition, and convincing rendering of detail—as well as its sympathetic portrayal of a black man (almost unprecedented in the art of the period) that elicit admiration.

107

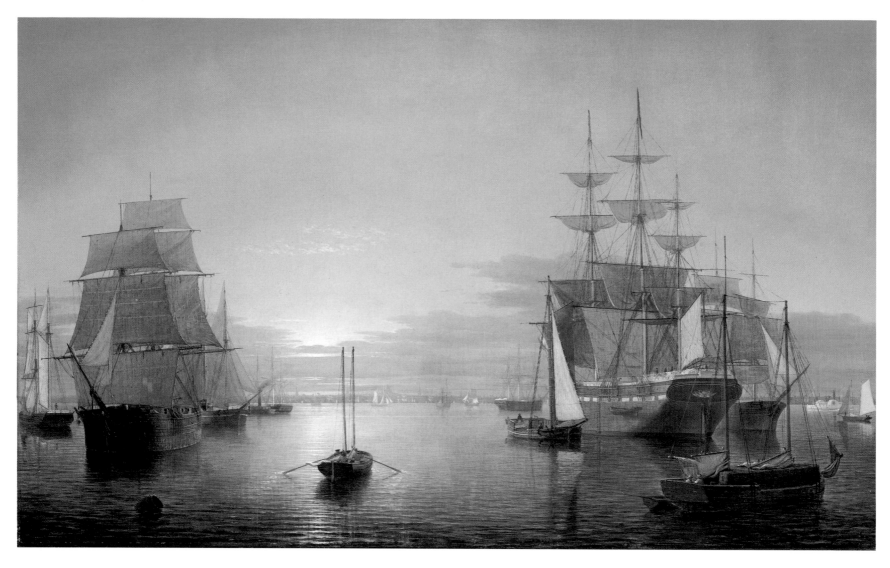

FITZ HUGH LANE
(American, 1804–1865)

Boston Harbor. ca. 1850–55
Oil on canvas, 26¼ × 32 in.
M. and M. Karolik Collection of American Paintings, 1815–
 1865, by exchange. 66.339

The painter Fitz Hugh Lane, the son of a local sailmaker, was wedded to the sea. He lived all of his adult life in a stone house he built looking out on the busy harbor at Gloucester, Massachusetts. As a young man, he suffered from infantile paralysis and became crippled; as a result, he could move about on land only with difficulty, with the aid of crutches. However, his skill as a sailor and his love and knowledge of the sea enabled him to roam widely by water. He explored every inch of Gloucester and its environs in his small boat, and during the summers he cruised with friends on a larger vessel to Boston, New York, and Baltimore, and also made frequent trips eastward to Maine.

Lane painted more than a dozen views of Boston Harbor during the 1840s and 1850s, and in this final picture on the theme he created an image of singular beauty. Boston Harbor is portrayed as a busy and complex place, full of commercial sailing vessels that denote the importance of Boston's port and the trade that made the city rich. One feels also a sense of calm as the ships drift slowly toward their anchorages and the summer wind dies away at the end of day. Twilight colors pervade the whole scene, and the viewer's eye is led inexorably to the center of the painting, to the small boat being rowed down the channel toward the distant dome of the Massachusetts State House, still visible on the horizon.

108

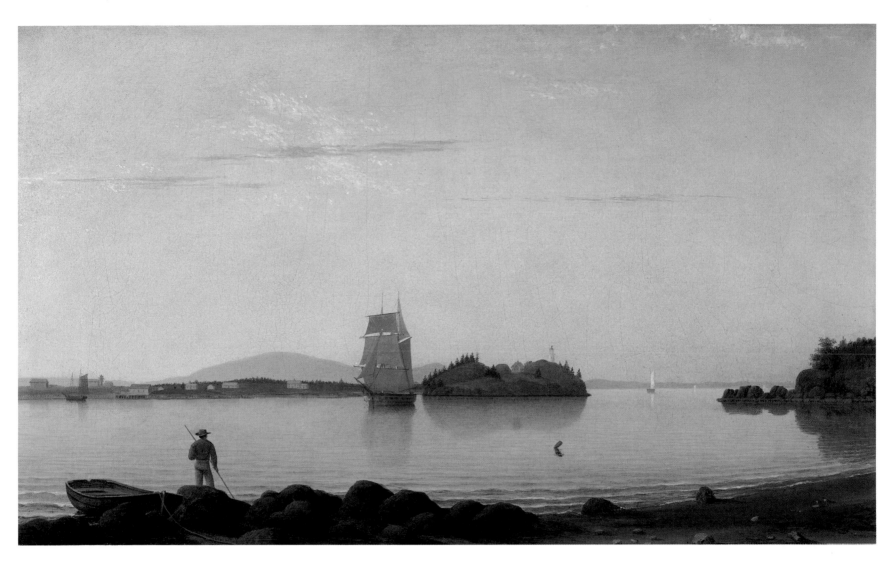

FITZ HUGH LANE
(American, 1804–1865)

Owl's Head, Penobscot Bay, Maine. 1862
Oil on canvas, 16 × 26 in.
Bequest of Martha C. Karolik for the Karolik Collection of
 American Paintings, 1815–1865. 48.448

During the last few years of his life, Lane perfected his art. In an era when the most popular American painters, such as Frederic Church and Albert Bierstadt, were gaining fame by exploring and then painting the wilderness of South American jungles or the great mountain ranges of the American West, Lane simplified his compositions and began to paint just light itself. Here, in one of his most spare, poetic views, the artist depicts the tender light and pale pink and yellow colors of dawn on Penobscot Bay in Maine. A single standing figure pauses to look out over the bay as he begins his day's work; in the center, a small brig has raised its sails and weighed anchor but remains motionless in the calm air. The point of land called Owl's Head lies just to the right of the boat, and to its left, in the distance, one sees the Camden Hills.

Fitz Hugh Lane exhibited his work yearly in Boston, and his paintings were popular with local collectors. After his death in 1865, however, Lane was quickly forgotten, and it was only in the 1940s that he was rediscovered by Boston's great collector of American art, Maxim Karolik.

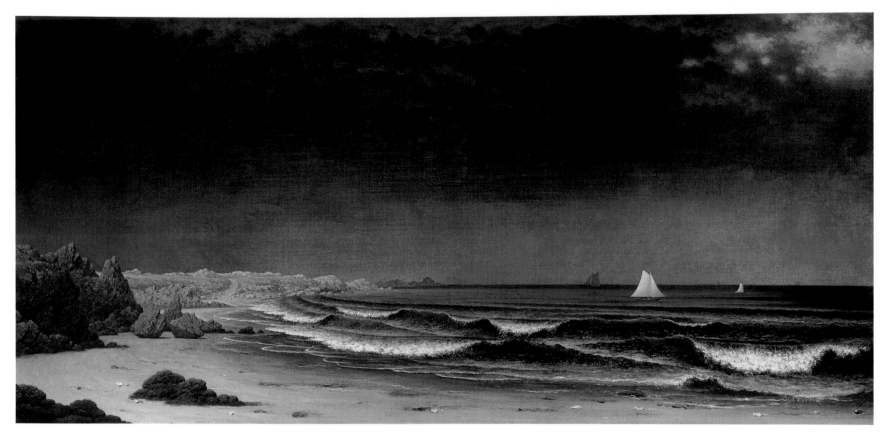

MARTIN JOHNSON HEADE
(American, 1819–1904)

Approaching Storm: Beach near Newport. ca. 1860
Oil on canvas, 28 × 58¼ in.
Gift of Maxim Karolik. 45.889

Though Martin Heade knew the members of the Hudson River School, such as Frederic Church, he rejected their generally optimistic, sunny vision of the American land, and he painted instead in a highly visionary, romantic style. Whether painting orchids and hummingbirds in the tropics, salt marshes he found from Newburyport to Florida, or the sea, Heade worked in an intense and original way. In *Approaching Storm* he eliminated all unnecessary details, reducing the scene to one of land, sea, and sky. On the left lies the long, rocky Point Judith, strange and barren, more like a moonscape than earth; above is a forbidding sky, and below, long, cresting waves roll in from the dangerous, dark sea. One feels, with the artist, a sense of awe at the power and the mystery of nature.

Heade's work was not highly regarded by his contemporaries and was totally forgotten after his death. Only in the 1940s was he rediscovered by the Museum of Fine Arts's great patron, Maxim Karolik, who collected over fifty of Heade's paintings, and since then he has come to be considered one of the most powerful and most original American artists of the nineteenth century.

JAMES ABBOTT MCNEILL WHISTLER
(American, 1834–1903)

The Last of Old Westminster. 1862
Oil on canvas, 24 × 30½ in.
A. Shuman Collection. 39.44

Whistler was a highly innovative American proponent of modern art who worked and lived in Paris and London. Although a friend and sympathizer of the Realist and Impressionist painters from the 1860s on, he maintained an independent stance and preferred to be identified as an eccentric individual rather than part of either group. *The Last of Old Westminster* is an early London painting dominated by the construction of a new bridge replacing the original eighteenth-century stone structure that spanned the River Thames near the Houses of Parliament. Whistler's application of thick, heavy paint creates a crusty surface reminiscent of the contemporary work of his friend Gustave Courbet, and like the early Impressionists he sought to capture an overall effect, accurate in color and tonality, deliberately sketchy, suggestive, and without painstaking detail. The unusual composition, with a strong contrast between the spacious foreground and complex, oddly angled view of the bridge, shows the artist's interest in Oriental art. Indeed, inspired by Japanese prints, he pursued these ideas to more radical extremes in the 1870s, creating vague, relatively monochromatic twilight landscapes which he evocatively titled with musical analogies (for example, *Nocturne in Blue and Silver: The Lagoon, Venice*, 1879–80, Museum of Fine Arts, Boston).

JOHN LA FARGE
(American, 1835–1910)

Vase of Flowers. 1864
Oil on panel, 18½ × 14 in.
Gift of Misses Louise W. and Marian R. Case. 20.1873

John La Farge, best known for his murals decorating Boston's Trinity Church and the Church of the Ascension in New York and for his designs for stained glass windows, was as well an extraordinarily gifted still-life painter, creating many small-scale, delicate compositions in watercolor and in oil, as here. In the earliest of these works, made during the Civil War era, La Farge used a compositional type long favored by American still-life painters—a bowl of fruit or bouquet of flowers simply placed on a marble or wooden tabletop—but rather than striving for botanical accuracy and precise detail, La Farge deliberately created an air of mystery. Here he employs a columnar, vaguely Oriental-style vase which seems far too massive for the delicate blossoms it contains. The paint handling is soft, almost impressionistically blurred, so that the blossoms' species cannot be identified, except for the tiny red bachelor's button lying on top of the artist's calling card, a detail that serves as an enigmatic forget-me-not. Behind the vase is a Japanese screen, itself (like the vase) decorated with painted flowers. The items La Farge has chosen to paint are exotic and evocative, creating a feeling of melancholy, but also of preciousness, that would characterize the best of La Farge's still lifes for the rest of his career.

LEVI WELLS PRENTICE
(American, 1850–1935)

Apples in a Tin Pail. 1892
Oil on canvas, 15½ × 12½ in.
The Hayden Collection. 1978.468

Throughout the nineteenth century, two separate artistic traditions existed side by side in America. There were on the one hand the "sophisticated" artists, from Gilbert Stuart to Whistler and Sargent, who had traveled extensively, studied in Europe, and won national and international reputations. Then there were the rural or "folk" painters, who were largely self-taught, whose style was painstaking and unsophisticated, and who were known only in their own home areas. It is usually thought that the tradition of the self-taught painter died out after the Civil War, but it did not. One finds in particular that some of the most highly original American still-life painting of the late nineteenth century comes from this indigenous school. Leading artists of this kind were *trompe l'oeil* specialists such as William Harnett, John F. Peto, and vegetable and fruit painters, notably Joseph Decker and Levi Wells Prentice.

Prentice is a perfect example of the local, journeyman painter who rose at times to moments of artistic greatness. Born in the Adirondacks in upper New York State, and self-taught, he moved frequently from one place to another before settling in Brooklyn in the years 1883 to 1901. There he supported himself as a carpenter, frame-maker, and art teacher, while painting a series of highly realistic landscapes and still lifes. His masterpiece, *Apples in a Tin Pail*, is both convincing and very modern in its sharp, hard-edged realism. Taking the most humble of rural objects, Prentice celebrates both his own skill as a craftsman and the rich and colorful produce of America.

WILLIAM RIMMER
(American, 1816–1879)

Flight and Pursuit. 1872
Oil on canvas, 18 × 26¼ in.
Bequest of Miss Edith Nichols. 56.119

A practice as a physician, the teaching of anatomy and drawing, the writing of instructional drawing books, and the making of sculpture and painting played equally important roles in the career of Boston's William Rimmer. *Flight and Pursuit*, his most enigmatic painting, was painted less than a decade after the Civil War, and several scholars have suggested that its unsettling aspect derives from that national trauma. However, its vision of terror might just as well represent Rimmer's emulation of popular Gothic novels, or of their most brilliantly imaginative exponent, Edgar Allan Poe. The setting and the figures suggest the ancient world, particularly the period of the Old Testament as it was imagined by nineteenth-century illustrators. A terrified warrior fleeing an unseen force is but a few steps in front of his assailant's shadow; in the middle a ghostlike, shrouded figure echoes the flight of the man in the foreground. An inscription on a related drawing suggests that the picture may depict the conspirators Adonijah and Joab racing to sanctuary from the soldiers of King David (I Kings 1:50).

Flight and Pursuit is a perfectly crafted and composed image, with a brilliant counterpoint of shadows echoing throughout the picture space. For modern viewers, accustomed to the Surrealist paintings of Dali and Magritte, its cryptic meaning has become one of its principal attractions.

114

WILLIAM MORRIS HUNT
(American, 1824–1879)

Self-Portrait. 1866
Oil on canvas, 30 × 25 in.
William Wilkins Warren Fund. 97.63

William Morris Hunt painted four self-por-
traits, which span his entire career: the earliest
was executed about 1848, during his student
days in Paris, and the latest in 1879, the year of
his death. This portrait, painted on the eve of
the artist's departure for Europe, is the most
dramatic and revolutionary of all his self-im-
ages. Hunt portrays himself as the romantic
artist: moody and intense, with an intelligent
high forehead and a full, flowing beard (a bo-
hemian fashion well in advance of prevailing
Boston styles). His cross-armed pose suggests
defiance, and, even more startling, he shows
himself against a creamy yellow background.
The use of a light background recently had
been popularized in France by Hunt's teacher
Couture, among others, but was unknown in
America, where dark backgrounds (often with
interior furnishings suggestive of the sitter's
occupation and social status) were still cus-
tomary. For Hunt, the use of the light back-
ground was a well-chosen dramatic device, for
it enabled him to push himself forward toward
the viewer and thereby assert the power of his
personality.

115

ALBERT BIERSTADT
(American, 1830–1902)

Wreck of the "Ancon" in Loring Bay, Alaska. 1889
Oil on paper, mounted on panel, 14 × 19¾ in.
Gift of Mrs. Maxim Karolik for the Karolik Collection of
 American Paintings, 1815–1865. 47.1250

In the years following the Civil War, Albert Bierstadt became the best known of American landscape painters. Most admired were his large, highly detailed, and dramatic views of the American West, especially of the Rocky Mountains, the Sierras, and Yosemite Valley. Bierstadt would travel during the summers to these wilderness regions, there making dozens of on-the-spot sketches, using either pencil or oil on paper to record what he saw. During the winters, back in his New York studio, he would use some of these sketches in composing his large, finished paintings. Bierstadt's oil sketches were meant only for his own use; they were never sold to collectors or publicly exhibited during his lifetime, and he would be amazed to find one of these sketches regarded as a "masterpiece." Today, with twentieth-century eyes, we admire the *Wreck of the "Ancon"* as the finest of Bierstadt's sketches, with its simple, strong composition, its depiction of the grays of sea and sky contrasted with the strong yellows on the boat, and its freshness and simplicity.

Bierstadt himself had been a passenger on the *Ancon*, a side-wheeler that made monthly excursions from Tacoma, Washington, up the Alaska coast to Juneau and Sitka. She was lost on August 28, 1889, at Loring in the Revillagigedo Islands, when a strong tide carried her onto a reef as she backed out from the wharf. Bierstadt's painting conveys both the beauty and the sadness of this scene, as the ship settles into her final resting place.

MARY STEVENSON CASSATT
(American, 1844–1926)

Five O'Clock Tea. 1879
Oil on canvas, 25½ × 36½ in.
M. Theresa B. Hopkins Fund. 42.178

Mary Cassatt was among the first of many Americans in the late nineteenth century to paint in an Impressionist style, and she was the only one to actually join the radical French artists and to show with them in their independent exhibitions in Paris. Cassatt became associated with Edgar Degas, and her asymmetrical, closely cropped compositions reflect her admiration for his work. *Five O'Clock Tea* was painted in France at Cassatt's summer house in Marly-le-Roi. Lydia Cassatt, the artist's sister and frequent model, is shown at left, while a young visitor, wearing hat and gloves, daintily sips tea. The silver service on the table before them was a Cassatt family heirloom made in Philadelphia in the 1820s, and it is also in the collection of the Museum of Fine Arts. Its prominent place in the composition, acting almost as a third person, is typical of the Impressionists' desire to paint exactly what they saw rather than to subordinate inanimate objects to human figures. Along with the elegant striped wallpaper, the carved marble mantelpiece with its Chinese vase, and the pink chintz sofa, the tea set reveals the elegance of Cassatt's world. She embraced a modern aesthetic but retained a gracious and refined way of life.

JOHN FREDERICK PETO
(American, 1854–1907)

The Poor Man's Store. 1885
Oil on canvas and wood, 36 × 25½ in.
Gift of Maxim Karolik for the M. and M. Karolik Collection of
 American Paintings, 1815–1865. 62.278

Philadelphia-born Peto was a friend of the still-life painter William Harnett, but their lives and art took very different directions. While Harnett developed an elaborate, highly polished style that won him far-reaching popularity, Peto worked in a softer, more poetic manner for a local audience. *The Poor Man's Store* is a tender and whimsical record of someone's humble attempt to make a living selling candies, apples, peanuts, and cookies from a tiny street-front window. But for all its naive charm it is a sophisticated object, combining a canvas for the central window area with an illusionistically painted wooden "frame" for the outer areas representing the wall, shelf, and door. The use of bright pastel colors against the black interior space has a lively and pleasing impact, although that mood is countered somewhat by the worn and tumble-down quality of the signs, numbers, and placards on the green wooden surround.

A few years after painting this work Peto moved to the small resort town of Island Heights, New Jersey, where he spent the rest of his life in relative obscurity. His current high standing in the history of American art stems from the revival of interest in early American still life in the 1930s. There are clearly affinities between his more haunting still lifes and the box constructions of Joseph Cornell and even the assemblage art of Robert Rauschenberg.

118

WILLIAM MICHAEL HARNETT
(American, 1848–1892)

Old Models. 1892
Oil on canvas, 54 × 28 in.
The Hayden Collection. 39.761

Old Models was the last painting completed by Harnett before his death in 1892. It represents the culmination of a still-life formula he had popularized in the preceding decade: a group of well-worn, much-used objects artfully arranged on a tabletop or hanging against a door, as here, painted in a manner so realistic that in Harnett's day (as well as our own) spectators were fooled into seeing real objects where the artist had used only paint.

Harnett enjoyed enormous popularity in the late nineteenth century. Audiences delighted in his skill in simulating real objects with paint, and the battered, old-fashioned items (the tattered sheet of music on the ledge is "The Last Rose of Summer") painted in an earth-toned, masculine palette appealed to the country's sentimental mood during the Brown Decades. But the arrival of Impressionism in America in the 1890s ushered in a vogue for sunny, outdoor subjects painted in bright, pastel colors, and as a result, Harnett's sentimental works fell out of favor. They vanished from view until the 1930s, when they were rediscovered by the New York art dealer Edith Halpert, and have since become the most sought after of all nineteenth-century American paintings.

119

FREDERICK CHILDE HASSAM
(American, 1859–1935)

Boston Common at Twilight. 1885–86
Oil on canvas, 42 × 60 in.
Gift of Miss Maud E. Appleton. 31.952

Famous for his shimmering coastal views and his lively urban street scenes, Hassam was a pioneer American Impressionist. He was a native New Englander, raised in Dorchester, Massachusetts, then a prosperous middle-class suburb of Boston. As a young artist, he was inspired by the popular views of modern Paris, which he saw in Europe in 1883. Upon his return, he leased a studio on Tremont Street in downtown Boston and began to paint large-scale city scenes.

Boston Common at Twilight shows the historic public park, once the city's grazing land, directly across the street from Hassam's studio. The busy life of the city, with its crowded procession of trolley cars and hackney cabs, is contrasted with the tranquillity of the snow-laden common. A woman has stopped to admire the scene while her two young charges feed a tiny flock of sparrows. The atmosphere is permeated with a soft, rosy glow, the colors reduced to soft browns with touches of pink and orange. Hassam used the repetitive verticals of the fence posts and trees to draw the viewer into the scene and invite him or her to share its simple beauty.

JOHN SINGER SARGENT
(American, 1856–1925)

The Daughters of Edward Darley Boit. 1882
Oil on canvas, 87 × 87 in.
Gift of Mary Louise Boit, Florence D. Boit, Jane Hubbard Boit,
 and Julia Overing Boit, in Memory of their father, Edward
 Darley Boit. 19.124

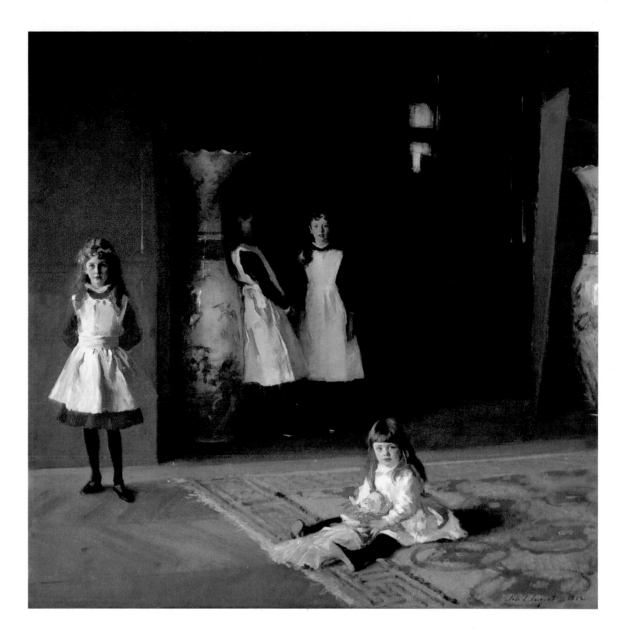

Painted in their Paris residence, the girls in this picture were the daughters of a wealthy Boston artist who divided his time between America and Europe. When he received this commission from his friend Boit, Sargent was emerging as a rather daring and stylish painter in Paris, where he had received his professional training. The painterly execution of this work—especially the thickly brushed highlights in the white pinafores—demonstrates Sargent's interest in Impressionism. At this time, however, he was less influenced by the bright colors favored in Monet's circle than by the darker tonalities of Manet. Like Manet, Sargent was deeply affected by the brilliant technique of Hals and Velázquez.

Most critics of the day, Henry James included, found this composition extremely unconventional, particularly the asymmetrical arrangement of the figures and the dominance of the shadowy "void" of the background. The artist had in fact based the proportions, spatial progressions, and overall mood on Velázquez's masterpiece *Las Meninas*, which he copied on his visit to the Prado in 1879. Intuitively Sargent also made a striking, if enigmatic, statement about childhood's pleasures and terrors, giving a note of seriousness to even the youngest child, clutching her doll in the foreground. None of the subjects of this portrait married, and in 1919 they gave the picture to the Museum in memory of their father.

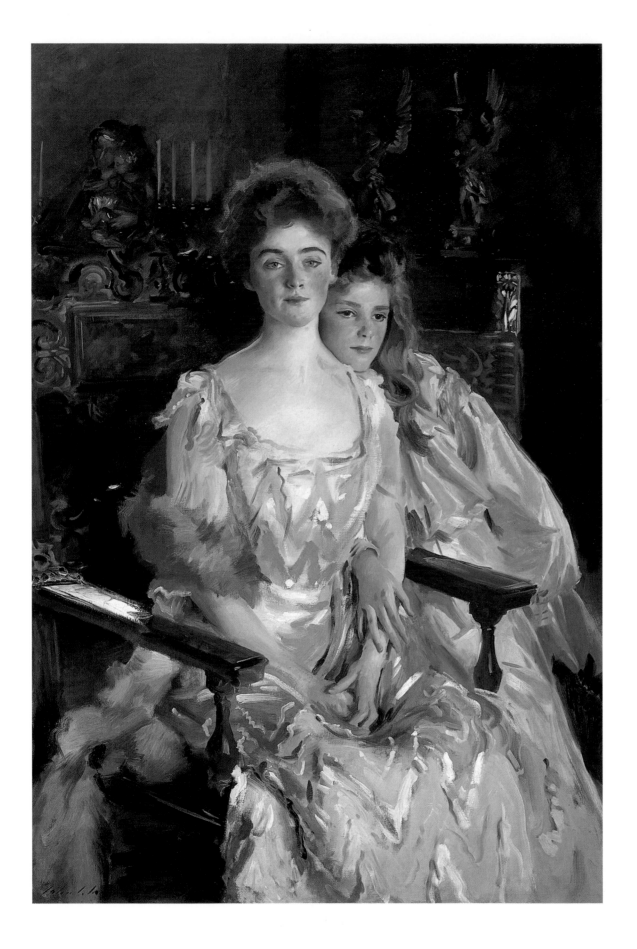

JOHN SINGER SARGENT
(American, 1856–1925)

Mrs. Fiske Warren and Her Daughter. 1903
Oil on canvas, 60 × 40¼ in.
Gift of Mrs. Rachel Warren Barton and the Emily L. Ainsley
 Fund. 64.693

Soon after moving his residence from Paris to London in 1886, Sargent became a frequent visitor to Boston, where his portraits were eagerly sought by local society figures. This charming double portrait of a mother and daughter exemplifies the artist's dashing and showy application of paint while remaining a classic embodiment of Bostonian refinement and propriety. The Warrens sat for Sargent at Fenway Court, the home of a mutual friend, Isabella Stewart Gardner; the richly gilded accessories featured in their portrait are now on public display at the Isabella Stewart Gardner Museum. The Renaissance painted terra-cotta of the Madonna and Child seen in the upper left of the portrait seems to have inspired the affectionate pose with its nestled heads and entwined arms. Ironically, Mrs. Warren was not entirely pleased with the portrait, which she felt stressed a sweet social personality but ignored her serious interest in poetry and the performing arts. Nonetheless, it has always been widely admired as a tour de force of painting, and it is unsurpassed as an expression of the aura of life in Boston's most privileged and artistic circles at the turn of the century.

THOMAS EAKINS
(American, 1844–1916)

The Dean's Roll Call. 1899
Oil on canvas, 84 × 42 in.
A. Shuman Collection. 43.211

About 1890 Eakins embarked on a series of full-length male portraits. Most of these were not commissions, but rather depicted friends or family or locally prominent men he admired. Whatever the achievements of his subjects (and among his sitters were a brilliant physics professor and the head of Philadelphia's School of Industrial Arts), Eakins stressed their humanity rather than their social status: he customarily depicted them wearing rumpled, unstylish suits and in casual, unheroic poses, emphasizing their plain, even haggard features, and thoughtful expressions.

The Dean's Roll Call, a portrait of Dr. James W. Holland (1849–1922), is an exception on two counts. It was commissioned by Jefferson Medical College in Philadelphia, where Holland had served for thirty years as professor of chemistry and dean of the college. He is depicted wearing his academic robes, calling the roll of the new graduates of the medical school, and both his attire and his task attest to his public prominence. Yet the soft brown tones of the background, which seem to envelop the dean's figure in a dreamy haze, and his expression of thoughtful reverie transform this portrait from a public image to an extremely personal and individualized one. It may have been for this reason that the college did not accept the portrait. Subsequently, Eakins gave it to Holland's wife, and it remained in the family until the Museum of Fine Arts acquired it in 1943.

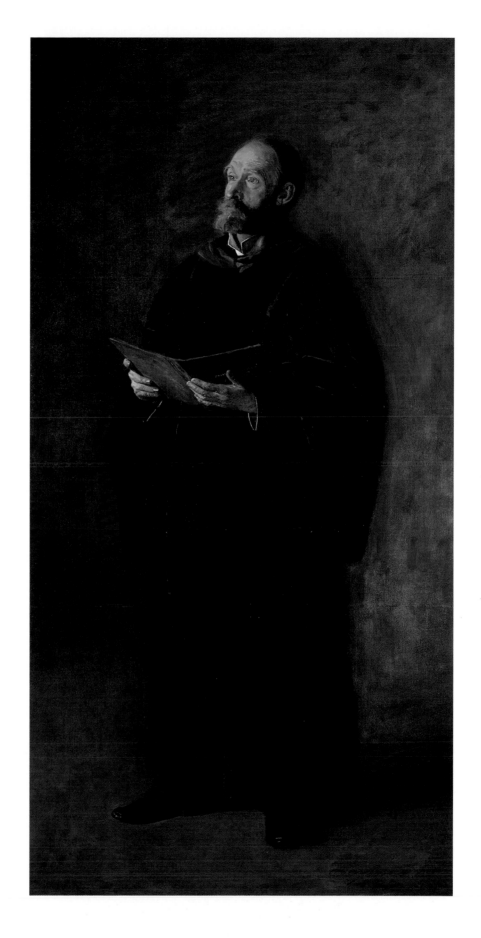

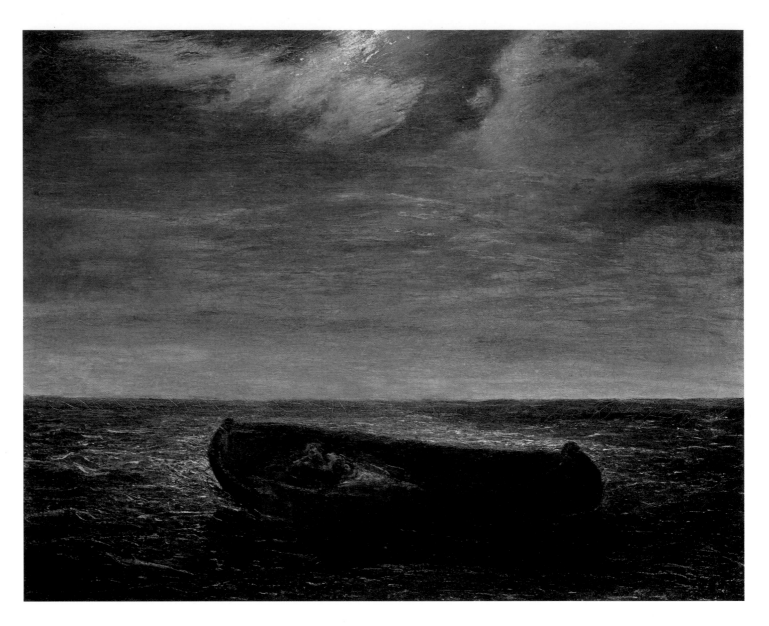

ALBERT PINKHAM RYDER
(American, 1847–1917)

Constance. 1896
Oil on canvas, 28¼ × 36 in.
A. Shuman Collection. 45.770

Living in Manhattan in the late nineteenth century, when Impressionism was the leading modern style and the minutely detailed illusionism of Harnett typified a more popular idiom, Ryder was a recluse with an idiosyncratic approach to art. His themes were often highly romantic and emotional—scenes from the Bible, Shakespeare, Byron's poems, Poe's tales, or Wagner's operas—and they were intended as visions captured in thick, expressive paint rather than as renderings of the real world. Because of this isolation and independent stance he has recently been considered by some critics as a major forerunner of the principal American modernist painters of this century, artists such as Marsden Hartley, Jackson Pollock, and Mark Rothko.

Constance is one of the artist's largest and most tragic pictures. In this episode from Chaucer's "The Man of Law's Tale," a Roman emperor's daughter and her infant son have been put to sea in a boat without sail or rudder; miraculously they survived for five years until their vessel was washed back to Rome. Ryder focuses on the bleak aspect of suffering and endurance by depicting the scene at night. Almost corpselike, the two figures can barely be seen within the shadowy hold of the boat. The boat itself is contained by the dark, horizontal band representing the sea. Above, however, a large expanse of tired sky is illuminated by moonlight, and the prospect of hope and salvation is suggested by the aura of light into which the vessel is passing.

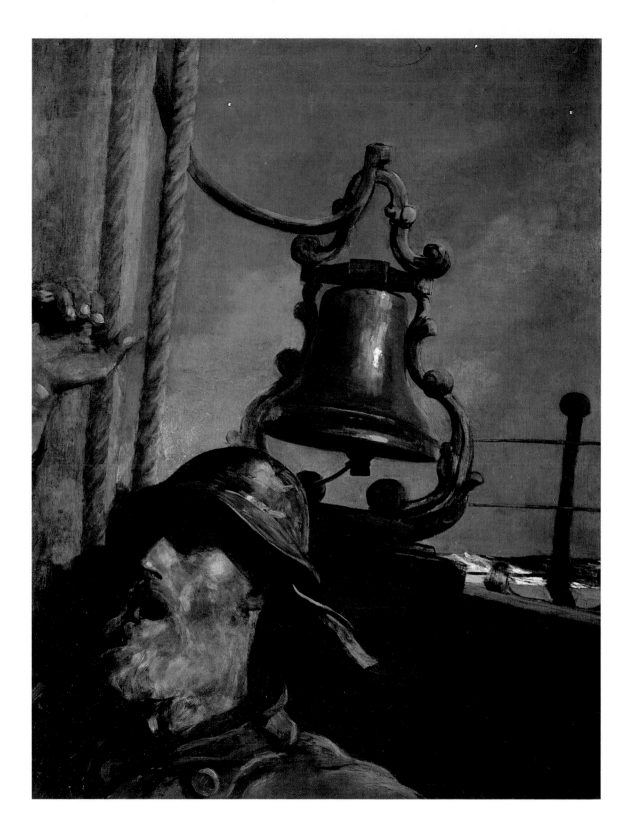

WINSLOW HOMER
(American, 1836–1910)

The Lookout—"All's Well." 1896
Oil on canvas, 40 × 30¼ in.
Warren Collection. 99.23

A Boston native, Winslow Homer worked first as an apprentice in a local lithographic company and then as an illustrator; he became a Civil War correspondent for *Harper's Weekly* and drew scenes of life on the front, which later became the subject of his first large-scale oils. His work of the 1870s was devoted to idyllic images of country life, but his style shifted after he spent over a year in a small English fishing village on the North Sea, mastering the subject that would be central to his work for the rest of his career, man's struggle with the force of nature.

Using a local fisherman as a model and an elaborate clay bell he sculpted himself, Homer painted *The Lookout—"All's Well"* at his studio in Prout's Neck, Maine, where he had settled in 1882. The picture belongs to a series of night scenes begun in 1890 in which his frequently subdued palette is further reduced, here to dark browns and a steel blue-gray, activated by the white dabs of the flickering stars and the crest of a breaking wave. The seaman is anonymous and roughly drawn, his heroic bulk subordinated to a corner of the canvas. The routine rhythm of the large bell, rung six times a day, is his attempt to regularize his contact with the shifting, autonomous ocean he travels. Homer himself called this picture "unexpected and strange" and doubted its appeal to the general public. He sold it to Thomas B. Clarke of New York, a major collector of American paintings, who at one time owned thirty-one works by Homer.

JOHN WHITE ALEXANDER
(American, 1865–1915)

Isabella and the Pot of Basil. 1897
Oil on canvas, 75½ × 35¼ in.
Gift of Ernest Wadsworth Longfellow. 98.181

A successful illustrator and portraitist in the 1880s, John White Alexander moved from New York to Paris in 1890. He became a close friend of James M. Whistler, and through him he met many of the leaders of the Symbolist movement, including Octave Mirabeau, Oscar Wilde, André Gide, and Stéphane Mallarmé. Alexander's Parisian work also reveals his interest in the sinuous decorative designs of Art Nouveau.

Isabella and the Pot of Basil illustrates an 1820 poem of John Keats in which he recounts the Renaissance story of a beautiful daughter of a Florentine merchant. Her humbly born lover was murdered by her ambitious brothers; the distraught maiden found the body, cut off the head, and hid it in a large pot in which she planted sweet basil, a symbol of love. Alexander depicts the grieving Isabella with intense theatricality, lighting the scene from below in a manner he used for portraits of actors on stage and compressing the gruesome scene into a shallow niche. Her sensuous gesture as she strokes the pot is echoed in the snaking curves and folds of her gown. The eerie light, the almost monochromatic palette, and the coarsely woven canvas itself underscore this mysterious, bizarre subject.

ABBOTT H. THAYER
(American, 1849–1921)

Caritas. 1894–95
Oil on canvas, 85 × 55 in.
Warren Collection and Contributions through the Paint and
Clay Club. 97.199

At the turn of the century Abbott Thayer was one of America's best-known artists, famous for both his easel paintings and his decorative murals. Like his colleagues in architecture and sculpture, he was inspired by works of the Italian Renaissance and of classical antiquity. In their monumental forms he found a model to express the ideals of the gilded age—beauty, civic-mindedness, and manifest destiny.

Thayer derived the composition of *Caritas* from one of his mural commissions. Representing the virtue Charity, the model for the central figure was Elise Pumpelly, a fashionable young New Yorker. Draped in a classical Greek chiton, the woman extends her arms in a gesture of protection toward the two children at her side. Their innocence is highlighted by their nudity and by the fresh, green, springtime setting. The arrangement is architectural in its solidity; the idealized woman is anchored to the center, columnar in her white robes and caryatid-like stance. This stability is relieved by Thayer's fluid handling of the paint surface, with its flickering lights and darks, and by the charming gesture of the child to the left, who sucks her fingers and seems oblivious to her role as an icon. Thayer exhibited this picture in Philadelphia in 1895 and won a three-thousand-dollar prize.

WILLIAM McGREGOR PAXTON
(American, 1869–1941)

The New Necklace. 1910
Oil on canvas, 35½ × 28½ in.
Zoë Oliver Sherman Collection. 22.644

Old Master paintings in the Louvre, the light-filled pictures of the Impressionists, and solid academic training at the Ecole des Beaux-Arts had a significant effect upon the style of William Paxton. Like many of his Boston colleagues who were trained in Paris, Paxton returned to his native city and began a profitable career painting portraits, still lifes, and exquisitely detailed interiors such as *The New Necklace.* Here, two elegant young ladies discuss the implications of a recent gift from an absent suitor. Like the gold beads they hold, the women are beautiful ornaments in a rich setting. The decorative screen, Chinese tunic, and porcelain figurine reflect the contemporary taste for Oriental objects as well as a probable source for the opulent display— many Bostonians had made their fortunes in the China trade. In the background hang an antique tapestry and a copy of a painting by Titian; Paxton refers to another Old Master as well, for the composition itself is styled after the work of Vermeer, whose luminescent domestic scenes, with their pictures within pictures, were recently rediscovered and highly admired at this time. Paxton created here an elegant and refined example of his belief that the beauty of art was its only justification.

WILLIAM JAMES GLACKENS
(American, 1870–1938)

Italo-American Celebration, Washington Square.
ca. 1912
Oil on canvas, 26 × 32 in.
Emily L. Ainsley Fund. 59.658

Like many of his contemporaries, William Glackens was fascinated with the pageant of modern life. After a year of European study he settled in New York in 1896 and worked as an illustrator for newspapers and magazines. His associates, such as Robert Henri and John Sloan, were friends from his Philadelphia youth; together they developed a loose, painterly style and took as their subjects the daily activities of the city. In 1908 they held an independent group exhibition; although formally titled "The Eight," they became well known as the "Ashcan School."

Italo-American Celebration, Washington Square addresses both the new and old New York. Since 1904 Glackens had had a studio in Washington Square, once a socially elite residential area, which by 1900 was becoming a bohemian neighborhood. Its central feature and a symbol of the cosmopolitan city was the marble arch designed by architect Stanford White; it served as the focus of many political and social events such as the parade Glackens shows here, capturing the festive spirit of the occasion with bright colors and flickering brushwork. That this is an ethnic celebration underscores the shifting nature of New York—the year this work was executed marked the peak of United States immigration from southern and eastern Europe, as a result of which a strict quota system would be instituted before the end of the decade. However, these social concerns seem secondary to Glackens's obvious delight in the shifting, colorful crowd and the pageantry of flags; in fact, the composition recalls the urban scenes of Impressionist painters like Renoir, whom Glackens greatly admired.

Modern Paintings

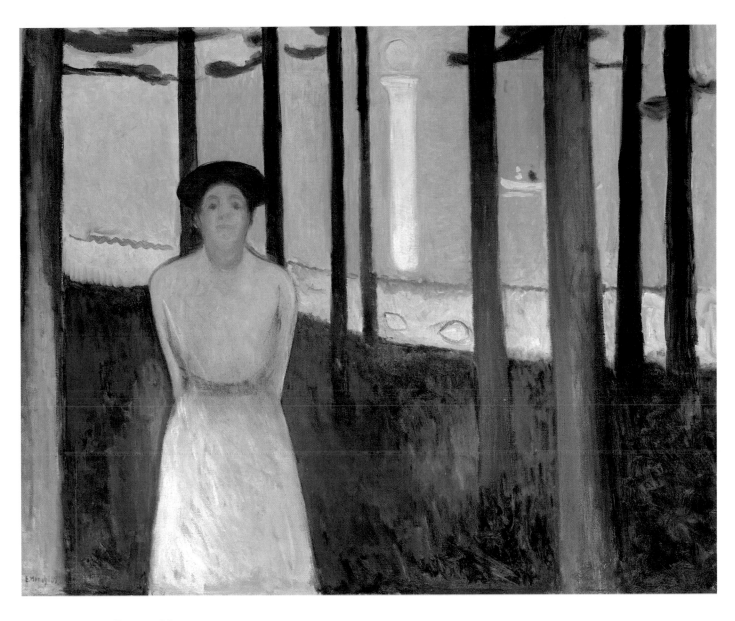

EDVARD MUNCH
(Norwegian, 1863–1944)

Summer Night's Dream (The Voice). 1893
Oil on canvas, 34⅝ × 42½ in.
Ernest Wadsworth Longfellow Fund. 59.301

In the late 1880s Edvard Munch conceived the idea of creating an epic series of paintings he called *The Frieze of Life*, which would deal primarily with life, love, and death on a poetic and symbolic level. The project was never completed, but many of his most memorable images investigating feelings of anxiety, despair, loneliness, and psychic pain are from this body of work, the bulk of which was done in the 1890s. Painted in Berlin in 1893, *Summer*

Night's Dream is the first in his cycle of *Love*, and portrays the initial glimmer of adolescent sexual awakening. Suffused by an eerie mystical light, the painting is probably set in the Borre Forest of Norway, a traditional place of courtship during the endless midsummer nights.

Presumably reflecting the artist's intentions, the Polish poet Stanislas Przybyszewski (a close friend of Munch who was married to Dagny Juell, traditionally identified as the model for the painting) wrote: "The objective scene is nothing more than an accessory, but the mood is intensely effective. It is the longing of puberty . . . the intense listening-into-yourself, half horror, half pleasure in the sensual

subterranean areas of sexual arousal." Munch has created a tension between the strong phallic verticals of the trees and reflections, and the still figure of the girl, who both offers herself to and holds herself back from the viewer, whom the artist has placed in the position of anticipated lover. The inspiration for the picture, for which there is another painted version as well as several prints, is said to be Munch's recollection of his first adolescent romance.

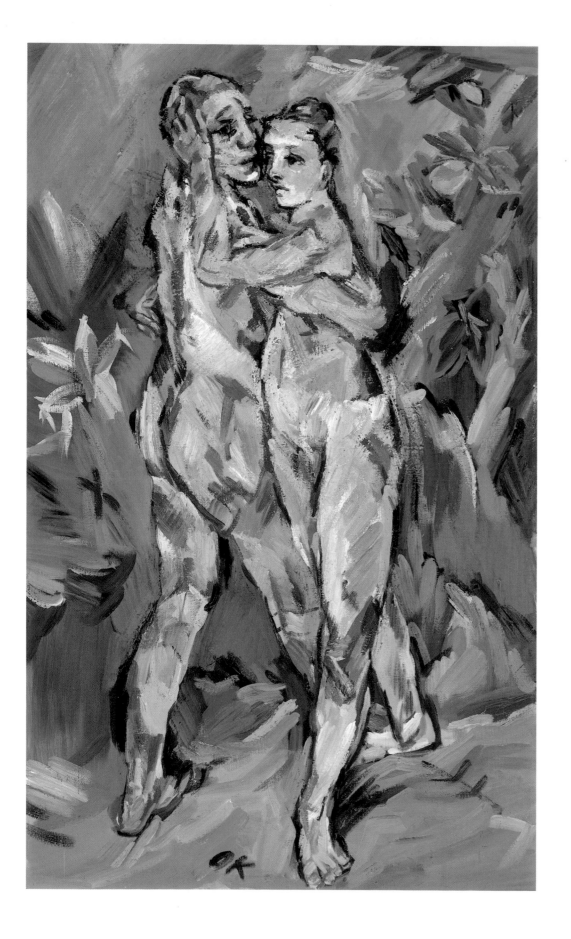

OSKAR KOKOSCHKA
(Austrian, 1886–1980)

Two Nudes (Lovers). ca. 1912–13
Oil on canvas, 64¼ × 38⅜ in.
Bequest of Mrs. Sarah Reed Blodgett Platt. 1973.196

Painted in Vienna in the years just prior to
World War I, Oskar Kokoschka's *Two Nudes*, a
self-portrait of the artist with Alma Mahler, is
a monumental testimonial to his tumultuous
affair (from about 1911 to 1914) with the wid-
ow of the great musical composer. It is signed
with the artist's characteristic "OK" at the
bottom and painted with the bold expression-
istic brushwork and cool color that are typical
of the powerful works from this period. Turn-
of-the-century Vienna experienced a cultural
blossoming evidenced by the decorative mas-
terworks of Klimt and the achievements of
Freud, Schoenberg, and Mahler. Kokoschka,
best known for his psychologically acute por-
traits, came of age in these years; his work be-
trays more of the influence of Freud's interior
explorations than the decadent fantasy of
Klimt, with whom he studied.

Prior to his return to Vienna in 1911, Ko-
koschka was in Berlin. Like that of the German
Expressionists, his painting was influenced by
the pioneering works of earlier artists like
Vincent van Gogh and Edvard Munch, who
sought to express their emotions through the
boldness of their brushstrokes and colors. Ko-
koschka's *Two Nudes* reflects these Expression-
ist sources and also betrays a debt to the
turbulence of the Austrian Baroque which
preceded him. The painting complements the
other works by Kokoschka in the Museum's
collection, including his 1908 sculpture *Self-
Portrait as a Warrior* and his 1931 *Double Portrait
of Trudl*.

134

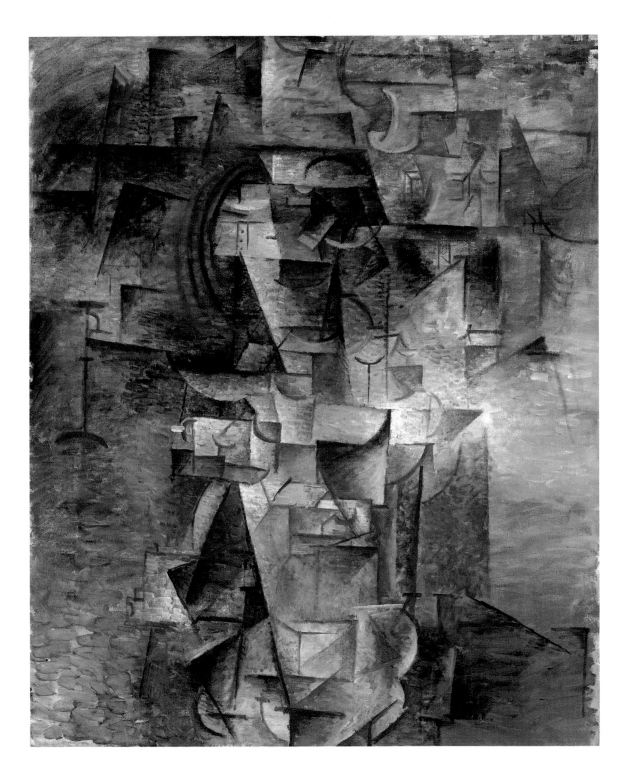

PABLO PICASSO
(Pablo Ruiz Blasco, called Pablo Picasso;
Spanish [worked in France], 1881–1973)

Portrait of a Woman. 1910
Oil on canvas, 39⅝ × 32 in.
Charles H. Bayley Picture and Painting Fund and Partial Gift
 of Mrs. Gilbert W. Chapman. 1977.15

Painted in 1910 when Picasso was not yet thirty, *Portrait of a Woman* is one of seven or eight paintings he did in that year and a superb example of the analytical Cubist style he was then formulating with Georges Braque. The model for *Portrait of a Woman* is said to be the wife of Georges Braque.

The importance of Cubism to twentieth-century art as a revolutionary new way of rendering reality cannot be overstated. Picasso's experiments with the dissolution and fracturing of representational form began in 1909 and reached a peak during the summer of 1910, which he spent with the painter André Derain and others in Cadaques on the Catalonian coast of Spain. He returned to Paris in September with a number of finished works as well as several unfinished ones, including this one, which he completed that fall in Paris. The painting is a pendant to a similarly conceived portrait of Daniel-Henry Kahnweiler (now in the Art Institute of Chicago), the German art dealer who was an early supporter of Cubism. Picasso did not stay with the cerebral monochromatic style of analytic Cubism for long; by 1912 he and others were evolving the less severe "next step" of synthetic Cubism.

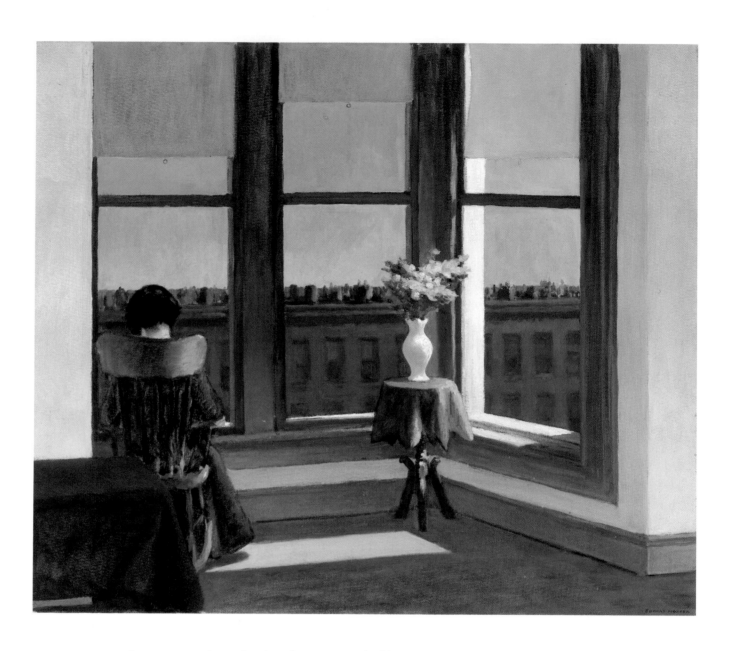

EDWARD HOPPER
(American, 1882–1967)

Room in Brooklyn. 1932
Oil on canvas, 29 × 34 in.
The Hayden Collection. 35.66

Edward Hopper studied under Robert Henri and William Merritt Chase at the New York School of Art from 1900 to 1906 and spent several years in Europe before focusing on a realist style based upon everyday life in America. Despite his topical subject matter, Hopper never identified with such painters of the American scene as Thomas Hart Benton and John Steuart Curry, nor did he find a kindred spirit in modernist abstraction, although his use of geometric ordering has long been admired by proponents of abstraction. Ironically, Hopper's consistently wistful images of lonely, almost wooden figures and vacant, unadorned urban and seashore scenes were often grouped with the more celebratory realism of his contemporaries. The artist once said: "The thing that makes me so mad is the American scene business . . . I think the American scene painters caricatured America. I always wanted to do myself."

Room in Brooklyn is a striking example of one of Hopper's most enduring themes, a quietly subjective treatment of the solitary figure. A woman sits at a window before a faceless brick building whose summarily defined windows suggest a void. The figure's back is to the viewer, underscoring her remoteness as the long shadows suggest a slow wait for day's end. Hopper's palette is drab: the dominant colors are the soft gray walls and the olive green of simple window shades, a darkly shadowed, patternless green rug; a cool blue sky offsets the rust-red building. Yet the painting is richly handled: sunlight on the windowsill conveys a warm glow, embracing a gently textured bouquet, touching against the woman's neck, and lighting up a rectangle of yellow-green on the rug. Such contrasting elements lend a tender quality to Hopper's sense of melancholy.

CHARLES SHEELER
(American, 1883–1965)

View of New York. 1931
Oil on canvas, 47¾ × 36¼ in.
The Hayden Collection. 35.69

William Merritt Chase ranked Charles Sheeler among his best students at the Pennsylvania Academy of the Fine Arts, yet Sheeler soon rejected the style of his teacher. He developed instead a precise, analytical way of painting, based on formal ordering, which made him a leading figure in American Modernism. Sheeler participated in the Armory Show of 1913, was loosely connected to the Stieglitz circle in New York, and attended the Arensberg salon, where he met and was influenced by Marcel Duchamp. He persistently explored abstract structure, finding it in barns, still life, industrial scenes, and utilitarian forms such as Shaker objects and architecture.

When Sheeler turned to the camera in 1912 to support his painting, he did not anticipate how it would extend his aesthetic investigations. *View of New York* can be interpreted as a painting about Sheeler's photography. While he considered himself first a painter, he often embraced photography for creative ends; during the 1920s it was Sheeler's principal preoccupation. The scene here is in fact his commercial photography studio in Manhattan, but the veiled camera, unlit photography lamp, and vacant "safari" type chair suggest equipment no longer in use. While Sheeler frequently made photographs as an aid for painting, *View of New York* corresponds to his difficult decision at this time to end his most productive period in photography for a return to painting as his dominant concern.

Sheeler's works often gain resonance through what is implied or left out. Although *View of New York* is still and restrained, the mechanical motion of opening the window is implied through its subtle association with the crank of the camera stand. The exterior view is of a cloudy sky, not the city below, making the title ironic and enigmatic. Sheeler hints at meaning but continually refuses to complete a story. He called *View of New York* "the most severe picture I ever painted."

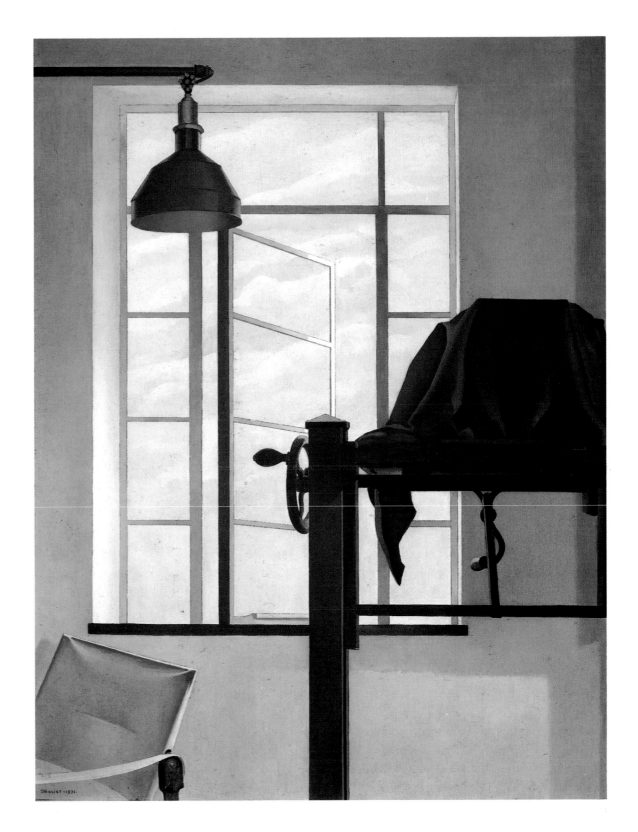

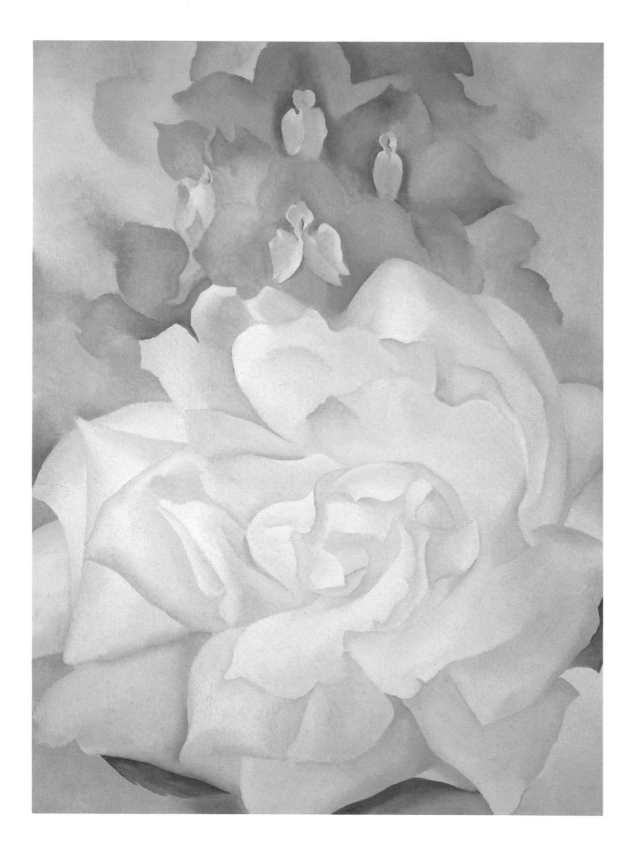

Georgia O'Keeffe, truly a great heroine of American art, was a pioneer abstract painter who pursued a rigorously independent course, developing a style marked by its often austere vision and concomitant sensuality of forms persistently grounded in nature.

O'Keeffe studied under William Merritt Chase at the Art Students' League in New York and became an early member of the avant-garde gallery "291," owned by Alfred Stieglitz, whom she later married. She was identified during the 1920s with a group called the Precisionists because of the emphasis on smooth, flat surfaces and taut geometric shapes in her unpeopled urban scenes. But also during the 1920s O'Keeffe painted a series based on magnified flowers that are rich in curvilinear lines, soft modulations, and subtly alternating color. *White Rose with Larkspur No. 2* is a remarkable example of this series. It exemplifies the evocative, undulating quality, unique among her contemporaries, that often gave way to sexual interpretations of her flower imagery, which the artist refused to acknowledge. "I paint what I see—what a flower is to me," the artist once said, adding in a reference to critics, "I made you take time to look at what I saw and when you took time to really notice my flower you hung all your own associations with flowers on my flowers."

The Museum of Fine Arts made a thorough three-year search during the late 1970s to find a great representative work by O'Keeffe. It ended in 1979 during a curator's visit to O'Keeffe's home in New Mexico, when she produced from her bedroom *White Rose with Larkspur No. 2.*

STUART DAVIS
(American, 1894–1964)

Hot Still-Scape for Six Colors—7th Ave. Style. 1940
Oil on canvas, 36 × 45 in.
Jointly owned by the William H. Lane Foundation and the
 Museum of Fine Arts, Boston; M. and M. Karolik Collec-
 tion, by exchange. 1983.120

New York was Stuart Davis's principal subject from the time he moved there at age nineteen and began to draw. His first images were in the social-realist style of the Ashcan group of artists, who focused on the city's underside. In the 1920s he painted street scenes in which familiar forms—buildings, automobiles, signs —were reduced to geometric silhouettes. In the 1930s New York's landmarks became legible once again, and lettering appeared in concert with Davis's jaunty line and vibrant palette to produce images filled with references to current events; Governor Al Smith and Mayor Jimmy Walker became favorite targets for Davis's satire. But toward the end of the decade he turned again toward abstraction. *Hot Still-Scape* is one of the first works in which his enthusiasm for the city is expressed in the new style.

The painting combines elements of still life and landscape, and conflates an exterior view (contained for the most part by the diamond shape running from upper left to lower right) with the interior space of his studio, whose walls are defined by single-point perspective. Floating around these spaces are both urban images (traffic arrows at lower left, a lamppost at right) and forms with no clear referents (ladders, animal-like forms, and abstract patterns), all defined by Davis's saucy line. The painting does not illustrate New York, but rather summarizes Davis's enthusiasm for the city he observed from his Seventh Avenue studio, or, as he explained, it celebrates "the many beauties in the common things in our environment, and it is a souvenir of pleasures felt in contemplating them."

JOSEPH STELLA
(American, 1877–1941)

Old Brooklyn Bridge. ca. 1941
Oil on canvas, 76 × 68 in.
Partial Gift of Susan Morse Hilles. 1980.197

The Italian-born painter Joseph Stella came to
New York at the age of twenty and studied
painting with the noted American Impression-
ist William Merritt Chase. Traveling to Eu-
rope in the years 1909–12, he was influenced
by avant-garde movements there, especially
Futurism in Italy. When he returned to New
York, Stella quickly became one of the first
modern painters in America.

Stella settled in the Williamsburg section of
Brooklyn, near the bridge, and he became ob-
sessed with painting it. The bridge itself had
been completed in 1883, spanning the East
River between Brooklyn and Manhattan, and
for Stella and others of his generation it sym-
bolized the best in American life and the hope
of American cities. With its soaring, symmet-
rical towers and its graceful struts and cables,
it demonstrated the nation's engineering ge-
nius and its industrial might. Stella himself de-
scribed it as "a weird metallic apparition...
supported by the massive dark towers domi-
nating the surrounding tumult of the surging
skyscrapers with their gothic majesty sealed in
the purity of their arches," and he saw it as
"the shrine containing all the efforts of the
new civilization of AMERICA."

FRANZ JOSEPH KLINE
(American, 1910–1962)

Probst I. 1960
Oil on canvas, 108 × 79⅝ in.
Gift of Susan Morse Hilles. 1973.636

The course of Kline's art as a major statement of Abstract Expressionism was greatly affected by the artist's friendship with Willem de Kooning, which began in New York in 1938. A decade later Kline achieved his most characteristic and individual style painting a series of large "black-and-white" pictures. Painting on a white ground, the artist employed large, broad brushes to create magnificent black devices, which, although abstract and unidentifiable, projected the tremendous presence and heroic scale associated in the urban environment with massive bridges and construction sites. On the one hand they seemed to embody the essential liberty of modern gestural painting, but they were also frequently compared to the ancient Oriental artistic discipline of calligraphy, whose quickly brushed quality they recalled on a huge scale. Significantly, Kline had frequently sketched in ink on paper, and his "black-and-white" paintings did seek to preserve the look he had achieved with that medium.

Probst I was named after Jack (Yoachim) Probst, an artist Kline knew in Greenwich Village during the 1950s. Part of the picture's great beauty is its subtly colorful aspect, in which touches of very pale orange and yellow and quantities of rich dark brown enliven the supposedly monochrome palette for which the series is now named.

JACKSON POLLOCK
(American, 1912–1956)

Troubled Queen. 1946
Oil and enamel on canvas, 74 × 43½ in.
Charles H. Bayley Picture and Painting Fund, and Gift of Mrs.
 Albert J. Beveridge and Juliana Cheney Edwards Collection,
 by exchange. 1984.749

Jackson Pollock holds a central position in twentieth-century American art for the critical role he played in establishing Abstract Expressionism as a vital international trend in the late 1940s. Once a student of Thomas Hart Benton, the Wyoming-born Pollock ultimately purged the literal treatment of the romantic American landscape from his art, developing a turbulent and revolutionary style in which the very act of painting became the subject. The rhythmic, flowing forms of his early landscapes, gleaned from Benton, soon yielded to an enigmatic, symbolic language wrought out of a close study of Picasso, primitive art, and Jungian psychology. As he matured stylistically, Pollock began to subordinate these mythic, iconic images to the very texture and surface of his paintings; ultimately such imagery often disintegrated in the wake of bravura paint-handling and subjective gesture; the process of painting took reign as an expansive, emotion-laden event.

Troubled Queen is a major transitional painting. It bridges his intensely iconographic period and the later panoramas of coiling paint that often defy representational allusion. In *Troubled Queen* fluid passages and splattered incidents anticipate the later phase while suggestions of human and animal heads reminiscent of Picasso combine with writhing, slashing brushwork to produce a resounding tour de force.

PABLO PICASSO
(Pablo Ruiz Blasco, called Pablo Picasso;
Spanish [worked in France], 1881–1973)

Rape of the Sabine Women. 1963
Oil on canvas, 76⅞ × 51⅝ in.
Juliana Cheney Edwards Collection, Tompkins Collection, and
Fanny P. Mason Fund in Memory of Alice Thevin. 64.709

Following in the tradition of his masterpiece *Guernica*, and perhaps painted with the Cuban missile crisis in mind, the *Rape of the Sabine Women* is Picasso's last major statement about the horrors of war. Purchased by the Museum just one year after it was painted in 1963, the painting is the final work in a series based on works of similar themes by the great French classicists Poussin and David. This reinterpretation of the past is not unique in Picasso's oeuvre, and other series include variations on works by Velázquez and Delacroix.

In 1963 Picasso was eighty-two. Two years earlier he had married a much younger woman, Jacqueline Roque, and bought a new villa, Notre Dame de Vie, near Mougins in the hills overlooking Cannes, where this painting was made, and where he spent most of his remaining years. At a time when many of his friends from earlier years were either dead or dying (both Braque and Jean Cocteau died in 1963), Picasso was embarking on what would become his final decade—a period of amazing productivity and great energy that is only recently being understood and appreciated.

Rape of the Sabine Women synthesizes much of Picasso's previous work in a large and dramatic canvas summing up his abhorrence of violence and war. It was the last time Picasso would deal with a theme of such universality—the rest of his output concerned much more personal subjects, often of a sexual nature.

143

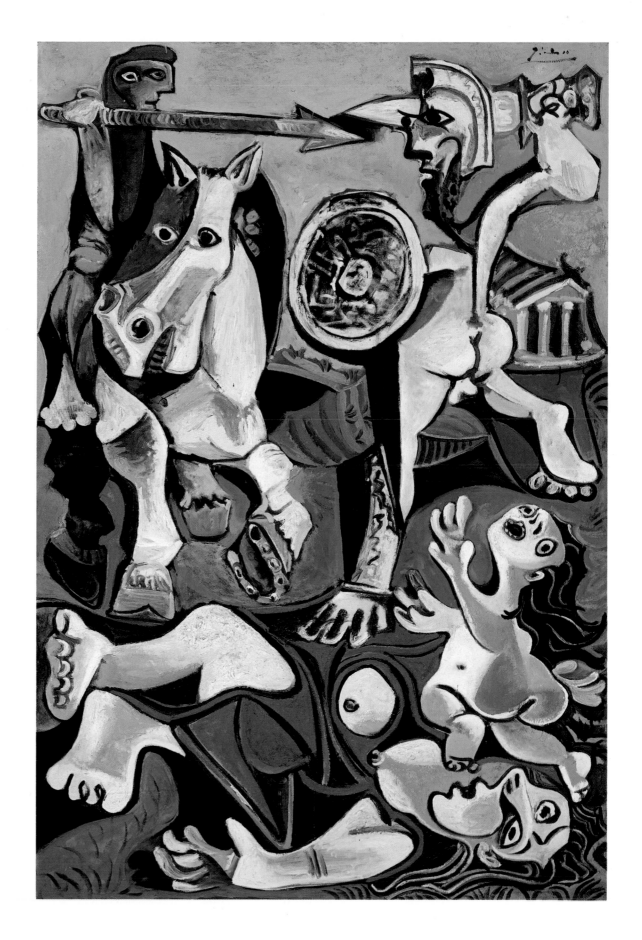

MORRIS LOUIS
(American, 1912–1962)

Delta Gamma. ca. 1960
Oil miscible acrylic (Magna) on canvas, 103¼ × 150⅝ in.
Anonymous Gift. 1972.1074

Morris Louis started his career painting somber, isolated figures in drab New York dwellings and later participated in the WPA easel project. In 1953, however, he underwent a conversion to abstraction after confronting the stain paintings of Helen Frankenthaler, a pivotal influence on his development as a color field artist. Louis's ultimate distinction within this mode rests with paintings made between 1956 and 1962, when he died at age fifty.

A striking feature of *Delta Gamma*, which ranks among this artist's major achievements in the series known as the "Unfurleds" (1960–61), is its center. Louis makes the raw canvas of the empty middle an airy, expansive presence, its rippled contours defined by brilliant blue and purple rivulets that stream in opposing diagonals at left and right. These trailing, elastic shapes reverberate through varied repetitions and brilliant color alternations, descending in dramatic reduction of scale to the lower corners. The rivulets form flaglike groupings at either side which seem to unfurl against a widening middle. The result is a pictorial drama in which simple blankness

and fluid, unmixed colors play tensile roles.

The title, taken from the Greek alphabet, reflects Louis's lifelong preoccupation with series and progressions (his earlier "Veils" were named for characters in the Hebrew alphabet). By working in series, Louis could focus on procedural variations of color and application guided by logical, self-imposed restrictions. Each successive group further removes the suggestion of the artist's hand, eschewing metaphorical associations for an experience based entirely on the shape and beauty of color itself. The "Unfurleds" gave way to a format of vibrant stained stripes, Louis's last major formal investigation.

ANDY WARHOL
(American, born 1930)

Red Disaster. 1963
Silkscreen on linen, 93 × 80¼ in.
Charles H. Bayley Picture and Painting Fund 1986.161a

The son of Czechoslovakian immigrants, Andy
Warhol studied pictorial design at the Carne-
gie Institute of Technology, Pittsburgh, then
moved to New York as a commercial artist in
1949. He enjoyed success with advertising
campaigns, book jackets, and window dis-
plays, then embarked on a painting career
about 1961. His earliest pictures—following
the precedent of Rauschenberg and Johns—
relied on the painterly look of Abstract Ex-
pressionism while depicting common printed
materials such as comics. Warhol quickly ar-
rived at a style both severe and classic, which
seemed to abandon brushstroke altogether,
and employed the silkscreen process to repro-
duce photographic images.

Soup cans, cola bottles, Elvis Presley, and
Marilyn Monroe were key subjects in 1962, but
the following year saw a change of mood, ad-
dressing death in modern American society.
The electric chair, the first such subject, was
followed by car crashes and police brutality at
race riots. *Red Disaster* is a monumentally
scaled example. The gridlike repetition of the
motif, prophetic of Minimal Art, encourages a
scrutiny of the slight variations in screening:
the artist was acutely aware of ways to manip-
ulate the process, bringing attention to details
that should not be overlooked. Warhol makes
the pathetic "SILENCE" sign over the door-
way at the right disappear into menacing ob-
scurity in the lower images, and all the while
the repetitions of the chair and its straps and
cables evoke an evil presence. Created at a
time of enormous social and political change,
when the debate over capital punishment was
vigorously pursued, *Red Disaster* is a tragic evo-
cation of violence in modern America.

145

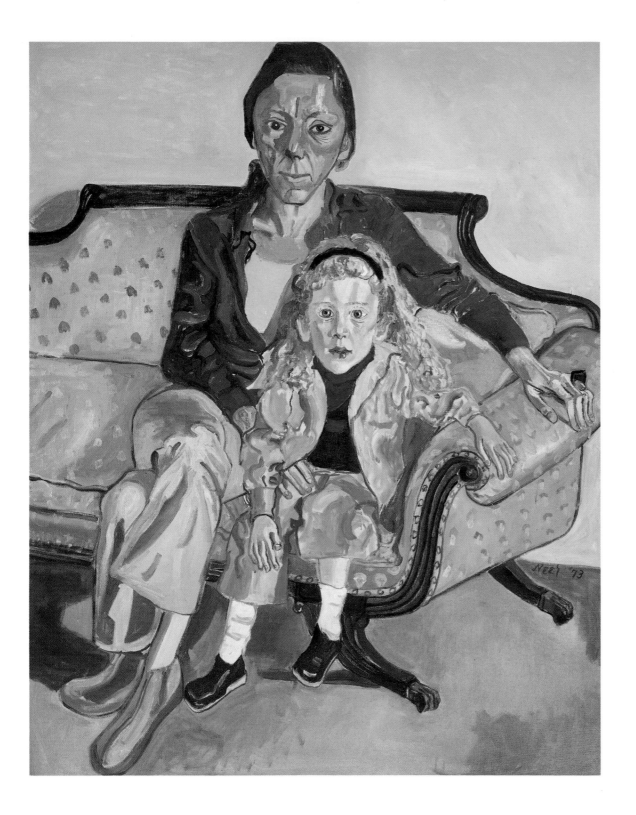

ALICE NEEL
(American, 1900–1984)

Linda Nochlin and Daisy. 1973
Oil on canvas, 55⅞ × 44 in.
The Hayden Collection. 1983.496

Alice Neel consistently painted in a figurative style from the 1920s to her death in 1984. Living in New York since the early 1930s, she concentrated on portraits of friends, art world personalities, and sometimes politicians, the results of which were rarely complimentary. Generally as probing as they are unflattering, Neel's paintings often record a psychological relationship between painter and subject or among the subjects portrayed.

Linda Nochlin and Daisy is one of the most tense and penetrating portraits in Neel's oeuvre, fully manifesting the discomfort of the situation in which a painter engages a distinguished art historian as subject. Squirmy paint handling and raw, complementary hues combine with awkward poses to heighten the viewer's uneasy interaction with the figures. Nochlin's looming head and large, discriminating eyes challenge the viewer as perhaps they did the painter. The confrontational stare is made all the more forcible through the emphatic contrast offered by the ingenuous, open expression of the child's face. Nochlin appears strong but ill at ease. Her hands seem to protect the space she occupies with her daughter, rather than to move freely within it; this element contributes to a psychological complexity which makes the painting provocative and affecting.

Neel's work was long eclipsed by the dominant abstraction heralded by the New York School and later trends in nonobjective art. Only within the decade before her death, with the resurgence of the figure and a new focus on art by women, did Neel's art begin to receive the careful consideration it now enjoys.

146

Index of Artists

Acknowledgments

Commentaries on the paintings were written by the following members of the Department of Paintings: Trevor J. Fairbrother, Helen Hall, Erica E. Hirshler, Laurence B. Kanter, Norman Keyes, Jr., Theodore E. Stebbins, Jr., Peter C. Sutton, Pamela S. Tabbaa, and Carol Troyen. The book's production was overseen by Patricia Loiko and Laurie Lebo, with the assistance of Harriet Rome Pemstein, Pamela J. Delaney, and Lydia Staab. Photography and coordination were done by the staff of the Photographic Services Department.